THE **PACIFIC CENTER**
FOR **WESTERN STUDIES**

at the UNIVERSITY OF THE PACIFIC
Stockton, California 95211

THE SIOUX OF THE ROSEBUD

FRONTISPIECE: Sam Kills Two (also known as Beads) working on his winter count. The death of Turning Bear, killed by a locomotive in 1910, is shown in the second row just above Kills Two's left foot. See Plate 191. (Courtesy of Nebraska State Historical Society, Lincoln.)

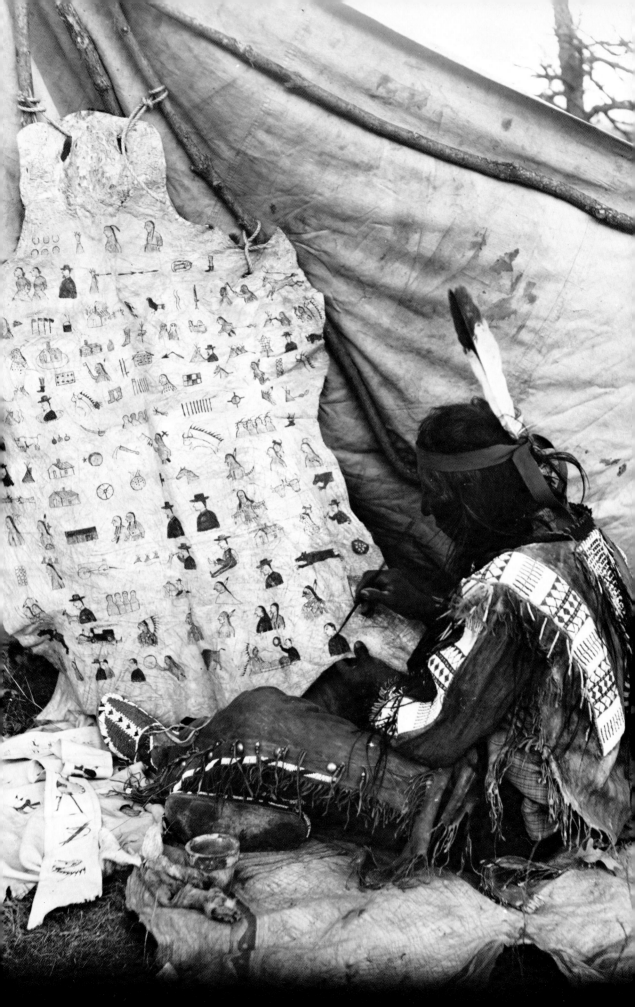

THE SIOUX
OF THE
ROSEBUD

A HISTORY IN PICTURES

Photographs by John A. Anderson

Text by Henry W. Hamilton
and
Jean Tyree Hamilton

UNIVERSITY OF OKLAHOMA PRESS

NORMAN

By Henry W. Hamilton

> *The Spiro Mound* (Columbia, Missouri, 1952)
> *Tobacco Pipes of the Missouri Indians* (Columbia, Missouri, 1967)

With Jean Tyree Hamilton

> *The Sioux of the Rosebud: The Early-Day Photographs of John A. Anderson*
> (Norman, 1971)

By Jean Tyree Hamilton

> *Arrow Rock, Where Wheels Started West* (Columbia, Missouri, 1963)

International Standard Book Number: 0–8061–0953–X

Library of Congress Catalog Card Number: 78–145506

The Sioux of the Rosebud: A History in Pictures is Volume 111 in *The Civilization of the American Indian Series.*

To J. O. and Evelyn Brew

Preface

WE first became aware of John A. Anderson and his photography while going through the papers of the artist-writer Remington Schuyler, Anderson's friend and contemporary on the Rosebud Reservation in South Dakota. Among these voluminous papers, given into our safekeeping after Schuyler's death in 1955, were sixteen original Anderson prints and five postcard reproductions.

Inquiries to the state historical societies of the region revealed that, although all of them had examples of Anderson's work, none had any biographical information about him. Anderson, who had left a dramatic record of the development of the West and whose photographs had captured history in the making, was all but forgotten. He was a misty figure who had crossed a page of history, made his contribution, and disappeared.

Anderson's photographs record the transition of the Brulé Sioux from the free, nomadic warriors fresh from the Battle of the Little Big Horn to the subjugated remnants of the tribe compelled to live on a reservation whose boundaries and controls had been established by the white man's government. The beef-issue photographs taken between 1889 and 1893 (Plates 61 to 74) are poignant illustrations of that transition. The buffaloes were gone, intentionally destroyed to bring the Indians to starvation and submission. The beef issue represented life itself to the Sioux.

Anderson's work can be divided into three phases. From 1885 to about 1900 he photographed life among the Indians as he found it, mostly recording

groups and group activity. During his middle phase—approximately 1900 to 1910—he did portrait photography, recording Indians as individuals. In his final phase, starting around 1911, he often photographed Indians in deliberately posed scenes, showing them preparing a hide for tanning, making a fire with flint and steel, cooking meat in skins.

Convinced that the man and his work were important, we set about reconstructing the events of his life and to identifying the subjects and circumstances shown in his pictures. We obtained biographical information about Anderson from members of his family, his friends, and his associates.

We were also given access to the known diaries kept by Anderson and his wife. The earliest diary was written by John before his marriage and covered the period from March 25, 1889, to February 25, 1890. The second was kept by Mrs. Anderson from January 1 to January 17, 1930. Both are in the Sioux Indian Museum at Rapid City, South Dakota, deposited there in 1969 by their grandson, Harold Anderson. There was also a third Anderson diary, which we were unable to find. Mrs. Alma Roosa, Anderson's niece, read parts of it with Mrs. Anderson years ago. She thinks that, although the Andersons collaborated on its contents, it was actually written by Mrs. Anderson. The dates it covered are unknown.

In the 1889–90 diary Anderson did not always make his entries day by day but sometimes made a number of them at one time. Thus occasionally the events noted are not in chronological order. That is perhaps to be expected, for in his work he covered a wide territory by horseback, by carriage, and on foot, and sometimes he was away from home for extended periods of time. There are tantalizing omissions in the record. He barely mentions the Crook Treaty Council, for example, except to state that he photographed it and obtained some interesting negatives.

Our work was simplified by the fact that most of Anderson's prints carry his name, and many of them also have a title and a date, although some of the titles are general. A few photographs were mounted on backings that carried the printed name and address of the photographer. Since Anderson started his career in the Fort Niobrara–Valentine area of Nebraska, spent two short intervals in Williamsport, Pennsylvania, and after that lived for over forty years on the Rosebud Reservation, the address sometimes gave a clue to the approximate time an undated picture was taken.

Anderson numbered many, but not all, of his prints. Evidently his numbers did not always indicate the order in which the photographs were taken, and therefore we could not always rely on the number to help establish the date. He seems to have copyrighted them when it was convenient, sometimes grouping for a specific purpose pictures taken at different times.

The earliest copyright date we found was May 18, 1893. The nine photographs copyrighted in that lot were mailed from Williamsport, but the mountings bore the address Valentine, Nebraska. Anderson copyrighted on nineteen occasions between that date and the last, November 24, 1929, and these transactions showed his address as either Rosebud or Rosebud Agency, South Dakota, except for one mailing in 1903 that came from Jersey Shore, Pennsylvania. He usually applied for copyright as "John Alvin Anderson, nationality Swedish."

Most of his copyrighted photographs are in the 200's, 300's, and 900's (his numbering), which are arranged by subject as well as by copyright date. The 200- and 300-series views are generally of groups and group activity and were copyrighted during the years 1893 to 1897. One lot, copyrighted on November 5, 1897, by Anderson and Schempp, Rosebud, is composed entirely of scenes of the Bad Lands. No further copyrighting was done until 1900; in that year he submitted seven different lots—mostly portraits of individuals numbered in the 900 series. We have no evidence that he numbered any of his prints after 1900, although he worked as a photographer for another thirty years. He apparently copyrighted 145 prints in all, most of which are shown in these pages.

None of Anderson's military work at Fort Niobrara from 1885 to 1889 was copyrighted, and apparently none of the prints were ever numbered. Few of the pictures he took during this period are available to us, since he sold most of them to individual soldiers. He did begin numbering photographs of non-military scenes taken elsewhere at this time, beginning with 1. How many he numbered in this series is unknown.

For identification of the people, places, and events shown in the photographs, we consulted persons living in the Fort Niobrara–Rosebud Reservation vicinity, checking dates, names, and ages in contemporary newspapers and the census files of the Rosebud Agency.

Often we would sit down with our consultants around the big table in the home of Mr. and Mrs. William Jordan in Mission, South Dakota (on the reservation), and pass the prints around, one at a time, for each person to study. Some of the scenes and people were identified at once; others were never identified. Some of the photographs, or details in them, led to a great deal of discussion and debate, and when the conversation got heated, the Indian disputants slipped into the Dakota language for a lengthy and animated discussion. The magnifying glass was put into use as specific points were argued, and the print was passed back and forth and across the table for a second and third examination. Finally, when our consultants had either come to a conclusion or agreed that they could not make an identification, they

would explain the situation to us in English, whereupon we would go on to the next print.

Naturally some of our consultants were particularly familiar with certain activities. Bob Emery, Jr., for example, was especially knowledgeable about the beef-issue pictures because as a young man he not only had been there but had helped handle the cattle. He was as familiar with the issue-station layouts and facilities as he was with his own corral. Mrs. Jordan had spent sixteen years in the agency at Rosebud and therefore knew the Indians from all over the reservation. She was also familiar with administrative procedures. In most cases our consultants described simply and objectively conditions as they remembered them, voicing neither approval nor disapproval of the government's treatment of the Indians.

This book contains a representative selection of Anderson's work and is, we believe, the largest collection in print. A few of the prints had been torn and repaired with transparent tape many years before we found them. Some had spent many years with their owners in Brulé Sioux cabins. The edges of some had become frayed from many years of handling, and the owners had occasionally trimmed them, sometimes removing the notations Anderson had made across the bottom. We present them largely as we found them, unretouched after more than a half century of wear.

HENRY W. HAMILTON

JEAN TYREE HAMILTON

Marshall, Missouri
January 10, 1971

Acknowledgments

PERHAPS our largest debt is to the late Remington Schuyler, among whose papers, after his death October 19, 1955, we first saw photographs by John A. Anderson. Schuyler's manuscripts contain many references to "Johnnie" (Anderson) and insights into conditions at the Rosebud Reservation during the time Anderson worked there.

Schuyler was a painter and writer who worked on the reservation in the trading post of A. K. Wood on Oak Creek in 1903 and as a cowhand on the E Bar Ranch of Bob Emery, Sr., in 1904. He sketched or painted almost everything around him, doing oil portraits of Picket Pin, Hollow Horn Bear, Crow Dog, and Stands and Looks Back. He met Red Cloud in 1903 and in 1904 visited the famous chief of the Oglala Sioux on the Pine Ridge Reservation.

Sources of biographical information:

Timothy Tackett, Upland, California, great-nephew of Mrs. John Anderson; Mrs. Mildred Parnham, Arcadia, California, widow of Roscoe Anderson; Mrs. Georgia Miller, Ontario, California, sister-in-law of Mrs. Anderson; Mrs. Wentworth (Melinda Carlson) Hogg, niece of John Anderson, her husband, Wentworth Hogg, their son Donald Hogg, and their grandson Christie Hogg, all of Lincoln, Nebraska; Mrs. Alma Carlson Roosa, Valentine and Hastings, Nebraska, niece of Anderson; Congressman Ben Reifel, Aberdeen, South Dakota, who knew the Andersons on the Rosebud Reservation; Miss Mary

Elizabeth King, Williamsport, Pennsylvania, who put us in touch with Larue C. Schempp, Williamsport, son of Charles A. Schempp, Anderson's business partner; Mrs. Robert Niblick, Sioux Falls, South Dakota, daughter of Dr. L. M. Hardin, physician on the Rosebud Reservation from 1895 to 1902, who permitted us to use Dr. Hardin's diary; Harold Woon, superintendent, Fort Niobrara Wildlife Refuge, who gave us information about Anderson's work at Fort Niobrara; Miss Ella C. Lebow, director of the Sioux Indian Museum, United States Department of the Interior, Rapid City, South Dakota, who permitted us to use the Anderson diaries and gave us information about Anderson's connection with the museum; Mrs. Rena McGhan, acting director, and Herman Red Elk, also of the Sioux Indian Museum; Charles M. Eads, Valentine, Nebraska, who worked for Anderson and his brother Charles Anderson; George E. Hornby, Valentine, Nebraska, son of T. C. Hornby, a business partner of Anderson's; Charles E. Lewis, Valentine, Nebraska, Anderson's banker.

Sources of photographs and technical assistance with prints:

All the photographs in this book are Anderson's work except for Plates 1 and 2, which were taken by commercial photographers; several pictures of Anderson himself, which were very likely set up by him but were taken by an assistant; Plates 30 and 31, photographs of drawings by James McCoy; Plate 84, taken by Charles M. Eads; and Plate 201, taken by Mrs. Anderson.

The following persons allowed us to use original Anderson prints belonging to them or their institutions:

Mrs. Peter Clausen, Mission, South Dakota; Charles M. Eads, Valentine, Nebraska; Bob Emery, Jr., Rosebud Reservation, South Dakota; Frank Helberg, Valentine, Nebraska; Christie Hogg, Lincoln, Nebraska; Mrs. Wentworth Hogg, Lincoln, Nebraska; George E. Hornby, Valentine, Nebraska; Mr. and Mrs. William W. Jordan, Mission, South Dakota; John F. Keller, president, Cherry County, Nebraska, Historical Society; Miss Ella Lebow, director, Sioux Indian Museum, Rapid City, South Dakota; Mrs. Hattie Marcus, Rosebud Reservation, South Dakota; Jake Metzger, Mission, South Dakota; Mrs. Alma Roosa, Hastings, Nebraska; The Remington Schuyler estate; Timothy Tackett, Upland, California; Harold Woon, Fort Niobrara Wildlife Refuge, Nebraska; Mrs. Robert Niblick, Sioux Falls, South Dakota; Frank Helberg, photographer, who copied many of the original prints for us.

Wayne L. Nelson, staff photographer of the River Basin Surveys Office, Smithsonian Institution, Lincoln, Nebraska, worked on the old prints to make them usable, doing much of this work in the River Basin Surveys Office, of which Warren W. Caldwell is chief.

Consultants for identification of people, places, and events shown in the photographs:

These consultants, most of whom live in the Rosebud area, studied the Anderson photographs in one or more conferences with us. The conferences took place on the reservation in August, 1961; March, 1962; November, 1963; March, 1966; August, 1968; and March, 1970.

William W. Red Cloud Jordan, born in 1884, the son of Colonel Charles P. Jordan and Winyan-hcaka (the True Woman, Julia), an Oglala full blood. Jordan is a graduate of Gem City Business College, Quincy, Illinois. He also provided Dakota names for the individuals in the portraits.

Mrs. William W. Jordan (Emma Sky, Santee Allotee), born October 1, 1881, on the Santee Reservation, Knox County, Nebraska; died December 7, 1964. She was the daughter of Jane Standing Soldier, full blood, and Ben Sky (Red Wing), three-quarter blood. She was a Carlisle graduate, class of 1903. She worked as a secretary in the Indian Service for thirty-six years, for sixteen of those years at the Rosebud Agency. She also worked at Carlisle, Pawnee Agency, Pine Ridge Agency, and Colville Agency, Nespelen, Washington.

Bob Emery, Jr., born on the Rosebud Reservation in 1896. He went to school in Rapid City, South Dakota, and attended Haskell Institute. He is the son of Bob Emery, who was Rosebud Agency brand inspector and farming instructor and, on the allotment of his full-blood wife, Rosa Dion (the mother of Bob, Jr.), operated the E Bar Ranch.

Mrs. Bob Emery, Jr., granddaughter of Jack Whipple, trail driver. Her grandmother was a half sister of Hollow Horn Bear.

Samuel White Horse, full blood. His father was Red Fish; his uncle, Turning Bear. He is a member of the Tribal Council from the Antelope community on the Rosebud Reservation and is past chairman of the Tribal Council.

Mrs. Samuel White Horse (Nancy). She is almost full blood. She organized and had charge of the Burnt Thigh Society Truth Keepers, a dance group authorized by the Tribal Council. This group performed in Crazy Horse Canyon in 1961 and was invited to the Century 21 Exposition in Seattle in 1962.

Mrs. Hattie Marcus, daughter of S. H. Kimmel, a contractor, who went to Rosebud with the first superintendent to build issue stations. Her husband, George Marcus, was a cousin of Mrs. Anderson's who in 1911 moved to Rosebud from Williamsport, Pennsylvania, to work for Anderson in his store. Marcus was later in the Indian Service. Mrs. Marcus was postmistress of Rosebud from 1916 to 1919 and is a skillful beadworker.

Antoine Roubideaux, son of Louis Roubideaux, interpreter. He has been secretary of the Rosebud Tribal Council.

Mrs. Antoine Roubideaux (Clara), daughter of William C. Courtis, an Oxford graduate who served in the British Army and the French Foreign Legion, and in the United States Army against the Apaches in the Southwest and with Custer at the Little Big Horn. A corporal at the time, Courtis was not killed in the battle; just before it took place, Custer sent him back with a message for Major Marcus Reno. He remained in the area and in 1877 married a full blood, Emma Red Warbonnet. They had ten children. At the age of seventy-seven he went grouse hunting with Anderson. His four-hundred-volume library is still a prized possession among his Indian descendants on the Rosebud Reservation.

Mrs. William Colombe, Sr., Mrs. Laura Gunhammer, Mrs. Peggy Bent, and William Colombe, Jr., all descendants of William C. Courtis.

Mrs. William Colombe, Jr. (Charlotte), daughter of Mr. and Mrs. William W. Jordan.

Henry Crow Dog, grandson of Crow Dog; Minnie Many Stripe, Red Leaf District.

Mrs. Harvey Little Thunder (Gertrude), Lincoln, Nebraska, daughter of Mrs. Alex Bordeau, Jr. (Mary Jordan).

Katie Roubideaux Blue Thunder, sister of Antoine Roubideaux.

Adam Bordeaux, vice-president, Rosebud Tribal Council.

Dan Hollow Horn Bear, son of Chief Hollow Horn Bear. He died in the winter of 1961.

Mrs. Dan Hollow Horn Bear (Julia). She died in 1965.

John Neiss, Jr., son of John Neiss, beef contractor for the Rosebud Reservation.

Jake Metzger, teacher, former inspector of day schools on the reservation and postal clerk at Mission, South Dakota. He went to South Dakota from Williamsport, Pennsylvania, where he had lived next door to Mrs. Anderson's parents.

The Reverend John Booth Clark, rector, Trinity Episcopal Church, Mission, South Dakota, and director, Bishop Hare School for Boys. He was on the Rosebud for seventy years and retired in the fall of 1961.

Mrs. Nellie Star Boy Menard, born on the Rosebud Reservation. She is a full blood, a daughter of Bert Star Boy and Grace Leads the Horse, of the Cut Meat District. She attended the Rosebud Boarding School and Flandreau High School. When she first entered the Indian Service, she worked at the Rosebud Agency and then at the Museum of the Plains Indian, Browning, Montana. Since 1947 she has been arts-and-crafts specialist at the Sioux

Indian Museum, Rapid City, South Dakota. It was she who inventoried the Anderson collection for the Indian Bureau when it was purchased in 1938. She had known Mrs. Anderson from childhood.

Identifications of the guns shown in the photographs were made by T. M. Hamilton, Miami, Missouri.

Sources of various kinds of information and assistance:

Marvin F. Kivett, director, Nebraska State Historical Society; Donald F. Danker, archivist, Nebraska State Historical Society; Will G. Robinson, former director, South Dakota State Historical Society; Mrs. Edyth George, South Dakota State Historical Society; Mrs. Josephine O'Neil, South Dakota State Historical Society; Harry Anderson, South Dakota State Historical Society; Dayton W. Canaday, director, South Dakota State Historical Society; Russell Reid, superintendent, North Dakota State Historical Society; John L. Champe, past chairman, Department of Anthropology, University of Nebraska; James H. Howard, Oklahoma State University, Stillwater; Miss Josephine Motylewski, Still Picture Division, National Archives, Washington, D.C.; Mrs. Laura E. Kelsay, Cartographic Records, National Archives, Washington, D.C.; the Reverend Webster Two Hawk, chairman, Rosebud Tribal Council, and Henry Horse Looking, Tribal Land Enterprise, who helped us place on the map on page 68 the old districts, or communities, on the Rosebud Reservation.

The opportunity to examine old files of the Cherry County and Rosebud newspapers was given us by the Nebraska State Historical Society, the South Dakota State Historical Society, and Ervin Figert, editor, *Todd County Tribune*, Mission, South Dakota.

The frontispiece is reprinted through the courtesy of the Nebraska State Historical Society.

We are grateful to J. O. Brew, Peabody Museum, Harvard University, for reading the manuscript and offering suggestions and for rendering other valuable assistance.

Robert L. Stephenson, director, Institute of Archaeology and Anthropology, University of South Carolina, Columbia, gave us assistance and advice throughout the years of this project.

To William H. Claflin, Belmont, Massachusetts, Henry S. Streeter, Boston, Massachusetts, and Dr. and Mrs. Peder T. Madsen, South Newton, Iowa, we are especially grateful for financial assistance that helped make possible the publication of this book.

Contents

The Photographs

3. The Rosebud and Pine Ridge Agencies (pages 53 to 61)

4. Sioux Camps and Villages (pages 63 to 74)

5. Councils with the Indians (pages 75 to 80)

9. *Buffalo Bill Cody's and Charles P. Jordan's Show Indians*
(pages 133 to 139)

10. *Day Schools (pages 141 to 147)*

11. *Ceremonies (pages 149 to 157)*

15. Daily Life on the Reservation (pages 203 to 229)

16. Burial Customs (pages 231 to 236)

20. Supplication to the Great Spirit (pages 309 to 313)

Maps

THE SIOUX OF THE ROSEBUD

WE are only trying to make known the fact that God breathed into the thinking Indian a soul of which the public at large knows little nor has ever tried to understand.

From the preface to *Sioux Memory Gems*,
by Myrtle Miller Anderson and John A. Anderson

John A. Anderson: A Brief Biography

Jⁿⁿ Alvin Anderson was born in Stockholm, Sweden, on March 25, 1869, to Anna and Andrew Solomon Anderson. John was the sixth of eight children.[1] On May 10, 1870, the family left Sweden for the United States on a ship of the Red Star Line. They stayed for a short time on Long Island before settling in Limestone, Pennsylvania.

John's mother died in 1879, when he was ten years old, and he lived with a married sister, Amanda Carlson, until April, 1883, when Andrew and his four sons made the long trip to Nebraska to settle on an eighty-acre homestead in Cherry County, near Fort Niobrara. Not long afterward the Carlsons homesteaded on adjoining land.

To help with expenses John started doing simple carpentry work in Valentine, the new town near the Anderson homestead. The first building had been erected in Valentine in 1882, shortly before the railroad arrived in 1883. Mari Sandoz, in her biography of her father, *Old Jules*, has graphically described conditions there in that period:

> Because in 1884 Valentine was the land office for the great expanse
> of free land to the west and south, Jules stopped there. The town was also

[1] His brothers and sisters were Mary (Mrs. John Johnson), b. July 22, 1852; Emma (Mrs. N. Burgland), b. July 13, 1855; August, b. May 5, 1858; Amanda (Mrs. Gustave Carlson), b. March 11, 1862; Charles, b. January 5, 1864; Jennie, b. June 13, 1874; and Claud, b. October 10, 1876.

3

the end of the railroad and the station of supply and diversion for the track crews pushing the black rails westward, for the military posts of Fort Niobrara and Fort Robinson, for the range country, and for the mining camps of the Black Hills. Sioux came in every day from their great reservations to the north, warriors who as late as '77 and '81 had fought with Crazy Horse and Sitting Bull; law was remote, and the broken hills or the Sioux blanket offered safe retreat for horse thief, road agent, and killer.[2]

To judge from various items in the *Valentine Reporter* throughout 1883, that was only part of the story. Horse thieves were caught and hanged by the local people. Desperadoes who shot up the town and were daring enough to try a repeat performance were themselves shot and killed.

The *Valentine Republican* for May 8, 1891, reported that a cowboy who had come to town looking for a fight had been shot and killed by the town marshal. Although the cowboy was a new man in the area, the people were afraid that his friends might come to town and start a war. In preparation, Valentine swore in eight extra deputy marshals. Another 1891 issue of the *Republican* reported an incident in which three horse thieves had been killed by four Indians, who had then joined a posse hunting for the Dalton gang.

It was during those years that John Anderson became a photographer. Just how he got started in the profession is not known. He appears to have saved his carpentry wages, bought a camera, and read everything about photography that he could lay his hands on. He began taking pictures for the army at Fort Niobrara in 1885.

Between 1883 and 1891 four other photographers arrived in the region: a man named Godkin, W. R. Cross, James Wagner, and A. G. Shaw. All of them were commercial photographers, and they seem to have stayed in business only a short time or to have worked only intermittently, perhaps because in that new and thinly settled country photography was an uncertain way to make a living.

Anderson became an apprentice to Cross, who established a photographic studio at Fort Niobrara about 1886. For a short time in 1888 the two men worked together at Fort Meade, in western South Dakota, but soon Anderson was back at Fort Niobrara, where, besides working as a civilian photographer with the army, he established his own studio and did commercial work for the public.

From the fort he made trips to distant points to take pictures. In his diary he told about one such trip:

[2] *Old Jules* (Boston, Little, Brown and Company, 1935).

April 30, 1889. The weather being favorable I went with the U.S. Mail Carrier to Tunnel Rock, a distance of 40 miles from Fort Niobrara to make pictures of the same. We drove the distance in 5 hrs. I made 3 views of the same from the West, S W and N W side.

Stayed with the mail carrier all night, and as his house was not large enough to hold his family and me, he sent his son and me to sleep in an old log house in the canyon about 1 mi. from his log mansion. We crawled into bed and had nicely got settled when to my surprise I leaped out of bed like a shot out of a canon and also my companion to find nothing but a Bull Snake trying to make friendship with us. He was crawling under my head when I realized what we had for a bed fellow, but our friendship was broken at once. After getting rid of the pet we went back to bed and put in a good night's rest. After breakfast we hitched up a team and drove 15 miles to Tunnel Rock which is located on a butte about 300 ft. high. The rock is composed of sandstone, magnesia and chalk rock. The hole is supposed to have been made by the winds, as it is always windy at that point.

The soldiers at the fort were evidently good customers, but they paid for their purchases only on pay day, a date that looms large in Anderson's records:

Nov. 5, 1889. Pay Day. Had good success in collecting. . . . Dec. 4, 1889. Pay Day for troops, had success in collecting, collected $85.00

In the spring of 1889 General George Crook asked Anderson to serve as official photographer to the Crook Treaty Commission during its visit to the Rosebud Reservation in South Dakota. Anderson's association with the Brulé Sioux had begun in 1883, almost as soon as he arrived near Fort Niobrara, which was only about seven miles south of the reservation boundary. This association was to endure for the rest of his life and was to be characterized by compassion and understanding on John's part and by undying friendship on the part of the Indians.

Later that spring John recorded his reactions to a reported Indian uprising in Nebraska:

May 27, 1889. A report was circulated through the country that the Indians had broken out, and were making depredations in Crookston [Nebraska]. I at once hired a horse and took my camera and went to the scene of the massacre which was not to be found.

I returned to Valentine and stayed there awaiting news of further trouble which did not come. As the sun was setting in the West the citizens of Valentine were surprised to see hundreds of frightened settlers coming in to town for safety, scared almost to death. The scene was one never to be forgotten. One farmer left their home forgetting a small boy who was out in the field somewhere at the time of departure and were so scared that they

had forgotten their boy. We had a great time in town that evening having mock drill which helped scare the poor farmers. The next morning the Fort was also full of settlers who left their homes for nothing. One woman near Norden was scared to death, she died in the wagon while fleeing for some place for safety.

In the late summer of 1889, Anderson accompanied the troops from Fort Niobrara to Camp George Crook, near Fort Robinson, on an extended training maneuver. His diary reports:

> Aug. 7. Soldiers left the Fort for Camp Crook, Neb. A very hot day which knocked out nearly all the boys, only about $\frac{1}{5}$ of the command getting to camp that evening, the others strung all along the road. In the evening myself and two Ladies drove from the Fort out to the night's camp to see the boys which we found nearly exhausted. 156 miles in all to march.
>
> Aug. 20. I left Fort Niobrara for Camp George Crook near Fort Robinson
>
> Aug. 21. In the City of Canvass which is the largest since the late rebellion the camp is about 1 mile long and $\frac{1}{4}$ mile wide, composed of 1,000 tents and 3,500 men, 7 regiments and 1 battery of artillery, 7 regimental bands.

The next day Anderson made arrangements with General Brook and Kautz to photograph the camp and took some pictures from the top of a butte north of camp. He goes on to say:

> Aug. 23. Made a picture of the 8th Infantry.
>
> Aug. 24. Witnessed an exciting game of baseball between 8th & 7th Infantries which was won by the latter.
>
> Aug. 25. Saw a game of baseball between the 8th and 21st Inft. Won by the latter 11–3.

The next entries were made in September:

> Sept. 5. The soldiers paid off, times very lively in the camp, especially around the canteen where the beer flowed very freely, the ground completely covered with empty bottles. Fights in all parts of camp and at the post trader's store, Fort Robinson.
>
> Sept. 6. A very lively day in camp, soldiers engaged in all kinds of sport. Some very interesting horse races in the afternoon.
>
> Sept. 9. Soldiers received orders to go on a 5 day skirmish, left camp about 9:30 A.M. had sham battle in the Hills. At night Jack Lutz and I went to Crawford, Nebraska to have a good time, which was 4 miles from the Camp. We walked down and as we arrived in the town my friend first thought of winning some money, and at once went into a gamboling [sic]

6

den, where in a short time he won $25. The man from whom he won the money tried to influence him to go into a back room and play for him with some of his gang, but he did not. We left the place and went to a restaurant, ate supper and while eating one of the severest fights I ever saw took place. Several men were stabbed and beaten badly.

Sept. 13. Visited the gamboling dens near the camp, was at Frank Owens and Larkin Cleveland's places. Found them both to be very tough places.

Sept. 14. Soldiers returned from their 5 day skirmish in the Black Hills. They were a sick looking set when they got back, as it rained nearly every day they were out. Several taken down with mountain fever afterwards.

Sept. 19. Broke up camp, this City of Canvass was moved in about 2 hours, all the boys feeling happy that the end of the tough time at Camp Crook was at hand. All things were moved to the railroad for shipment. We all went to R.R. and waited there from 6 P.M. to 4 A.M. for the train which was to convey us home. The night was very cold and damp and was very unpleasant indeed to lay or stand on all night in the open air—nothing to lay on but the wet ground. We managed to keep alive until the train came and we were not long in getting on and falling to sleep. Everybody looked tough the next morning.

Sept. 20. Arrived at Valentine about noon, was conveyed to the Post. After dinner I went home to see the folks and to my surprise found Big John [his brother-in-law John Johnson] visiting from Bradford, Pa.

Anderson decided to show Big John around the reservation:

Sept. 22. John Johnson, Claudy [Anderson's younger brother] and myself with a team of good broncs left home for the Rosebud Indian Agency, arrived at the Agency about 4 P.M. the distance being 50 mi. Lots of Indians around the Agency which was a great sight to "Big John." After supper I wished him to take a walk with me and see the Indian Camps but as the Indians were very noisy, I could not get him to go with me.

Sept. 23. Walked all around the Agency and took in all the sights, witnessed a Squaw dance in the afternoon, rain in the evening.

Fear of the Indians, no matter how "noisy" they became, was apparently unknown to the Andersons and the Carlsons alike. According to Mrs. Melinda Carlson Hogg, John's niece, there was a time in the early 1890's (no doubt during the Ghost Dance troubles) when reported depredations by the Indians sent every homestead family to the settlements—except the Andersons and the Carlsons.

Late in 1889, John prepared to move back to Pennsylvania:

Dec. 29. Printed my last at Fort Niobrara.

Dec. 30. Packed, to quit business and go East.

Dec. 31. Left Fort Niobrara for good, moved my outfit home. . . .

Jan. 8. 1890. Left the wooly west for Pennsylvania.

He was back in Valentine, however, by June 5, 1891. "Shaw's Art Gallery will be conducted by John Anderson who took lessons under a superior French artist this last winter," read an advertisement in the *Republican* that appeared in five successive weekly issues starting with the June 5 edition. In the July 10 issue the following three advertisements appeared:

There never has been such a grand rush for photographs as there has since A. G. Shaw started his gallery here in Valentine and he is turning out the best work, equal to any that can be had anywhere east.

Indian photographs and views taken during the late Indian war and views of the last Indian Sun Dance for sale at Shaw's Gallery.

Enlargements in crayon, India ink, and Bromide are now being made at Shaw's Gallery.

The last two ads appeared in the next sixteen issues, through November 20, 1891. The last ad was still carried in the issues of November 27 and December 4, although by that time Anderson was working as a clerk for Colonel Charles P. Jordan, a licensed Indian trader, in the Jordan Trading Post and living in Jordan's home at the Rosebud Agency (often called the Spotted Tail Agency). Occasionally John did work for Shaw, as evidenced by a grotesque story. A baby had died, and the parents asked Shaw to photograph it. The baby's eyes were closed, of course, in the photograph, and Shaw sent the negative or the print (or both) to Anderson on the reservation with a note reading, "Put eyes in the baby." How this difficult assignment was handled is unknown.

At some point during these years Anderson again returned to Pennsylvania. He attended Potts Commercial College in Williamsport, worked in Luppert's Furniture Factory, where he developed the carpentry skills he had begun to acquire in Nebraska and became an expert wood carver and cabinet-maker. Then, with Charles A. Schempp, a childhood friend, he opened a photographic studio. The partnership with Schempp was to continue after John returned to the Rosebud Reservation. While in Pennsylvania he met and became engaged to Myrtle Miller.

In 1893, Anderson bought an interest in the Jordan Trading Post, which became the Jordan Mercantile Company. The store handled everything—groceries, yard goods, clothing, furniture, blankets, coal, coal oil, hardware, buggies, harness, green hides, and coffins (the coffins were sold by the foot).

8

During this time John continued with his photography and woodworking, which included carving frames for enlargements of many of the prints he especially prized. In his spare time he built a house for Myrtle, with the help of Gus Carlson, his brother-in-law, an experienced builder. On October 13, 1895, John married Myrtle in Williamsport and took her to Rosebud, where they were to live and work for forty-two years among the Brulé Sioux:

Mrs. Anderson wrote, much later, of their trip west:

> There were no fast trains in those days but we finally reached Valentine, Nebraska, at one o'clock in the morning. I had never been out of the state of Pennsylvania before and when we walked up the dark streets of Valentine it all seemed pretty strange to me.
>
> We left in the morning with a team and buggy, for Rosebud, it was the early part of November but the day was warm and balmy, but it seemed to me like an endless trip as it is 40 miles and it took all day. Finally I saw Rosebud in the distance. When Mr. Anderson asked me if I would be willing to come west for no more than two years until we got a start, little did I know that I would be in South Dakota for 40 years. But I cannot say, "God kindly closed my eyes," for my life in South Dakota were the happiest days. I am a D.A.R. and I think my ancestors must have left me a little of their old pioneer spirit.
>
> The Indians were pretty wild then as it was shortly after the Wounded Knee outbreak. So I had thrills every day. I can remember so vividly when we were driving to Rosebud I noticed a small bunch of cattle running. I said to Mr. Anderson, "Why are the big dogs chasing them?" He looked and said, "Dogs nothing, they are gray wolves." I had read of gray wolves and how terrible they were, so I expected them to turn on us at once, but John said, "They won't bother us as long as they have cattle to chase."
>
> But I watched from the back of the buggy until we were out of sight of them.

Myrtle accepted life in the West with good humor:

> In 1895 Rosebud had not changed since it was first built. Our little house was built of boards and lined with ceiling boards. On Thanksgiving Day it had grown very cold and was snowing. I cooked our turkey in the little wood stove oven in our little lean-to kitchen. By that time the kitchen was so cold that we put up a little sewing table in the living room as close to the coal stove as we could get it, then brought in our turkey, put it in the middle of the table, sat up to the table with blankets around our shoulders and ate our Thanksgiving dinner. We were truly thankful for the shelter that we had from the terrible storm outside. Later we remodeled our house, put in a furnace and were very comfortable.

But the Indians took some getting used to:

> Once when I was scrubbing the floor in our little one window bed-
> room, it suddenly became dark. I looked up and there was a large painted
> Indian leaning against the window and trying to look inside. It frightened
> me but when I told Mr. Anderson about it he said, "Oh that is nothing, he
> was just curious."

On June 20, 1897, during a sojourn in Philadelphia, a son, Harold Roscoe,
was born to John and Myrtle. Some years after the Andersons were married,
Myrtle's parents, Mr. and Mrs. Henry Miller, and her brothers went to South
Dakota. Her parents homesteaded in the Wasta community, near Interior, and
her father later taught at the Red Leaf day school on the reservation, where her
mother was school housekeeper.

Charles A. Anderson, John's brother, worked on the Rosebud Reservation
from 1909 to 1910, building houses for the Indians. Charles M. Eads, also of
Valentine, worked for him. In 1912 and 1913, Eads worked for John in the
store, housed at that time in a two-story pressed-tin building. Business was not
brisk. In their spare time they organized an orchestra; John played the cornet,
Eads the clarinet, and George Marcus the violin. Someone from the agency
would play the piano, and someone else the drums.

Early in 1922 the Andersons decided to go to Atascadero, California, for
John's health. His son, Roscoe, who was cashier of the Todd County State Bank
in Mission, a bank John had organized with Peter Clausen, was to run the
store. "This has been a full week of entertainment for the Andersons who are
leaving for residence in California," reported the *Todd County Tribune* on
February 23, 1922. The Indians gave them a farewell dance in the council hall
and presented them with beaded tobacco pouches. At a dinner party given by
their white friends the next night they were presented a silver bread tray on
which was engraved "1895 Rosebud 1922."

In a tribute to the Andersons the *Tribune* said, in part, on February 16:

> It is deeply regretted by the Indians as well as the white people that
> Mr. and Mrs. Anderson have decided to withdraw from their banking and
> mercantile business and leave this part of South Dakota. It is very doubtful
> if any man or woman ever came this near of having the entire friendship of
> every citizen of the community as they do. It is felt that their departure is a
> great loss to the Indians, the Whites, and to Todd County, South Dakota.
> It is hoped that after further consideration they will ultimately abandon the
> idea of settling in California and return to establish their home among their
> friends in this part of South Dakota.

The hopes of the Todd County citizens were fulfilled. By October, 1922,

the Andersons were back in Rosebud. In December, Roscoe moved with his wife and son, Harold, to Davenport, Iowa, to study to become a chiropractor.

The *Tribune* reported on March 27, 1924, that John Anderson had "put up a radio receiving set on March 23, 1924, in a room over the store." The room also contained a pool table and was a general meeting place for the men of the region.

The Andersons were, from all reports, as humanitarian as they were social. "I've seen hungry old Indians with no money come in and go back and talk with John," Charley Eads said, "and he would give them things to take home and eat, and then charge them to himself." Remington Schuyler makes clear in his manuscripts that John felt compassion for the starving Indians through the long Dakota winters and did what he could to help them. Anderson's large collection of Indian wearing apparel, tools, weapons, and so on (which were to become the nucleus of the Sioux Indian Museum collection at Rapid City) were undoubtedly repayment of a kind for his help at various times (see Plate 232).

During those years John and Myrtle made many trips to California, and built a house in Atascadero. Mr. and Mrs. Wentworth Hogg managed the Jordan Mercantile Company for them from August, 1923, to August, 1924.

Roscoe died in Baltimore on June 6, 1925. Ben Reifel, who would later be elected United States representative from South Dakota, went to work for the Andersons in the fall of that year. "Mr. and Mrs. Anderson were almost father and mother to me," he writes. "I may have filled a void brought on by this tragedy in their lives." He attributes his education to their encouragement and financial help and states, "Were it not for them very likely I'd still be out on the reservation." He was very close to the Andersons and sat for the photograph of the flute player in the book of photographs and poems Myrtle and John wrote jointly, *Sioux Memory Gems* (Chicago, 1929). This was John's second book; the first was *Among the Sioux* (1896), a booklet of photographs.

In 1928 the Andersons' home on the reservation burned to the ground, and most of his photographic plates were destroyed in the fire. He built a second home on the same site, and they lived there until 1936, when they moved to Rapid City to manage the new Sioux Indian Museum, which had been built to house John's collection of Sioux ethnological materials. At that time the museum was a private venture. The Andersons charged admission, and John conducted guided tours, explaining to visitors what each article was, whom it had belonged to, and in many cases who had made it. In 1938 the Andersons sold the collection to the Bureau of Indian Affairs, and in 1939 they retired to their home in Atascadero. During World War II, John once more went to work as a photographer, helping out at nearby Camp Roberts.

John Anderson died of stomach cancer on June 26, 1948, at Atascadero. His ashes were sent to Salladasburg, Pennsylvania, where his old partner, Charles A. Schempp, attended to their interment. Myrtle sold the photographic plates that had been saved from the 1928 fire and most of his equipment for one hundred dollars.

For a time Myrtle continued to live in Atascadero. Later she went to live with relatives in Ontario, California. Not long before her death she wrote, "John never liked it here and always longed to be back in the wide-open spaces of South Dakota. I am still living in California. South Dakota would not mean anything to me without John Anderson, for he was part of it." She died in Ontario on August 22, 1961.

Today, on the Rosebud Reservation, one of the stained-glass memorial windows in the Trinity Episcopal Church in Mission honors John and Myrtle Anderson. Another honors their son, Roscoe.

John Anderson was unquestionably a photographer of rare talent, not only in his mastery of the skills required to operate the unwieldy equipment of the day but also in his ability to bring artistry to his record of a vanishing way of life.

Donald Hogg, a great-nephew of Anderson's and an expert photographer in his own right, owns one of Anderson's cameras. He has provided the following information about the equipment his great-uncle used:

> The camera which I have is, I have been told, Uncle John's second. According to members of the family, his first camera was identical to the one that I have.
>
> Uncle John lost his first one in the line of duty. He was preparing to take a picture of a beef issue. The beef was still "on the hoof." He had just focused his camera and still had his head under the dark cloth when on the ground glass he saw a longhorn steer charging straight for him. The camera was demolished. We were lucky to salvage Uncle John.
>
> The camera is an 8 x 10 Primo with revolving back. It was made by Rochester Optical Company, a predecessor of Eastman Kodak, I believe. The lens is a Bausch and Lomb twelve-inch focal length U.S. eight lens. The lens is mounted in a Rochester Optical or Victor shutter, with speeds from one second to 1/100 second, plus "time and bulb."
>
> The most impressive feature of the camera is the thirty-one-inch draw of the red bellows. This long bellows draw would permit photographing small objects slightly larger than life size. This feature must have been comparable to a four-hundred-horsepower engine in a small sports car today.

There are two dates on the camera. Apparently the body of the camera was patented on April 14, 1880. The lens is stamped with the patent date January 6, 1891. I should imagine that this camera-lens combination was the best and latest thing when Uncle John ordered it. In any case, the Smithsonian photographic staff in the Lincoln, Nebraska, office and I find the lens to be of high quality by today's standards, the shutter to be accurate within the tolerance of today's most critical film.

When I knew my great-uncle John, when I was a child, he did not use the camera I have. He used a 4 x 5 Graflex to take family pictures.

Wayne L. Nelson, staff photographer at the River Basin Surveys office of the Smithsonian Institution, Lincoln, Nebraska, has provided the following assessment of Anderson's work:

> While working with the John Anderson photograph collection, I developed an admiration for the early Great Plains photographers, and for John Anderson in particular. He was both artist and skilled technician. His landscapes are well composed, are of exceptional tone quality, and are sharp in focus—all this in the 1880's, during photography's early youth.
>
> The professional photographer of today has at hand a remarkable variety of films, developers, light-measuring devices, rare-earth lenses, and an array of specialized cameras that would have staggered the imagination of Mr. Anderson. Perhaps the newest development in photography of that time was the dry plate. Despite the poor quality of lenses, the slow film, erratic shutter speeds, inconsistent flash powder, and burdensome equipment, his work surpasses that of many of today's portraitists and landscape photographers.
>
> Like most successful pioneer photographers, John Anderson was both artist and technician—in the latter of necessity. The early-day photographer controlled and judged light intensity by trial and error; he had to process his own film in a covered wagon or a darkened bedroom with minimal temperature control of solutions; he often varied his shutter speed and lens opening on the basis of little more than a hunch; he loaded his bulky equipment and traveled by horseback, team and buckboard, or stage; and if he had the patience, insight, skill, and perceptiveness of a John Anderson, he came back with outstanding and historically important pictures of early mission and reservation towns such as Rosebud and Pine Ridge.

The Brulé Sioux: A Brief Account

EARLY mention of the Sioux Indians places them along the upper regions of the Mississippi River. They gradually moved westward, pushed in turn by their neighbors who were being pushed by the tide of white migration. Jesuits reported seeing Sioux in the Lake Superior region in 1641; Lewis and Clark encountered them at the mouth of Bad River, in present-day South Dakota, in 1804.

After the Teton Sioux (to which group the Brulé Sioux belonged) crossed the Missouri River, they secured horses and became accomplished buffalo hunters and warriors. A large group, having seven "campfires," or subbands, they gradually spread out to occupy a large portion of the northern plains, after defeating various other tribal groups along the eastern edge of the plains, with whom they maintained what amounted to an armed truce.

The Sioux steadfastly resisted white encroachment and settlement on land they considered their own, but finally, in 1868, they agreed to the Fort Laramie Treaty, which provided for their settlement on a permanent reservation. This reservation was to include all of present South Dakota west of the Missouri River and in addition all of the area north of the North Platte and east of the Big Horn Mountains.

Although it was to be some years before this settlement could be carried out, Custer's defeat at the Little Big Horn on June 25, 1876, crystallized the government's determination in the matter. The actual boundaries of the Rose-

15

bud Brulé Sioux Reservation in South Dakota were fixed on February 28, 1877, and the Rosebud Agency was established the following year.

In November, 1877, the Brulé Sioux under Chief Spotted Tail were moved to the Rosebud Reservation, and Chief Red Cloud's Oglala Sioux were placed on the Pine Ridge Reservation, which adjoined the Rosebud on the west. From the outset the Brulés resisted government efforts to compel them to "scratch the ground"—their contemptuous phrase for farming. This warrior-hunter people had been taught from childhood that such a way of life was dishonorable. The powers in Washington, however, decided that what the Sioux needed was to be taught the skills of the white man, and agriculture was one such skill highly regarded by the white man.

John Anderson first came in contact with the Brulé Sioux in 1883, seven years after the Battle of the Little Big Horn. Eight years later, in the Wounded Knee Massacre, Big Foot's band was practically annihilated by United States Army units, and the Hunkpapa leader Sitting Bull was killed at his log-cabin home on Grand River. It was in those tragic days that John Anderson commenced his record of a proud and extraordinary people.

THE PHOTOGRAPHS

1

The Anderson Family and Homestead

Anna and Andrew Solomon Anderson brought their six children to the United States from Sweden in 1870 when John was barely a year old. The Andersons were part of a group of settlers who organized the communities of Bradford and Limestone, Pennsylvania. In 1883, after the birth of two more children and the death of Anna, Andrew and his four sons went to Nebraska to homestead. They arrived at the railhead, Stuart, Nebraska, in April, 1883. Someone—possibly an agent of the railroad company—had accumulated a large number of horses, wagons, and harness and was selling the equipment to anyone who wanted to go farther west. The Andersons bought a wagon and a team and some supplies and continued to the area of Sparks, near Fort Niobrara, where they constructed a sod house to live in temporarily while they built a log house. Furniture and household equipment, which included a piano and a dining-room set, had been shipped from the East by rail and arrived later.

John was married to Myrtle Miller in 1895. Their son, Harold Roscoe, was born in 1897.

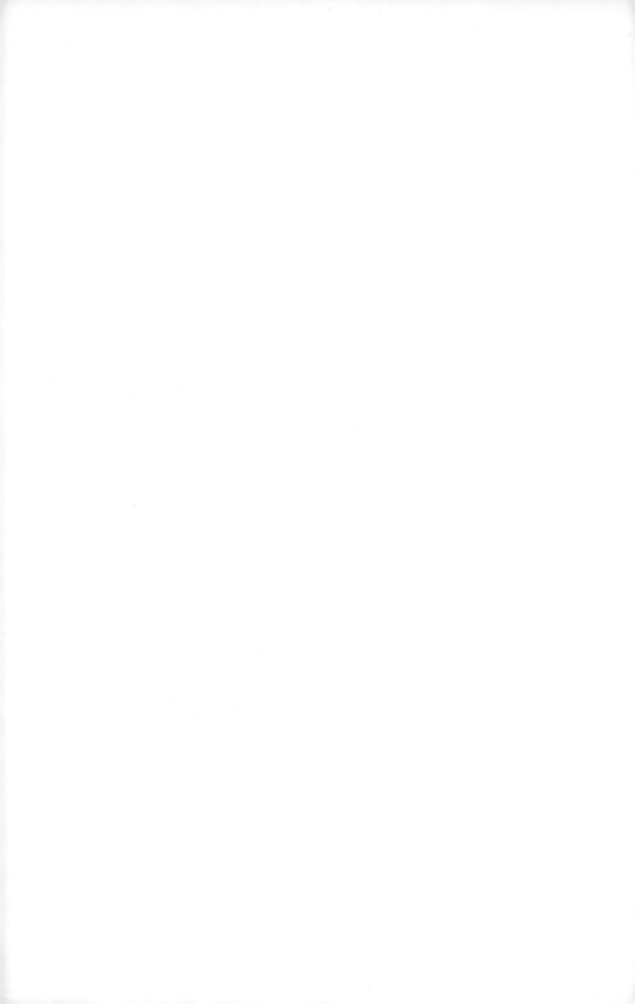

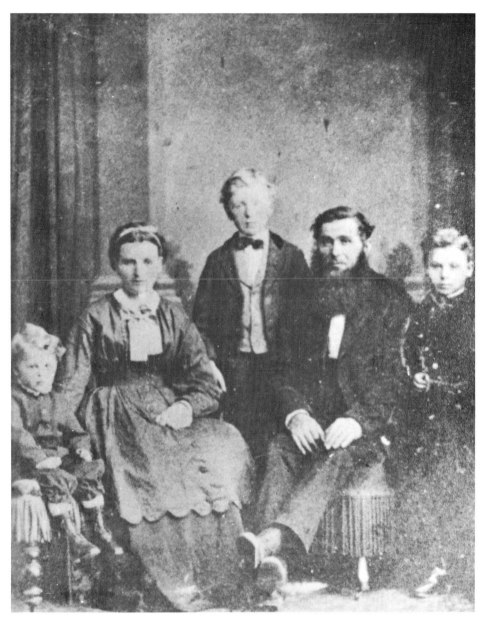

PLATE 1. Mr. and Mrs. Andrew Solomon Anderson and sons, 1872. John (left) is
three years old, August (center) is eight, and Charles (right) is five.
The photograph was taken by a commercial photographer in the East.

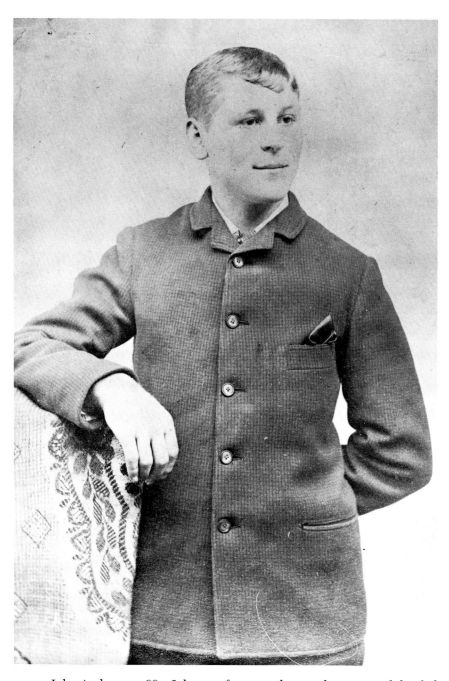

PLATE 2. John Anderson, 1883. John was fourteen the year he went with his father and three brothers to homestead in what is now Cherry County, Nebraska.

PLATE 3. The sod house built on the Anderson homestead in 1883. The house was dug into the ground on the high side, so that it was part dugout. The main building was a single room. A partly enclosed lean-to extends to the right. Most of the cooking was done outdoors on a cookstove set up under a tree. The boy in the doorway is John's brother Claud, who later opened the first store in what is now Mission, South Dakota. The date of this photograph is unknown, but the tall weeds and grass around the house indicate that it was unoccupied, which probably means that the family had already completed and moved into the log house.

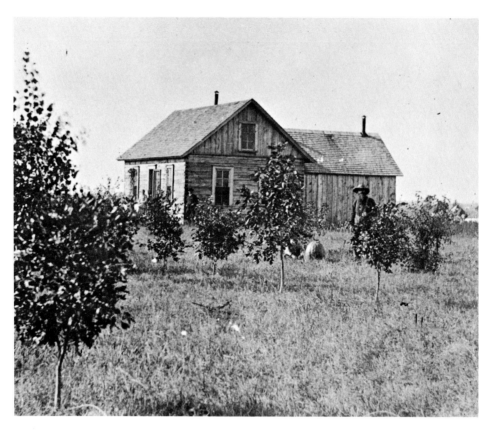

PLATE 4. The log house on the Anderson homestead, built about 1884. It is said to be the first log house built in Cherry County. The man with the whiskers is Andrew Anderson. His oldest son, August, stands at the corner, Claud is behind the pumpkin, and the Carlson girls, Emma and Alma, are in the doorway. The house was quite large. For a number of years after it was built, it was the meeting place for Sunday school, church, and various gatherings of the region.

When Gustave Carlson, who had married John's sister Amanda, had to quit his job as foreman of Luppert's Furniture Factory in Williamsport, Pennsylvania, because of ill effects from sawdust, he and his family followed the Andersons to Nebraska. For fifty dollars he was able to buy the rights to a claim which joined the Anderson homestead. Since the sod house on Carlson's claim was too small for his family, Carlson and a son lived there while Amanda and their other children stayed in the log house with the Andersons until a larger house could be built.

The log house was still standing and in reasonably good condition only a few years ago, at which time consideration was given to moving it into Valentine to house the headquarters and museum of the Cherry County Historical Society.

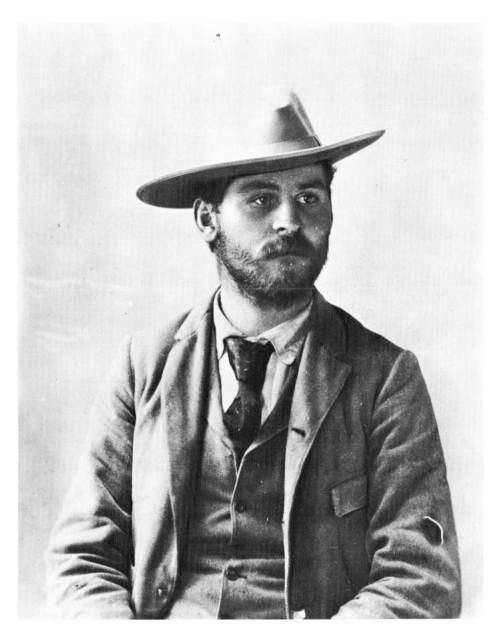

PLATE 5. John Anderson, 1889. John's wife wrote on the back of the original print: "This is John when he was about 20 years old. He had been out in the Bad Lands for a week making pictures and had not shaved. This was before we were married." Her statement helps date some of Anderson's pictures of the Bad Lands, since he was twenty years old in 1889.

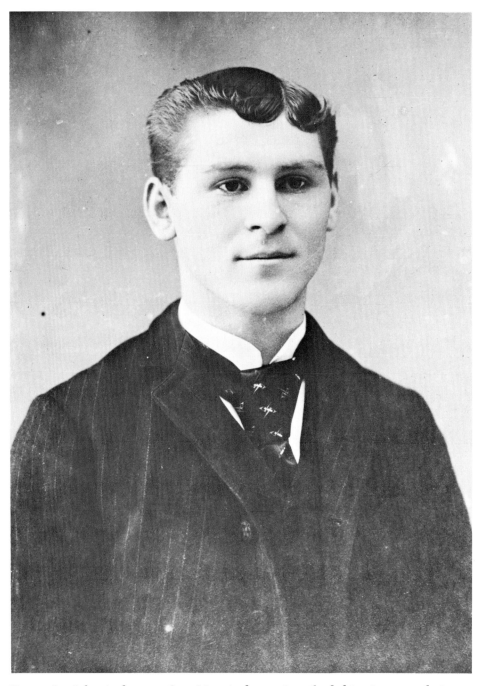

PLATE 6. John Anderson, 1890. Mrs. Anderson inscribed this picture to their son, Roscoe: "This is your father when he was 21 years old."

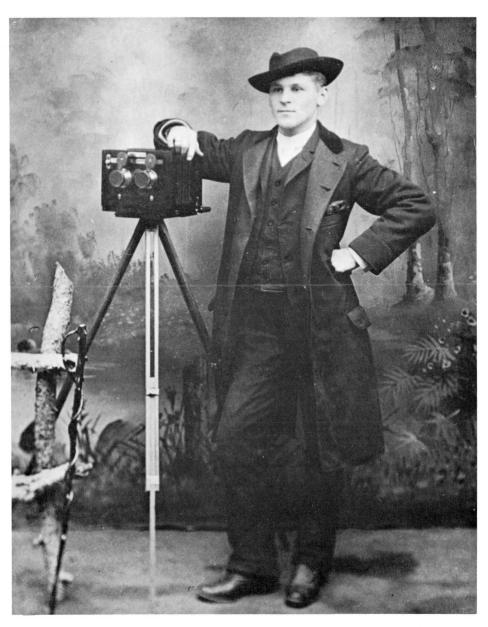

PLATE 7. John Anderson and his stereoscopic camera, about 1888. This picture
was taken at Fort Niobrara by a helper. On the mounting was printed
"J. A. Anderson, Fort Niobrara." If the date 1888 is correct, Anderson
had been doing photographic work at the fort for three years. Although
we have been unable to find any stereoscopic pictures taken by him, his
diary for October 10, 1889, reports, "I gave a stereopticon entertainment
in the hospital at Fort Niobrara which was well attended."

PLATE 8. Reverse sides of two of Anderson's photographic mountings. Top: "Copyright Nov. 5, 1897." Below: "Copyright Jan. 4, 1897."

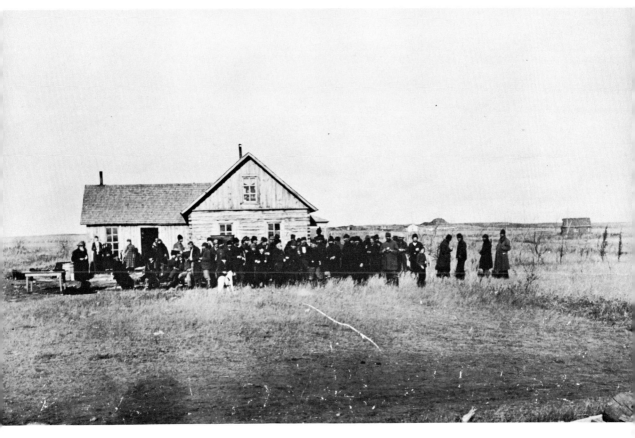

PLATE 9. Farm sale at the Anderson homestead, about 1893, when the family
moved into Valentine from the farm. A crowd is assembled at the log
house. The Andersons continued to own the land after this date.

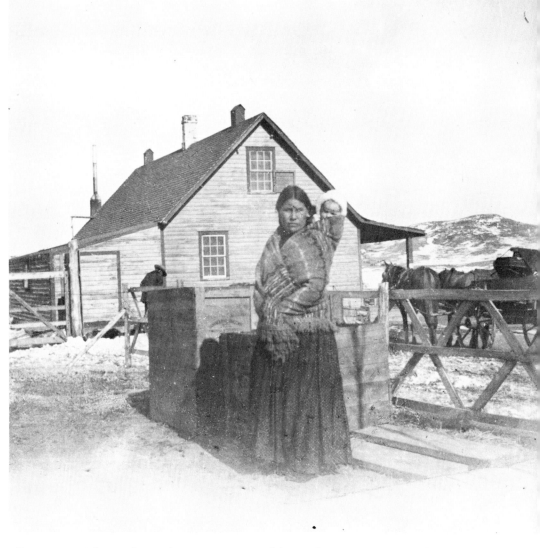

PLATE 10. The Andersons' son, Roscoe, and his Indian nurse, 1898. The Jordan
Trading Post is in the background. This plate was reproduced from a
print made from the original glass-plate negative.)

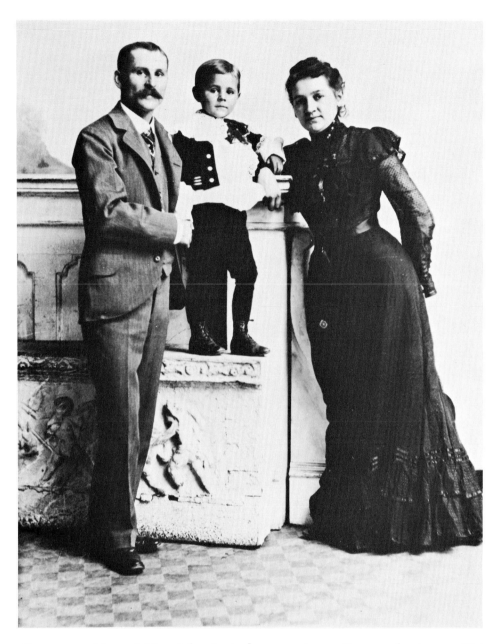

PLATE 11. Mr. and Mrs. John A. Anderson and son, Roscoe, about 1901. This picture is said to have been taken in the old Anderson and Schempp studio in Williamsport, Pennsylvania. (This plate was reproduced from a print made from the original glass-plate negative.)

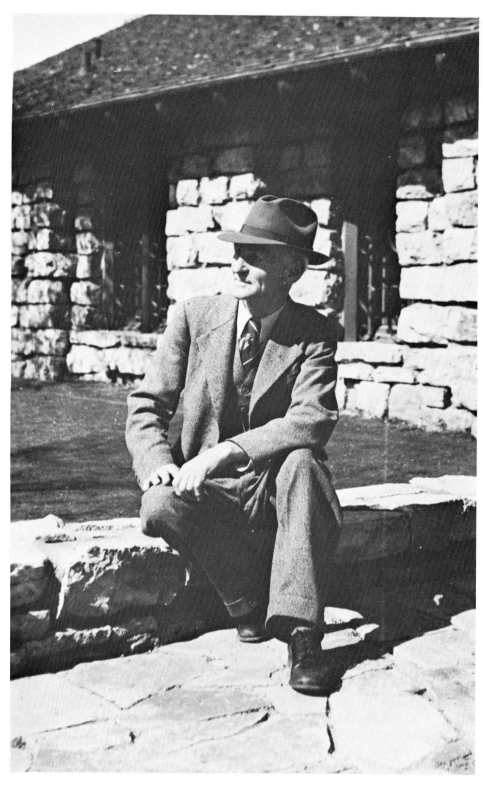

PLATE 12. John Anderson in front of the Sioux Indian Museum, Rapid City, South
 Dakota, 1937. The museum still houses Anderson's collection of Indian
 clothing and other ethnological material. He was director of the museum
 for a number of years.

2

Fort Niobrara, Nebraska

FORT Niobrara was established on April 22, 1880, to protect the Nebraska homesteaders from the Sioux on the Rosebud Reservation. John Anderson began work as a photographer at the fort in 1885. By 1889 he was civilian photographer for the army and had his own studio, where he did commercial work for the public. In his diary he often refers to his "gallery" at Fort Niobrara, and a number of times he reports that he spent the day developing negatives and making prints in those cold quarters. Many of the pictures he made there are not available to us because he sold them to individual soldiers, but we were able to find several views of the fort itself, group pictures of the soldiers, and scenes of the surrounding countryside.

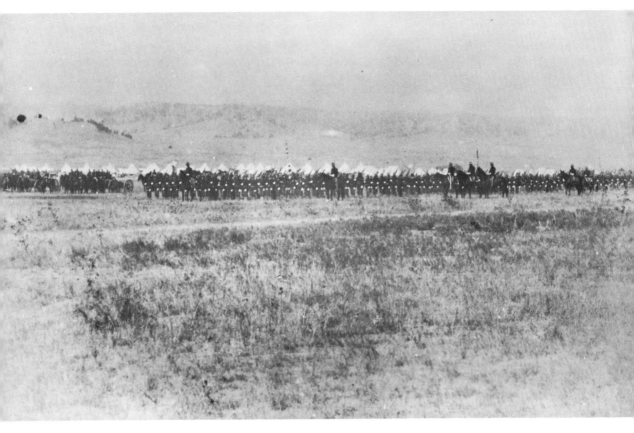

PLATE 13. Regiment camped in tents near Fort Niobrara, 1885. The Seventh Infantry and the Ninth Cavalry, commanded by Lieutenant Colonel James S. Brisbin of the Ninth Cavalry, were stationed at Fort Niobrara at this time.

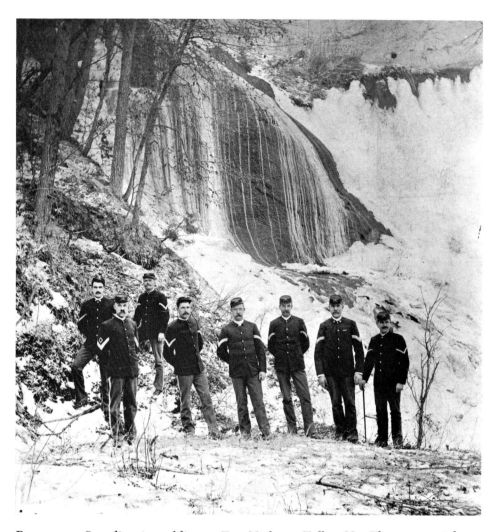

PLATE 14. Scandinavian soldiers at Fort Niobrara Falls, 1885. There were eight or nine Scandinavian soldiers at the fort. Anderson and these men became friends, and this friendship, with visits to the Anderson home, helped alleviate their loneliness. One of the men, whose name was Peterson, occasionally helped Anderson with his photographic work at the fort studio. Others of the group were "Larsen [Larson?], Dawson, Nelson, Vickerson, Martin, and Bloom," according to Anderson's diary. The group called itself the Pump House Band, and each of the men played an instrument. Larsen gave Anderson lessons on the alto horn. It is not known whether they were members of the regimental band.

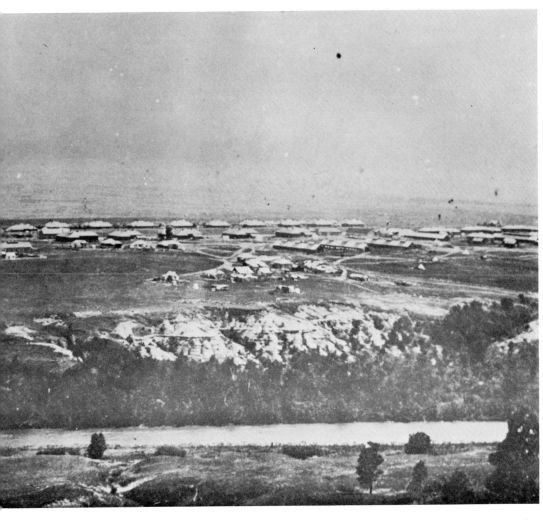

PLATE 15. Fort Niobrara, 1886. This picture was taken from the high hill north of the fort, facing south. The Niobrara River is in the foreground. The Second Infantry had by this time replaced the Seventh. Lieutenant Colonel James S. Brisbin of the Ninth Cavalry was still in command.

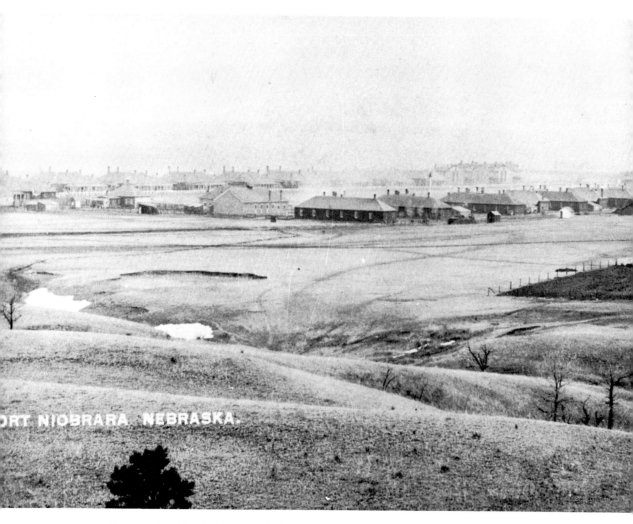

PLATE 16. Fort Niobrara, 1886.

PLATE 17. Funeral procession at Fort Niobrara, 1886. The fort band leads the procession. On Decoration Day it was customary to send wagons to town to bring seventh- and eighth-grade girls back to the fort to decorate the graves in the military cemetery. In 1893, when Mrs. Alma Roosa, Anderson's niece, participated, a mounted military band met the group at the top of the hill and escorted them to the cemetery.

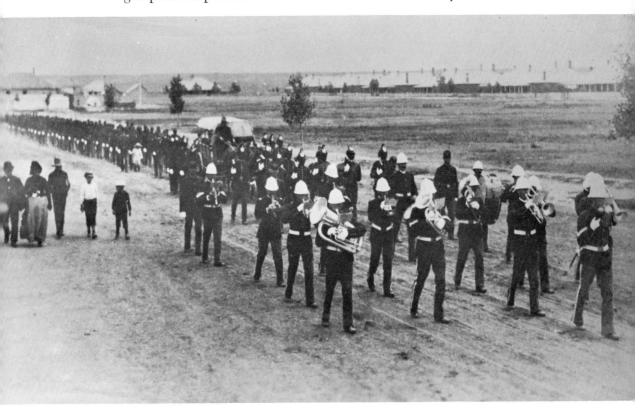

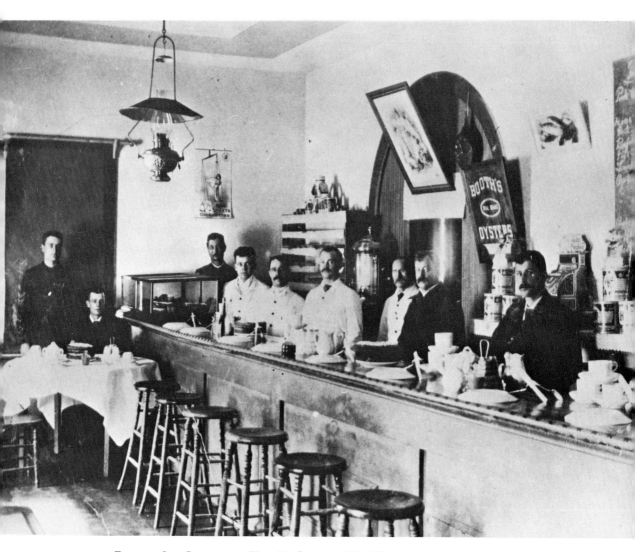

PLATE 18. Canteen at Fort Niobrara, 1886. The canteen was an eating place for travelers as well as army personnel. The help are standing behind the counter.

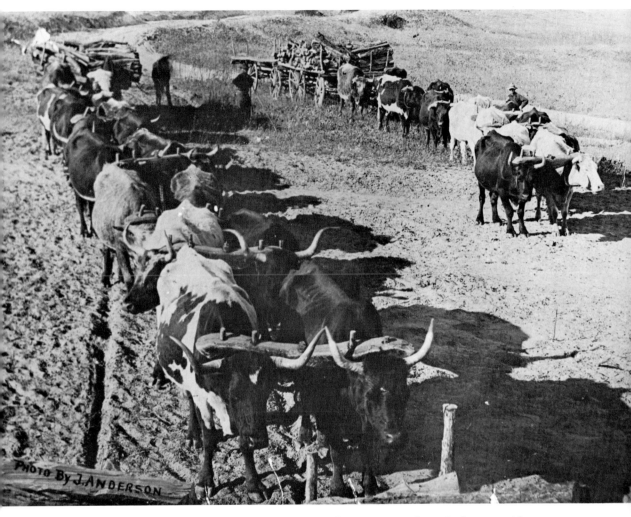

PLATE 19. Oxen hauling cordwood to Fort Niobrara, 1886. The yoked oxen with their load of wood await their turn to ford the Niobrara River. Their driver has not yet mounted his horse.

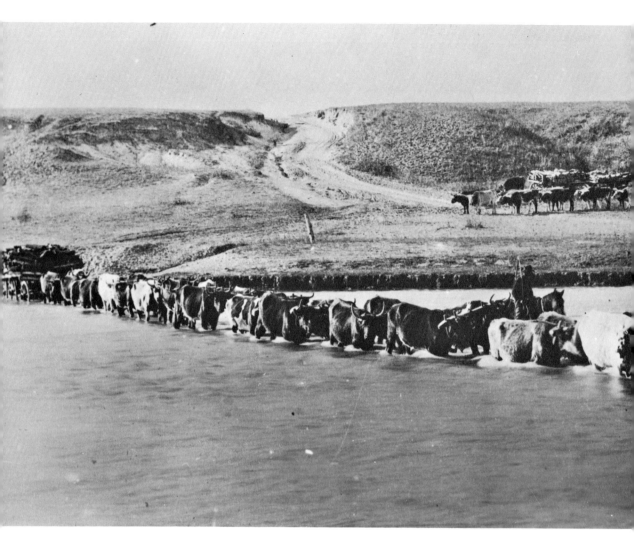

PLATE 20. Thirty head of oxen fording the Niobrara River, 1886. The oxen are being urged forward by the driver on horseback. Two more loads and their oxen wait on the far bank. Anderson called this print "Transportation in the Far West."

PLATE 21. Ox teams with wagons loaded with wood at Fort Niobrara, 1886. The post water tower and five buildings are in the background.

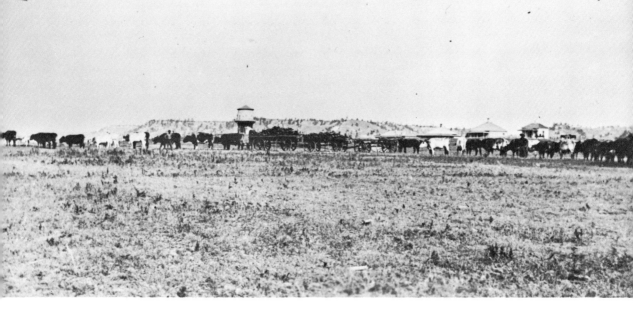

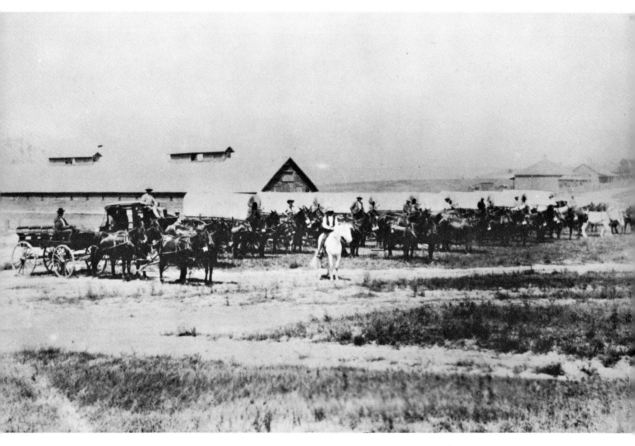

PLATE 22. Transportation equipment at Fort Niobrara, about 1886. In this group are a four-seated hack drawn by four mules, a closed carriage pulled by two, a smaller conveyance (which may be a buggy) pulled by two, and eight canvas-covered freight wagons, each pulled by six. All the pictured draft animals are mules. When driving a six-mule freight team, the driver was mounted on the near wheel mule.

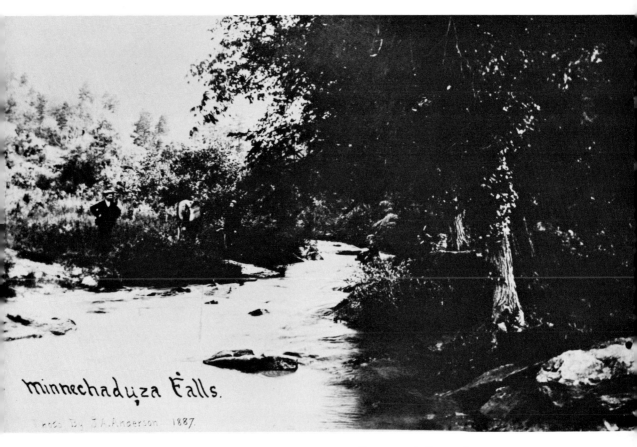

Minnechaduza Falls.

Photo. by J. A. Anderson. 1887.

PLATE 23. Minnechaduza Falls, 1887. This is a well-known falls on the Minne-
chaduza River near Valentine, Nebraska. The man with the heavy
beard is Jules Sandoz, the subject of the biography *Old Jules*, written by
his daughter, Mari Sandoz. The Indians shown dancing in Plate 26
were camping on the banks of this river.

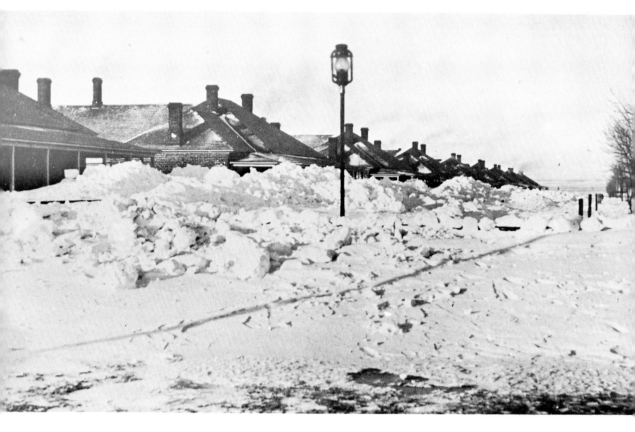

PLATE 24. Fort Niobrara after the blizzard of January, 1888. On the day before the blizzard Anderson, who was then nineteen years old, went to visit his father on the homestead and stayed overnight. The next morning, expecting to ride back to the fort with the mail carrier, he walked over to his sister's home to have a cup of coffee while waiting for his ride. He was watching for the carrier from the window facing the road. Suddenly snow began falling so heavily that he could no longer see the road. He at once started back to his father's house and said later that had there not been a wire fence between the two houses that he could follow he could not have made it.

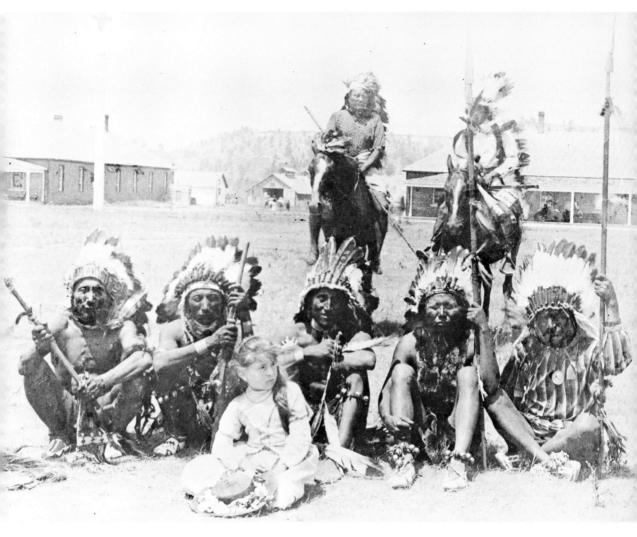

PLATE 25. Indians and a white girl at Fort Niobrara, 1889. Seated: second from
left, Turning Bear; center, Blunt Arrow; second from right, Follows the
Woman. On horseback: left, Goes to War. The others are unknown.
Buildings of the fort are in the background.

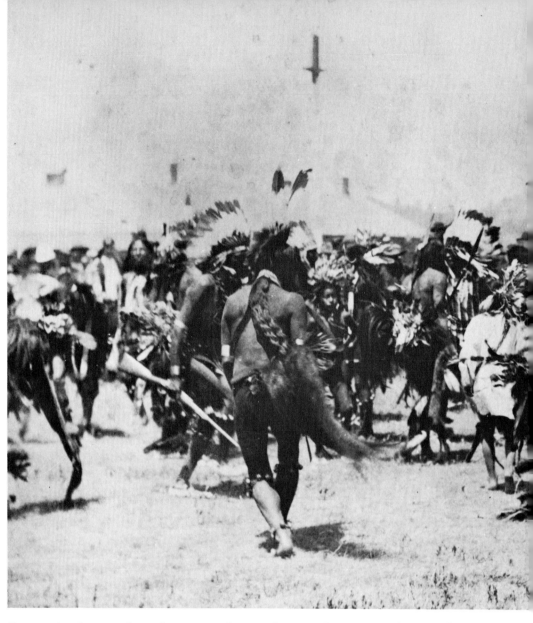

PLATE 26. Sioux Indians dancing on the parade ground at Fort Niobrara, July 4, 1889. Some of the fort buildings are in the background. On the mounting of the original print appeared the line "J. A. Anderson, Portrait & View Artist, Fort Niobrara, Nebraska."

Anderson tells about this occasion in his diary:

"July 3, 1889. 266 Indians on their way from Rosebud to Fort Niobrara camped on the banks of the Mineakeduza [*sic*] river put on their War Paint, mounted their steeds and with a rush, warwhoop and shooting came into town nearly scaring some people to death. The scene was very exciting indeed. At 11:30 that night they came to Fort Niobrara and camped back of the garrison.

"July 4, 1889. To the surprise of all the inhabitants of the garrison in the morning, the Indians were nicely camped and rustling around for something to eat, a large city of canvas inhabited only by Red Skins appeared as if it had come up out of the ground in an instant.

48

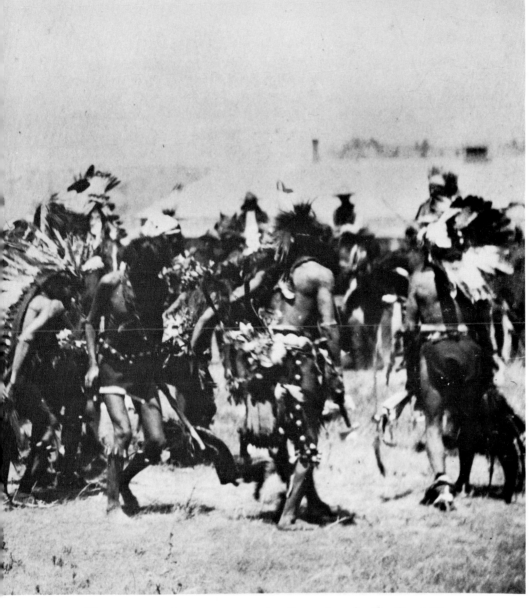

"At 10:00 A.M. they were preparing themselves for the Great War Dance which began at 11:00 A.M. and was the largest dance ever witnessed by White People.

"The day was very hot and sandstorms were numerous but in spite of all the Sioux kept up their curious manuevers until evening, when some drunken soldiers broke up the dance. At 6:00 P.M. I saddled my pony and rode to Sparks to a dance, a distance of 12 mi., returned the same night and in the next morning no Indians were to be seen. They disappeared as mysteriously as they came.

"July 5, 1889. Hot winds, the hottest day since the erection of the Post. 109° in the shade, 136° in the sun. The Indians were in Valentine dancing all day in spite of the hot weather, it was so hot that the grass which was green in the morning was burned like straw by night."

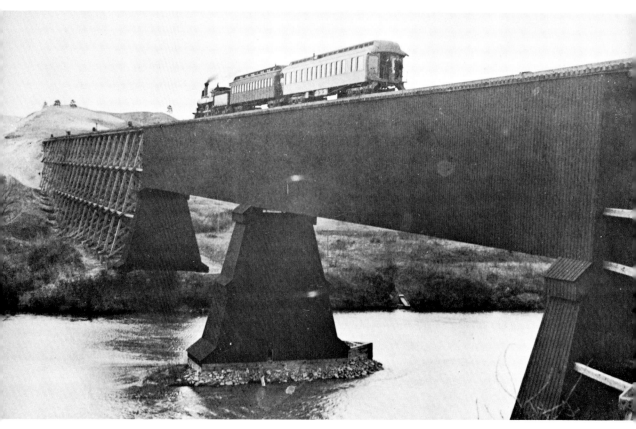

PLATE 27. Railroad bridge over the Niobrara River east of Valentine, May 1, 1889
(copyright, 1893). Anderson's diary of May 1, 1889, records: "Went out
to the F.E.&M.V. railroad bridge that crosses the Niobrara River to
make a picture of it, as I was ready to make an exposure, a train con-
taining Officials of the road came and they requested me to make the
picture, which I did."

The bridge was built the year the Andersons arrived in Nebraska.
C. S. Reece, Jr., writes in *Wagon Wheels to Wings: Seventy-five Years
of Progress, 1884–1959* (Valentine, Nebraska, 1959):

"The railroad accomplished the crossing of the Niobrara in 1883
over a wooden trestle bridge built by hand labor over a grade built by
many mule teams and hand operated fresnos. An extra steam engine was
required to pull the average train up the hill from the river to the new
metropolis. Because of this added chore the wooden structure was re-
placed in 1910 by the third tallest steel railroad bridge in the United
States at that time. Again huge cuts and fills for the approaches to this
structure were accomplished in the same manner as before."

50

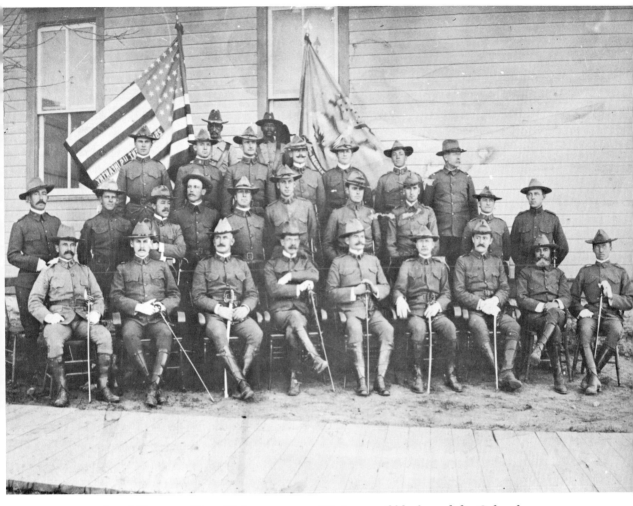

PLATE 28. Officers at Fort Niobrara, 1902. First row: fifth from left, Colonel
Alpheus H. Bowman, commander of the regiment; second from right,
Theophilus G. Stewart, chaplain. Second row: third from left, First
Lieutenant Berkeley Enochs. On the flags are printed "25th Regiment
U.S. Infantry."

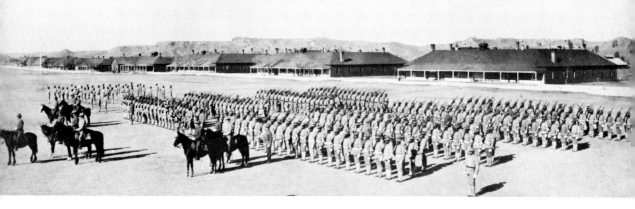

PLATE 29. Negro infantry at attention on parade grounds at Fort Niobrara, 1902. The First and Third battalions of the Twenty-fifth Regiment with their band arrived at Fort Niobrara in August, 1902, from Manila, Philippine Islands, and replaced the regiment manning the fort.

3

The Rosebud and Pine Ridge Agencies

THE Rosebud Reservation was established in 1878 for the Brulé Sioux. At that time only one town, in the present sense of the word, was established on the reservation—Rosebud, where the agency was located. "Districts," or communities, sprang up all over the reservation. They had no formal boundaries and were named for physical features, such as creeks, or for tribal leaders (see map, page 68). In time, issue stations, "boss farmers'" residences, schools, and field matrons' stations were established in the districts. Cash annuity payments to the Indians by the government attracted merchants, who opened trading posts on the reservations and became "licensed Indian traders." Colonel Charles P. Jordan was the licensed trader on the Rosebud Reservation. Anderson worked for him for a number of years before buying an interest in the company.

The Pine Ridge Reservation, occupied by the Oglala Sioux, adjoins the Rosebud Reservation on the west.

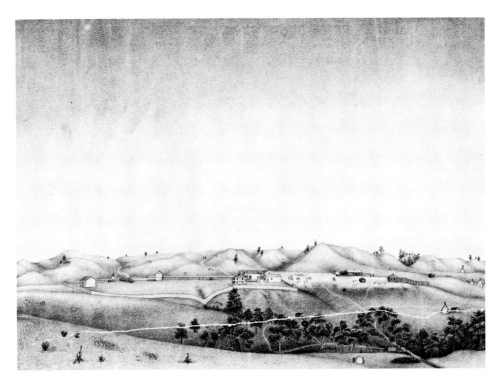

PLATE 30. This drawing, by James McCoy, dated May 3, 1879, is the earliest
known illustration of the Rosebud Agency (often called the Spotted Tail
Agency). This is the view facing west. The stockade, with firing step,
encloses the agency grounds and the big L-shaped warehouse is in the
northwest corner. The agency office is just east of the warehouse, and
the walls of these two buildings form a part of the stockade. Another
building, perhaps the agent's home, is near the warehouse and agency
building. The two-story hotel, in process of construction, is surrounded
by scaffolding. The barn is in the southwest corner, and just outside
the corral are several wagons and carriages. The building on the south-
east may be a granary. (Drawing from the records of the Bureau of
Indian Affairs.)

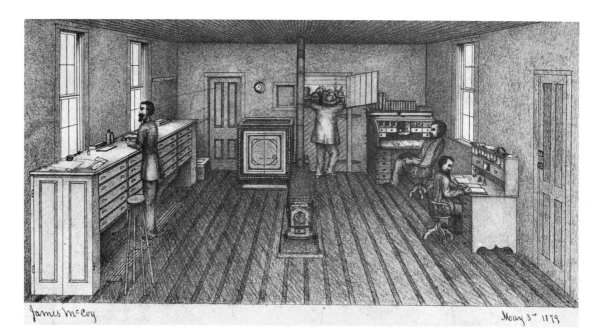

James McCoy May 3ʳᵈ 1879

PLATE 31. This drawing, by James McCoy, May 3, 1879, shows the inside of the
building east of the big warehouse shown in Plate 30. Seven Indians
who are conducting business with an agency employee, can be seen
through the open upper part of the divided door in the back wall. The
Indians are outside the stockade, since this wall forms a part of the
stockade line. The office is equipped with a large safe, a standard roll-
top desk, another desk with file drawers and pigeonholes, and a stand-up
desk with file drawers, which occupies almost all of the west wall. A
chest or trunk sits on the floor at the far end of the west wall. A cast-
iron wood stove stands in the center of the office. It is exceptionally long
and has a front-opening door that will take extra-long pole wood, thus
saving woodchopping labor. A heavy zinc with a raised rim, apparently
of cast iron, is under the stove, and the stovepipe goes straight up
through the ceiling. (Drawing from the records of the Bureau of Indian
Affairs.)

PLATE 32. Panorama of the Rosebud Agency, looking southwest, 1889. This and
the following three plates show the agency from different points of
view. This print is dated 1889 and the identification consultants (see
Acknowledgments) were of the opinion that all these pictures were
made during the same period, except for Plate 35, which was taken after
a fire had destroyed the Jordan Trading Post in 1892. According to Mrs.
Hattie Marcus, a number of the buildings in this picture were later

56

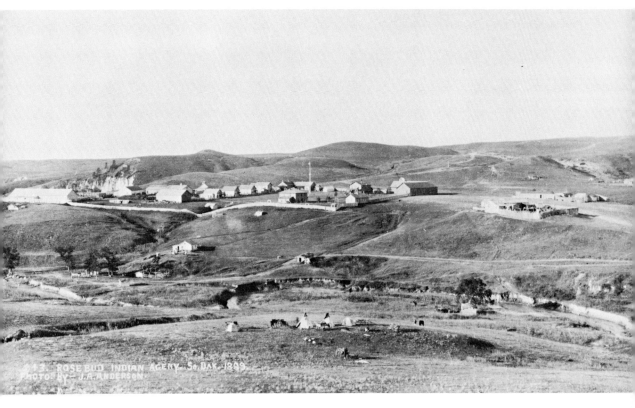

faced with bricks which her father, S. H. Kimmel, contractor, sold to the government.

The large frame building at the far left is the agency barn. At the right of the barn the next prominent building, which sits well back from the stockade, was used to store the fuel for the agency. More or less in line at the west of this building are four similar one-story or perhaps one-and-a-half-story houses where agency personnel lived. At the west end of this line of houses and slightly to the north is the agency office. North of the office is the two-story house where the Indian agent, or superintendent, lived.

At the right of the agent's house, in the northwest corner of the agency stockade, is the large L-shaped warehouse, or commissary. East of the warehouse, along the north line of the stockade, is the Rosebud day school. The large two-story square building around the corner of the stockade on the south is the hotel.

The Charles P. Jordan Trading Post is located on the same general elevation, outside the stockade on the right. A fence encloses this group of buildings, except for a cowshed on the north. The store, warehouse, and residence are one unit. The fire which burned the Jordan complex in 1892 started in the small log house just north of the main structure.

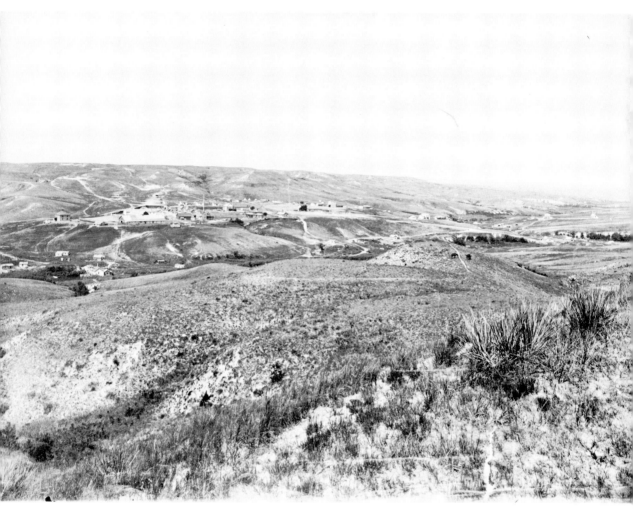

PLATE 33. Panorama of the Rosebud Agency, looking northwest, about 1889. The two-story square building on the far left and outside the stockade is the jail, which was still standing in 1970. As late as 1910 scaffold burials were still being conducted in the hills on the left. The steepled structure in the middle distance up the grade on the far right is the Episcopal Church. A hospital stands on this site today.

In this photograph the agency barn is in the near corner of the stockade and the big L-shaped warehouse is in the far corner. West of the barn is the large corral. During this period a stage line to Valentine was operated by Jack Whipple, a former Texas trail driver who had brought cattle to the reservation and remained there. He married the half sister of Hollow Horn Bear.

In each of these views the tall flagpole stands in the large open area toward the north end of the agency compound.

58

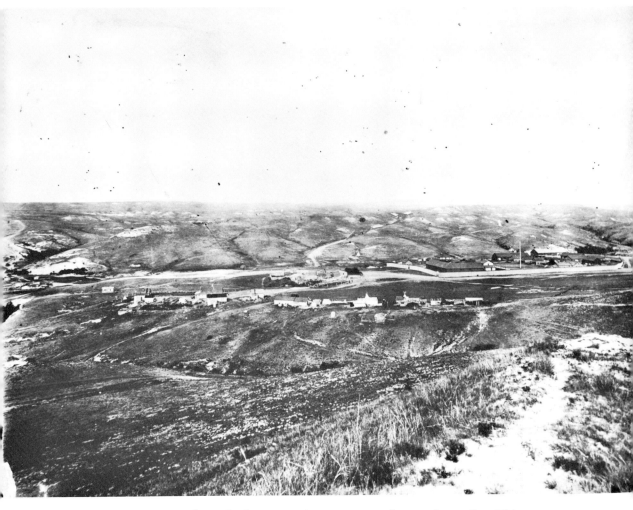

PLATE 34. Panorama of Rosebud Agency, facing east-southeast, about 1891. This photograph was taken from the top of Soldier's Hill. The edge of a trench and its embankment are in the right foreground; another section of trench is on the left and farther down the hill. Soldiers stationed at the agency dug the trenches at different times, some of them during the Ghost Dance troubles of 1890 (see Plate 35), and the deep gashes remain in the hill today. For many years Indian boys have dug sea shells from the ravine in the foreground. In the right middle distance, inside the near corner of the stockade, is the big L-shaped warehouse, and on the right of the warehouse is the home of the Indian agent.

William Colombe, one of the identification consultants, once lived in the smaller house inside the stockade at the left of the big warehouse. His grandfather William C. Courtis told him that when the reservation and the agency were being built the slopes along the sides of the ravines were wooded, which accounts for the large number of log houses. The Courtis home is among the buildings in the middle foreground, and the old "freight road," in the middle distance on the far side of Rosebud Creek, winds its way up the slope and on to Valentine, about forty miles away.

59

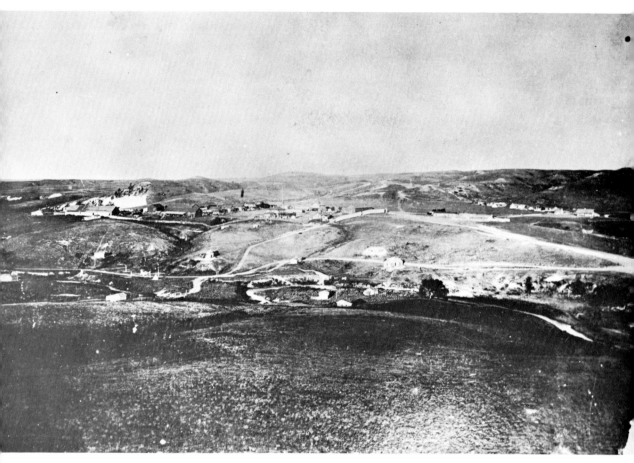

PLATE 35. Panorama of the Rosebud Agency, looking southwest, about 1892. This photograph was taken from approximately the same position as Plate 32. The buildings which constituted the Jordan Trading Post are gone, destroyed by a fire in 1892. Additions have been made to the hotel; a smaller extension has been added to the north end of the fuel building; and a roofed, open shed now extends along the east side.

In the middle of the photograph in the flat on the near side of the creek, are three structures added after 1889. The two buildings across the creek are probably homes. The various trails and roadways seem to have received much use since 1889 and have become more clearly defined. Especially noticeable is the road, almost in the middle of the photograph, which leads from the bottom across the creek up to the near corner of the stockade, where the Rosebud day school is located.

As evident in Plate 32 a number of trees had already been set out near various buildings on the agency grounds. In Plate 35 these trees are somewhat larger. Although the outer walls of the warehouse and the day school formed a part of the stockade in the 1889 photograph, in the

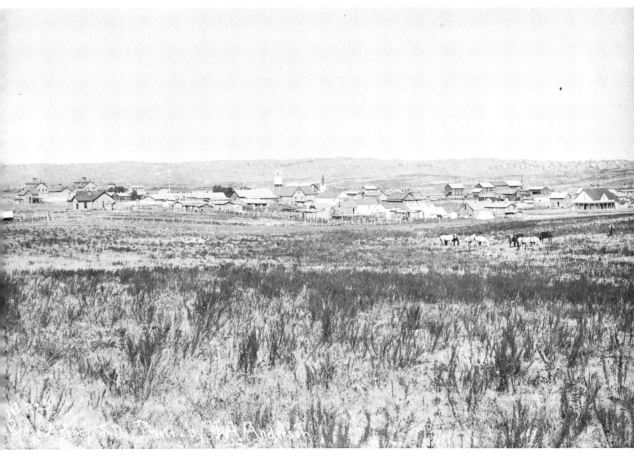

three later views of the agency both buildings are enclosed within the stockade, which stands several feet out from these walls. A new stockade has been built, at least across the north and west sides of the agency grounds, where it might otherwise have been possible for the Indians to make an attack on the agency, since the ground is level there and they would not have to charge uphill. The stockade is also taller in this photograph than in the earlier ones. Remington Schuyler said that in 1903 the stockade was about fourteen feet tall.

These panoramas of Rosebud were taken before and after the Ghost Dance troubles of 1890, when the Indians were performing certain rites in hopes of making the white man disappear and the buffalo reappear, so that life would return to normal. The stockade was very likely rebuilt and strengthened during the Ghost Dance scare.

PLATE 36. Panorama of the Pine Ridge Agency, west of the Rosebud Reservation.

4

Sioux Camps and Villages

FROM the beginning the Rosebud Sioux preferred to make their camps on the land of highest elevation farthest out on the plains rather than near the Missouri River, although they were some distance from their river point at Rosebud Landing.

Once while Anderson was preparing to photograph an Indian camp about a mile south of the Rosebud Agency, his life was in danger, although he was unaware of it at the time. He had set up his tripod and camera on a prominent knoll overlooking the camp and placed the black cloth over his head, eager to take pictures of unusual activity he saw below. Suddenly things quieted down. He later learned that he and his camera had been the cause of the activity. Thinking that his camera was a new kind of gun, the Indians had been preparing to retaliate when, fortunately, a white friend appeared and explained the situation to them.

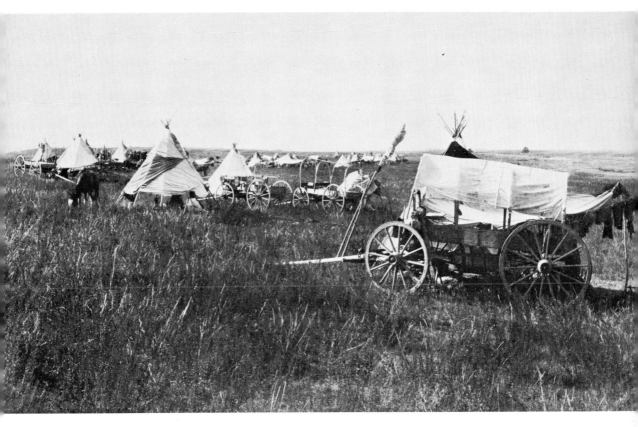

PLATE 37. White Thunder Camp, Rosebud, Dakota Territory, 1888. This repro-
duction is made from a print Mrs. Anderson tinted. Meat is drying on a
rack behind the wagon.

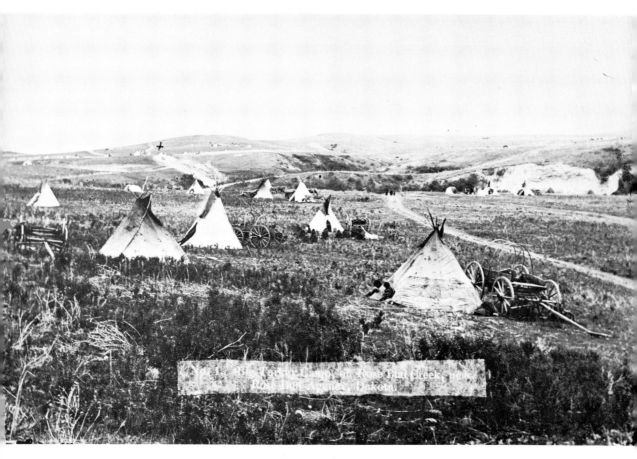

PLATE 38. Big Turkey Camp, on Rosebud Creek near Rosebud Agency, about
1888. A notation in Anderson's handwriting on the back of the print
says, "X marks the spot where Spotted Tail was shot in 1881." Another
print of Big Turkey Camp shows a dance house in the background.
(No. 1 in Anderson's numbering.)

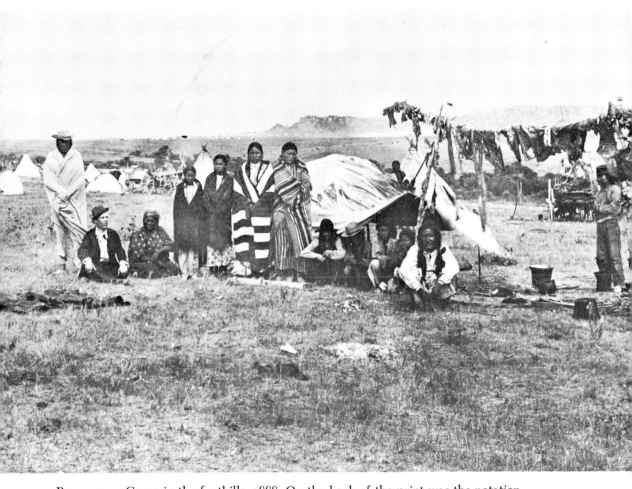

PLATE 39. Camp in the foothills, 1888. On the back of the print was the notation
"Cheyenne Indians camped near site of Old Red Cloud Agency near
Fort Robinson, 1888."

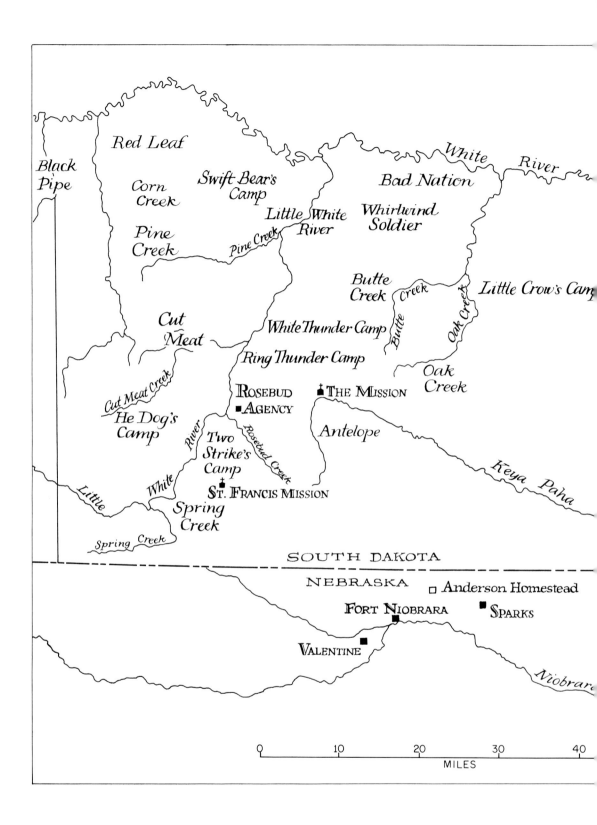

Black
Pipe

Red Leaf

Corn
Creek

Swift Bear's
Camp

White River

Bad Nation

Little White
River

Whirlwind
Soldier

Pine Creek

Pine
Creek

Butte
Creek

Creek

Little Crow's Cam

Cut
Meat

White Thunder Camp

Ring Thunder Camp

Butte

Oak Creek

Cut Meat Creek

He Dog's
Camp

Rosebud
Agency

The Mission

Oak
Creek

River

Two
Strike's
Camp

Rosebud Creek

Antelope

Keya Paha

White

Little

St. Francis Mission

Spring
Creek

Spring Creek

SOUTH DAKOTA

NEBRASKA

Anderson Homestead

Fort Niobrara

Sparks

Valentine

Niobrar

0 10 20 30 40

MILES

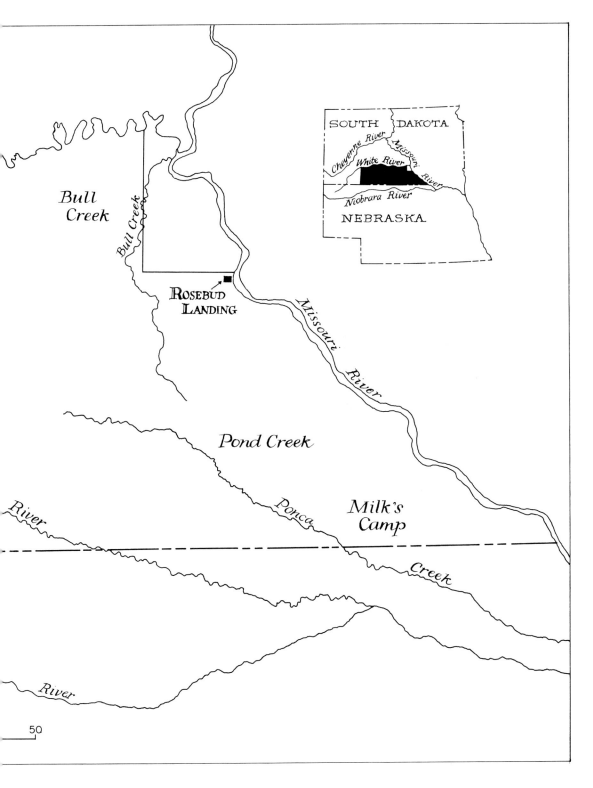

The Rosebud Reservation about 1895, showing the districts or communities

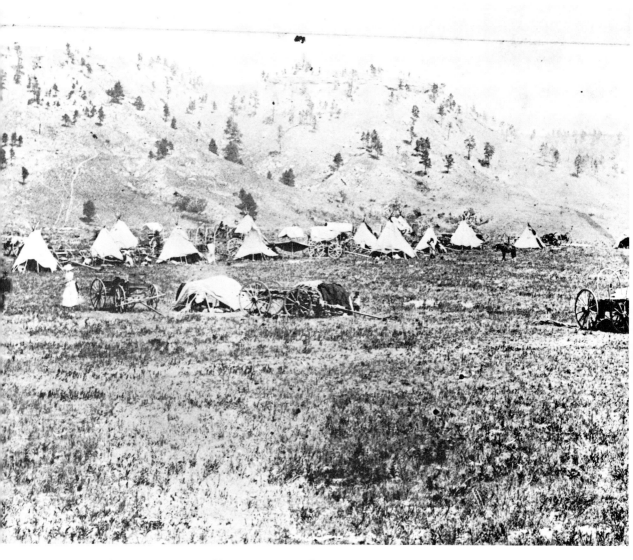

PLATE 40. A Brulé camp, 1890. This is one of the camps the Brulé Sioux made while fleeing from the United States Army as it neared the reservation during the Ghost Dance troubles of 1890.

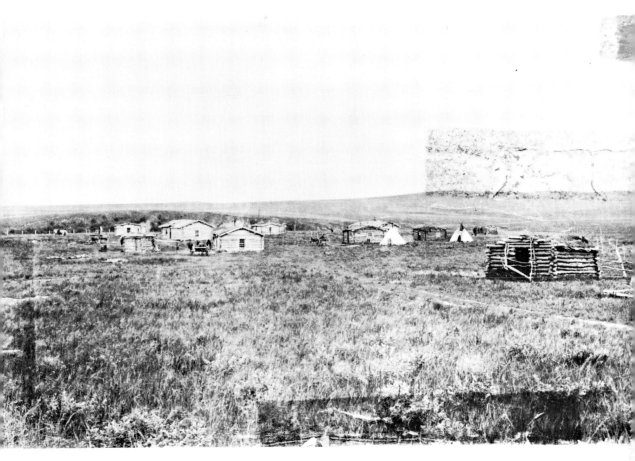

PLATE 41. Ring Thunder Village, Agency District, about 1893. By this time the Indians were building log cabins for use in winter. Two years later it was reported that all the Rosebud Indians had log cabins for winter homes.

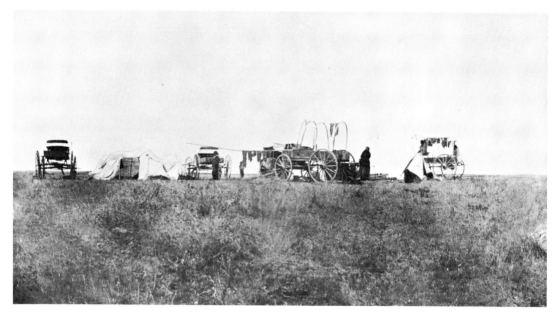

PLATE 42. Indian camp, about 1896. Three spring wagons, a farm wagon, a tipi,
and a temporary shelter are shown. Meat is drying on the wagon-top
bows as well as on a pole, one end of which is resting on the top edge
of the wagon box, the other lashed to the back rest of one of the spring
wagons. This plate was reproduced from a print made from the original
glass-plate negative.

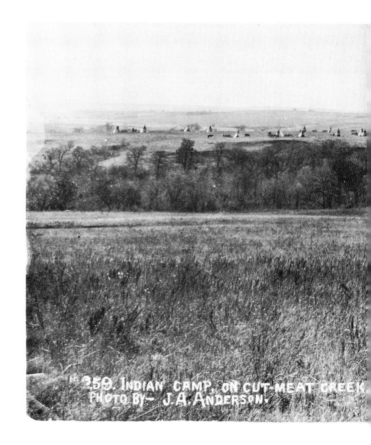

72

PLATE 43. Indian camp on Cut Meat Creek. Beef was issued here. David Parmalee later laid out the town of Parmalee on this site. (No. 259 in Anderson's numbering.)

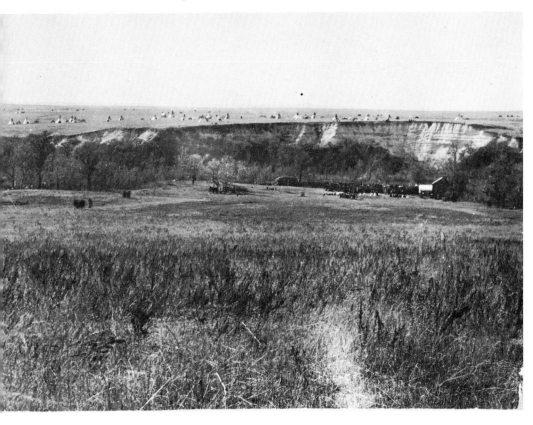

5

Councils with the Indians

ANDERSON was the official photographer at the Crook Treaty Council, held on May 4, 1889. According to his diary, while in Rosebud on this assignment he also photographed a large beef issue and various dances, and General Crook ordered twenty dollars' worth of his Indian views.

Many meetings were held to try to persuade the reluctant Rosebud Sioux to take allotments and sell land for homesteads. There were comparatively few districts, or communities, in the eastern part of the reservation, and consequently this portion of their land, granted as a permanent reservation for them and their children, was the first they lost to white settlement.

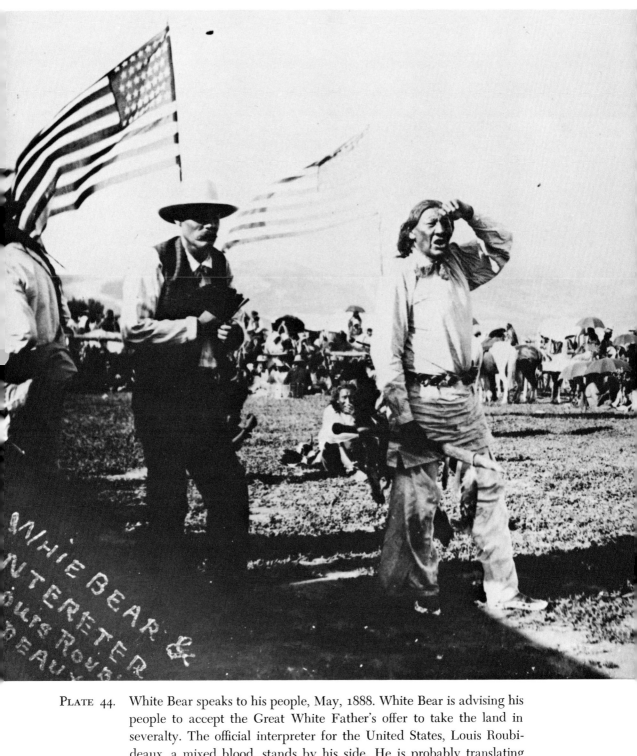

PLATE 44. White Bear speaks to his people, May, 1888. White Bear is advising his people to accept the Great White Father's offer to take the land in severalty. The official interpreter for the United States, Louis Roubideaux, a mixed blood, stands by his side. He is probably translating White Bear's presentation for a government official, not shown in the photograph.

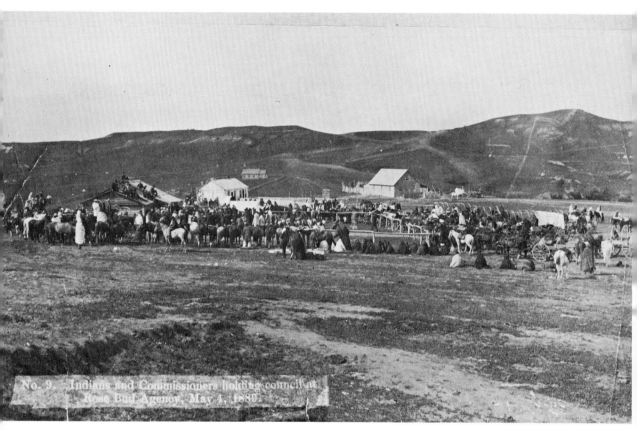

No. 9. Indians and Commissioners holding council at Rose Bud Agency, May 4, 1889.

PLATE 45. The Crook Treaty Council, held on May 4, 1889. Members of the commission were General George Crook, Major William Warner of Missouri, and Charles Foster, former governor of Ohio.

In this photograph, which faces north, the log house on the left (the one with people sitting on the roof), is the Louis Roubideaux home; the white log house with the picket fence is the William C. Courtis home; the high-gabled two-story house on the right was the home of Mrs. Gerry Shaw but was later converted into a store by Charles P. Jordan. The church across Rosebud Creek is the site of the present-day hospital. (No. 9 in Anderson's numbering.)

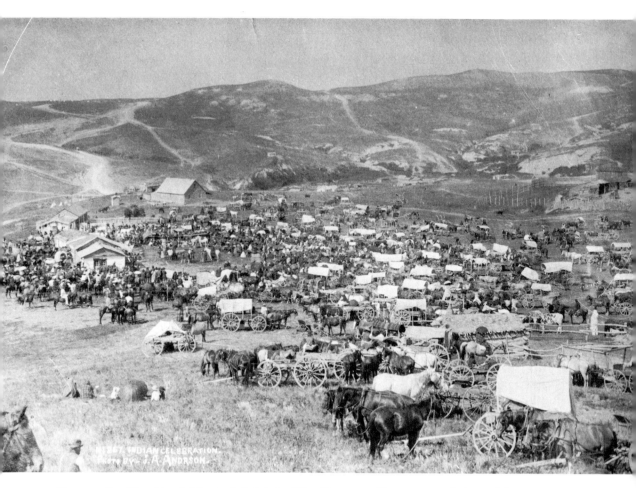

PLATE 46. The Crook Treaty hitch lot, 1889. Our consultants were of the opinion
that this was the hitch-lot scene at the time of the Crook Treaty Council,
which is substantiated by Anderson's own listing in the collection in
Rapid City, although he labels the photograph "Indian Celebration,"
an example of the general rather than specific titles he gave his pictures.
(No. 267 in Anderson's numbering.)

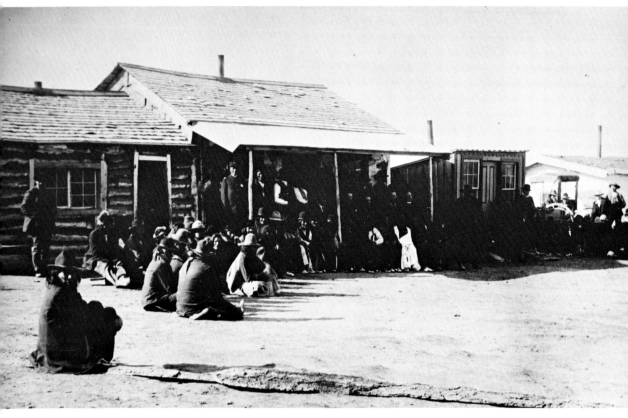

PLATE 47. The council held to persuade the Indians to sell Tripp and Gregory counties, 1892. On the back of the original print, now in the Sioux Indian Museum, appears in pencil in Anderson's handwriting: "This council was held to persuade the Indians to sign an agreement to sell Tripp and Gregory Counties to the government so that the area might be used for homestead settlement." Many such meetings were held to try to persuade the reluctant Rosebud Sioux to take allotments and sell land for homesteads.

The few photographs that were not up to Anderson's usual standard, such as this one, may have been test prints that he never expected the public to see. They are included here because of their historical importance.

6

Officials on the Reservation

THE Indian agent was the link between the people of the reservation and the government in Washington. He was in charge of the agency and of all other officials at the agency.

The Indian police force at Rosebud was authorized in 1878. The men preserved order, arrested offenders, guarded the issuing of rations, protected government property, and returned truant children to school. They escorted the annuity payments from the railroad at Valentine to the agency, frequently carried mail and delivered important messages on the reservation, and acted as an honor guard to welcome important visitors to the reservation.

Louis Roubideaux, the official United States interpreter, was at one time captain of the Indian police. Unable to teach the men to drill, he finally strode out in front of them and commanded, "Do just as I do." He had a habit of licking his prominent red mustache, and when he did so, the Indians obeyed him to a man, sticking out their tongues and licking their imaginary mustaches. It made him furious.

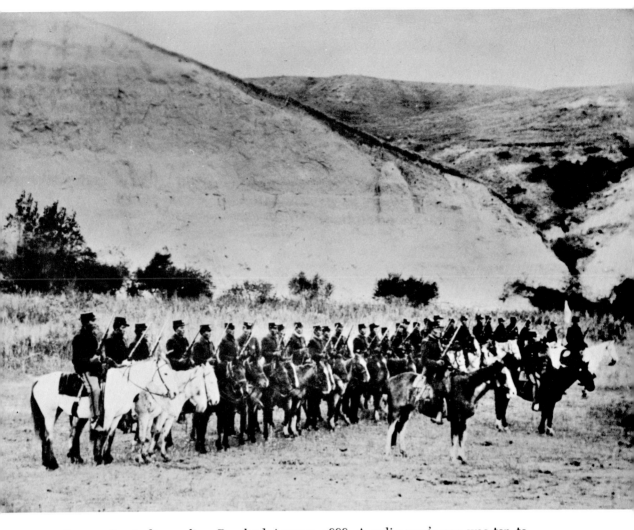

PLATE 48. Indian police, Rosebud Agency, 1888. A policeman's pay was ten to fifteen dollars a month, and he was provided uniforms, a log house, and extra rations.

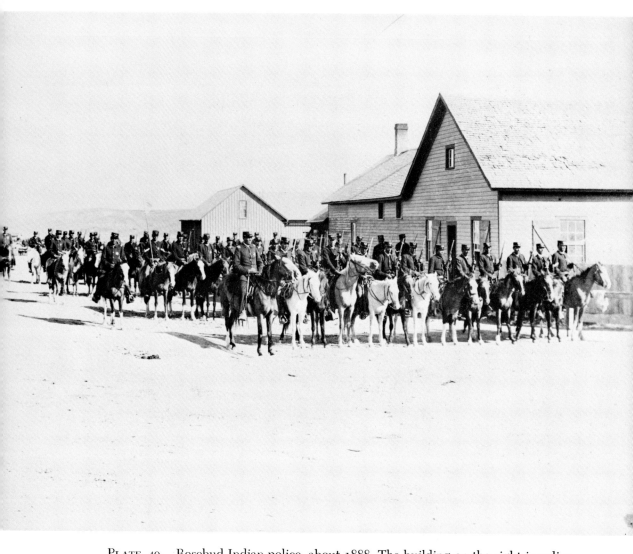

PLATE 49. Rosebud Indian police, about 1888. The building on the right is police headquarters.

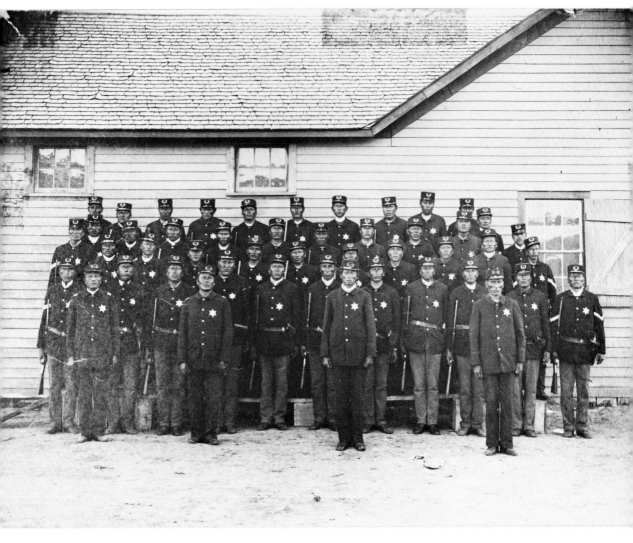

PLATE 50. Indian police in front of police headquarters, about 1890. Front row: far left, Good Shield. Second row: far left, Little Elk. Fifth row: fourth from left, Lights. Good Shield was a lieutenant. His six-point police star is exhibited at the Sioux Indian Museum.

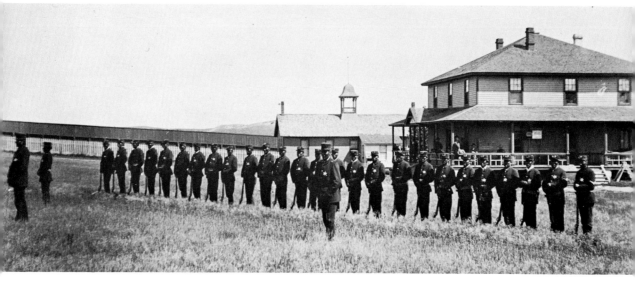

PLATE 51. Indian police drilling at the Rosebud Agency. The square building on the right is the hotel. Behind it is the day school. The Andersons lived in this hotel after their marriage while their house was being finished. William Red Cloud Jordan was born in this building. The stockade ran to the schoolhouse, which formed a part of it.

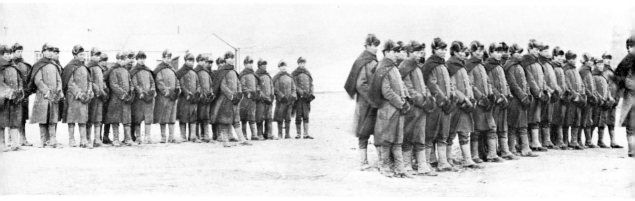

PLATE 52. Indian soldiers of Company I, Sixteenth Infantry, Rosebud, winter of 1890. First group (right): officer in front, Frank Janis; front rank, second from left, George Rogers; second rank, far left, David Dorian. Second group (left): officer in front, Jim Thompson; front rank, fifth man from left, Eagle Horn; sixth man from left, Oliver Eagle Feather; second rank, fourth from left, Charley Moore. The building in the background is Charles P. Jordan's first trading post.

A badly faded photograph of the military camp at Rosebud Agency taken by James Wagner on December 5, 1890, seems to show seventy-six tents. Dr. L. M. Hardin, agency physician from 1895 to 1902, wrote in his diary: "Indian Soldiers, Co. I, 16th Inf., left Rosebud Agency, January 30, 1892."

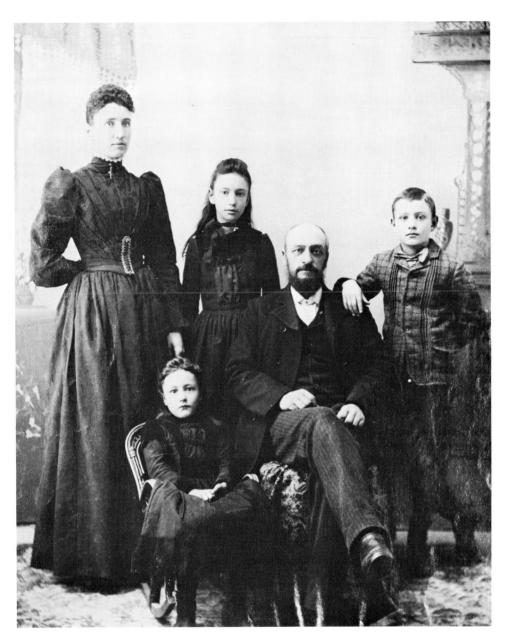

PLATE 53. Dr. A. J. Morris and family at Rosebud, about 1892. Dr. Morris was agency physician from early 1890 to November, 1895, when he was succeeded by Dr. L. M. Hardin. Agent J. George Wright stated in his report to the commissioner of Indian affairs dated August 23, 1892, that Dr. Morris' wife, Kate, had acted as the first field matron on the reservation, in 1891–92.

It has been said that Mrs. Morris was also a professional photographer. Older consultants said that this was not true at the time she was on the Rosebud. Some of the photographs attributed to her are actually some of Anderson's later Indian portraits.

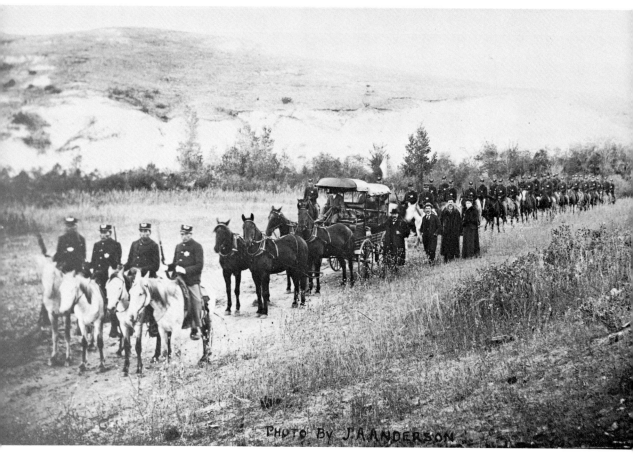

PHOTO BY J. A. ANDERSON

PLATE 54. The arrival of Commissioner of Indian Affairs D. M. Browning at Rosebud, 1894. Commissioner Browning is standing beside the hack. Indian Agent J. George Wright, in the fur coat, is second from the right. The Indian police are serving as escort and welcoming committee.

Wright was at Rosebud from 1883 to 1896. He entered the Indian Service in 1883, when he was twenty-three years old, and served first as farmer, then as chief clerk, and then as superintendent. In the words of the *Todd County Tribune*, he "stood like the Rock of [Gibraltar] between the covetousness of the Whites and the safety of the Indian property."

"A great celebration was held June 20, 1896 on Agent Wright's leaving," Dr. Hardin wrote in his diary. "5,000 Indians came from Rosebud and Pine Ridge. There was a 'Charge at Daybreak' a 'Charge' at 9:00 A.M., a 'Sham Battle' at 10:30 with 100 Indians on each side, 'War Dance' at 12:00, and 'Omaha Dances' in the afternoon and evening."

In 1915, Wright was appointed superintendent of the affluent Osage Indians, a position he was still holding in 1927, when he returned

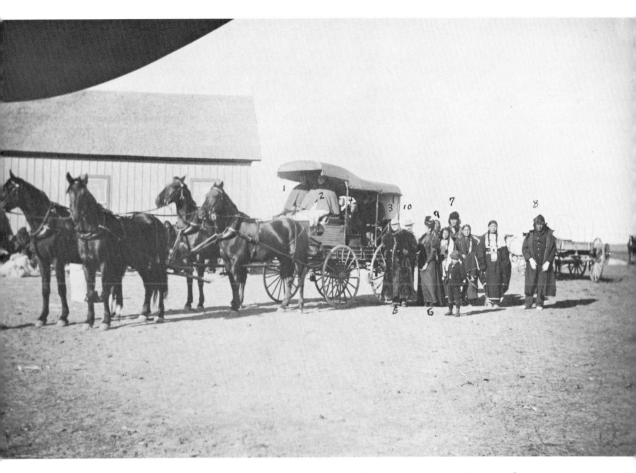

to Rosebud for a visit after an absence of thirty-one years. During the 1928 presidential campaign he led a large delegation of Osages to a rally at Rosebud for Herbert Hoover and Charles Curtis (who was part Indian). In spite of rain ten thousand people, delegates from many tribes, attended the rally.

PLATE 55. Arrival of commissioner Browning at Cut Meat, 1894. 1, J. George Wright, Indian agent; 2, Mrs. Charles R. Corning; 3, Indian Commissioner D. M. Browning; 4, Louis Roubideaux, interpreter; 5, Charles R. Corning, United States attorney; 6, Mrs. H. W. Caton, wife of the Cut Meat farmer; 7, Chief Hollow Horn Bear; 8, Good Shield, captain of the Indian police; 9, Bear Looks Back; 10, John Brown, chief of police.

Browning was commissioner of Indian affairs from 1893 to 1897. Corning was on the reservation at this time investigating depredation claims for the government. The dog must have been an important individual; at both Rosebud and Cut Meat he rated a seat in the hack.

7

Beef Issues, Domestic Issues, and Annuity Payments

BEEF was regularly issued to the Indians almost from the beginning of the reservation system to keep the people from leaving the reservation in search of meat.

Anderson's diary states:

"June 1, 1889. Went to the cattle corral and witnessed a small slaughter, made five negatives of Two Strike's camp and the slaughter.

"June 3, 1889. Got up early and went to cattle corral and there witnessed the large cattle issue which showed some very exciting scenes for negatives. . . .

"Sept. 24, 1889. Ate early breakfast, then drove to Beef Corral to see Issue. Stayed until about 4 P.M."

These entries make it definite that a number of Anderson's beef-issue photographs were taken in 1889. One of this series of photographs is dated 1891, and two are dated 1893. Five beef-issue prints were copyrighted in 1893, and the 1889 photographs were very likely among them.

The last beef issue on the Rosebud took place on September 21, 1913. Bob Emery, Jr., and his brother Clarence herded the last of these cattle. Five hundred head were turned over to them on May 1 by John Neiss, the beef contractor, and they were each paid seventy-five dollars a month to herd the cattle on the range around the reservation during the day and put them into the corral at night. Four monthly issues were made from this drove, and about 125 head had been allotted each time so that there would be just enough left for

the "fair," or last, issue. Bob Emery stated that the cattle issued earlier in the season were thin but that they put on weight as the season advanced because the grass was good. Cattle issues, however, were made by the head and not by weight.

The domestic issue consisted of such provisions as salt bacon, green coffee, sugar, navy beans, rice, hardtack, flour, baking powder, and yellow laundry soap.

For many years the various annuity payments were made in silver. The shipments were sent to Valentine by rail and escorted from the railhead to the agency by mounted police. Later on, from 1910 to 1926, purchase orders, or "checks," were used instead of silver.

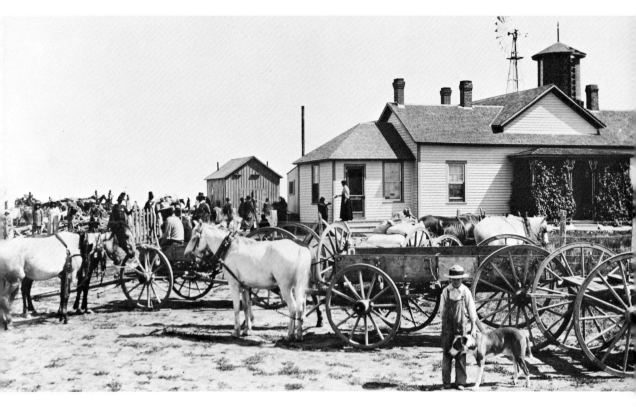

PLATE 56. Issue station at Cut Meat (Wowoso), about 1897. Each district had an
issue station, a slaughter house, and a corral. The house on the right is
that of the district farmer (sometimes called "boss farmer"), who, in
addition to trying to teach the Indians how to farm, issued beef, other
rations, wagons, and so on. He helped the Indians with their problems
and in general looked after them, more or less performing the duties of
an Indian agent on a small scale. Part of the farmer's house was used as
a storehouse for domestic issue. The beef-issue station was at the left
and is not shown in the photograph. In 1894, H. W. Caton was the
farmer at Cut Meat.

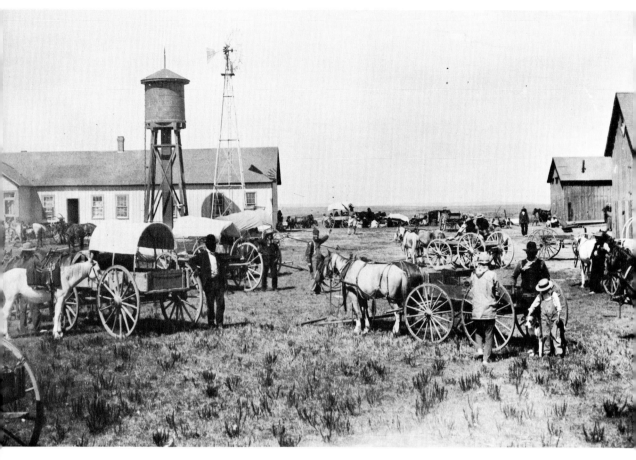

PLATE 57. Issue station at Cut Meat, rear view, about 1897. The windmill and water tower stand at the rear of the farmer's house. The beef-issue station is at the right. Sacks of staples (probably flour or navy beans) for the domestic issue are visible through a window.

PLATE 58. The cottage of the field matron, or district nurse, Black Pipe District, 1897. The matron's cottage was near the issue station. Her job was to care for sick Indians and teach them health care and sanitation. She dispensed government-issued medicines and at times acted as midwife to Indians and later to homesteaders. Mrs. Pat McDonald was nurse at Butte Creek for many years. She and Mrs. Melinda Carlson Hogg, John Anderson's niece, traveled around the reservation in the summer of 1924 giving the Indian children cod-liver oil to get them ready for school. It was necessary to dose the children personally; otherwise, the

94

mothers would use the oil in their buckskin-finishing process, having found that it made the skins much softer and more pliable than the traditional treatment.

PLATE 59. Butte Creek issue station and farmer's residence, about 1897. The field matron's cottage was at the right, out of camera range.

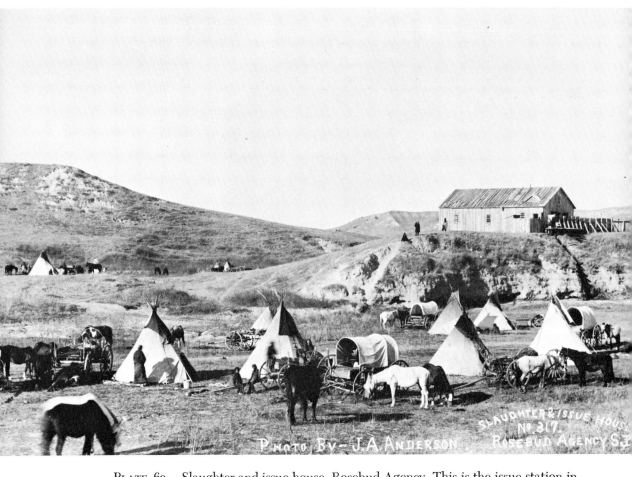

PLATE 60. Slaughter and issue house, Rosebud Agency. This is the issue station in the Agency District, where the seat of government was located. (No. 317 in Anderson's numbering.)

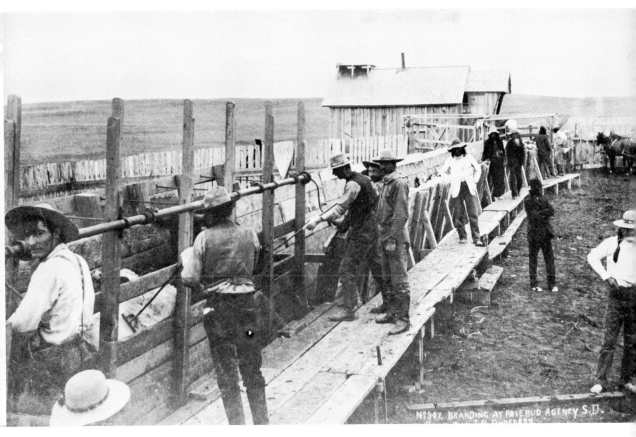

PLATE 61. Branding cattle at Rosebud Agency, about 1889. When the cattle had been driven to the reservation, frequently from points as far away as Texas, they were branded ID, for Indian Department. They were treated for ticks in the vat at the far end of the chute and then turned out on the range to graze until time for issue.

The chute in this photograph is a squeeze chute, used for close handling of livestock. The right side of the chute was rigid, and to it was attached a heavy round horizontal rod which rotated in a series of bearings attached to the upright timbers. On each end of this rod was a hand crank used to draw in or let out the five ropes (or perhaps light chains) extending from the rotating iron rod to the top of the movable left side of the chute. Two men, one on each crank, could draw in the left side of the chute to squeeze an animal and hold it quiet for branding or medical treatment. Since these were Texas cattle, they very likely had to be treated for screwworm infestation. (No. 307 in Anderson's numbering.)

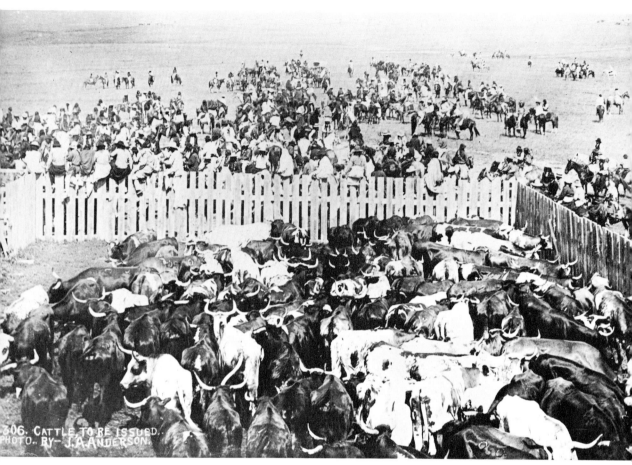

306. CATTLE TO BE ISSUED.
PHOTO. BY J. A. ANDERSON.

PLATE 62. Cattle to be issued, about 1889. Approximately ninety-five head of cattle are in view in this portion of the corral. The Indians on horseback are waiting for the cattle to be released through the chute onto the prairie. Many people have gathered to watch the activity.

According to Mr. and Mrs. William Jordan: "In the earlier years of the beef issue the cattle were turned loose on the prairie and the Indians shot them from horseback, somewhat like a buffalo hunt. It offered diversion as well as meat, and the Indian families would then skin and dress the animal out on the prairie where it fell. This was discontinued because with the cattle running loose, and so many people present, there was too much likelihood of someone getting shot. After some Indians were shot the practice was changed. Of course the authorities also wanted them to change to the white man's way." (No. 306 in Anderson's numbering.)

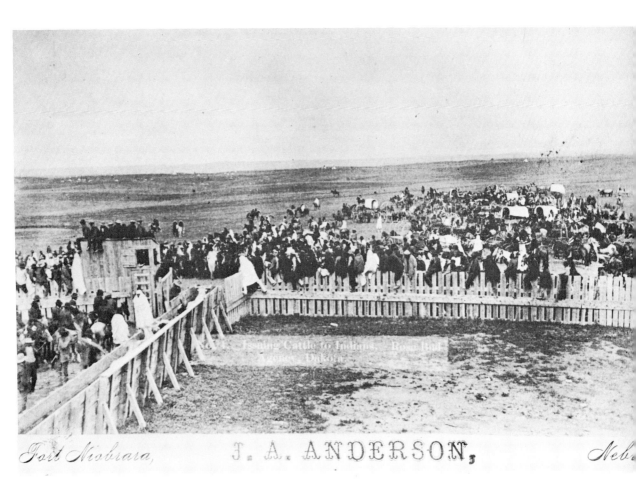

PLATE 63. Issuing cattle to Indians, Rosebud Agency, about 1889. The cattle are in the chute, ready to be released onto the prairie and shot, and the Indians are preparing to form guard lines. On the mounting of this photograph is printed "J. A. Anderson, Fort Niobrara, Nebraska." It is very likely one of Anderson's earliest prints, since he used Fort Niobrara as an address in the early years. His numbering of the print (No. 4) also indicates that the photograph was an early one. This and Plate 66 were taken at the same place but at different times, for in this picture an extra plank has been added along the top of the chute, and the pond on the far left is almost dry.

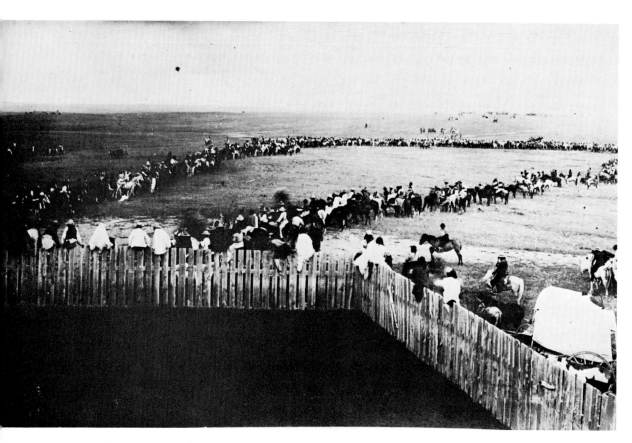

PLATE 64. Indians on horseback form a guard extending from the corral gate,
awaiting the release of the cattle, to be shot and butchered on the
prairie, about 1889.

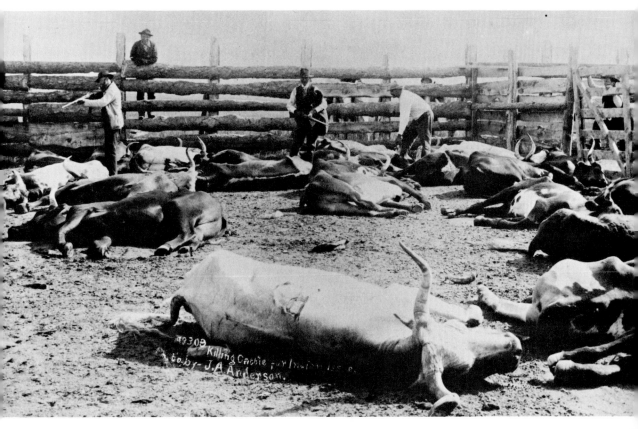

PLATE 65. Killing cattle for beef issue, about 1891. In keeping with new safety measures, Texas longhorns are being shot in a corral. (No. 309 in Anderson's numbering.)

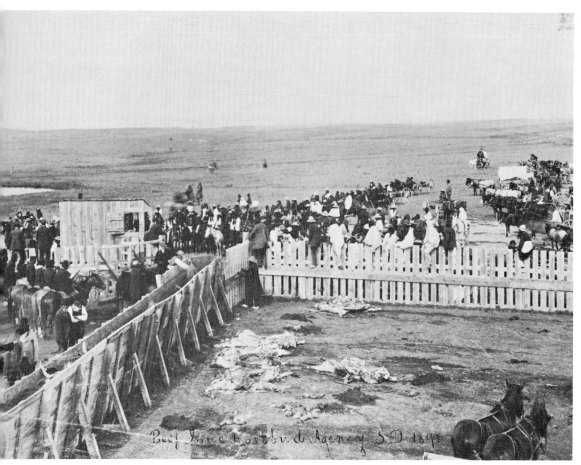

Beef Issue Rosebud Agency S.D. 1891

PLATE 66. Beef issue, Rosebud Agency, 1891. In the chute are cattle that have evidently just been driven in from the range by the Indians on horse-back in the background. The man in the window of the small shed is keeping the issue tally sheet. In the corral in the foreground are dressed beef carcasses, and several Indian mounted police are in the corral at the left of the chute. Some of the Indians are wearing white muslin sheets in place of their customary blankets, an indication that the photograph was taken during hot weather.

During this period Mexican traders sometimes brought blankets from the Southwest to trade with the Sioux. The Sioux also had some ordinary trade blankets from St. Louis and some Hudson's Bay blankets.

In a new country one would expect the corral fences and chutes to be constructed of poles rather than milled lumber. Almost all of the lumber seen in these prints is milled. The reservation had a sawmill al-most from the beginning, and the wood came from the Timber Reserve, an area of pine timber about five miles southwest of the agency. Since this part of the country had very little timber, one had to have a permit to obtain logs or lumber from the reserve, which was still producing timber in 1965.

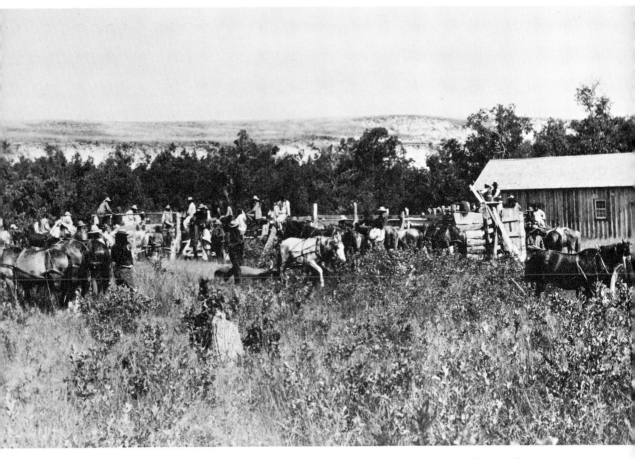

PLATE 67. Beef issue, about 1893. Rosebud Creek can be seen in the background. The team of horses in the center foreground is dragging a dead steer, shot in the corral, into the open, where it will be skinned and dressed. A number of other teams have been unhooked from wagons and are awaiting their turns to pull carcasses out of the corral to an open area where there will be more room to dress the animals. Most of the Indians gathered around the corral are wearing white man's clothing, but their hair is long and hanging loose.

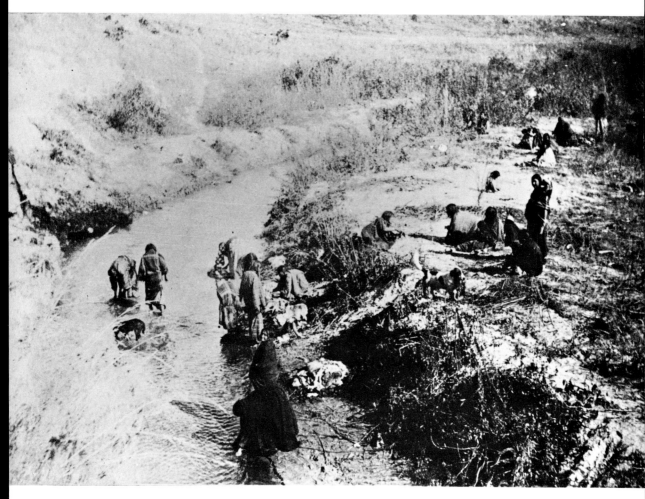

PLATE 68. Women washing cattle paunches and entrails in the creek. Some issue
stations were situated on relatively high ground over creeks so that
chutes could be constructed to the water. The paunches and entrails
from the butchered cattle slid down the chutes to the creek, where they
were washed.

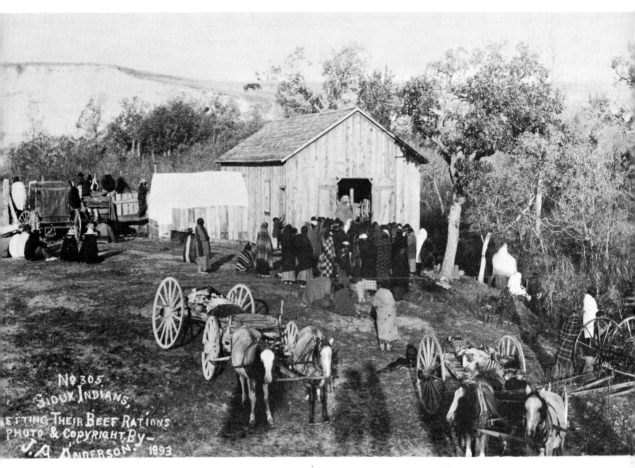

Within the image:
No 305
SIOUX INDIANS,
ETTING THEIR BEEF RATIONS
PHOTO & COPYRIGHT BY —
J. A. ANDERSON. 1893.

PLATE 69. Sioux Indians receiving their beef rations (copyright 1893). The dressed carcasses are already loaded on two of the wagons. About thirty Indians stand at the door of the building, others line the corral fence, and still others are seated behind a buggy in the left background. In the lower right corner two sulky hayrakes are pushed close together. Various types of farm machinery were provided for the Indians in the early years, especially hayrakes of this type, which in many cases rusted without ever being used. One enterprising schoolteacher later used the iron from the teeth of unused rakes in his blacksmith class to make door latches and other articles for the children to take home for use in their log cabins. (No. 305 in Anderson's numbering.)

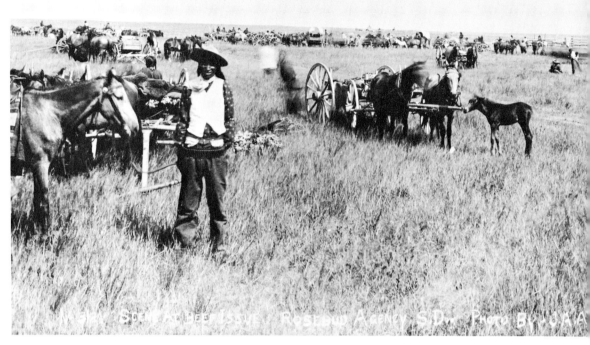

PLATE 70. Scene at beef issue, Rosebud Agency. The man in the foreground hold-
ing the reins of his saddle horse is obviously proud of his heavy cartridge
belt and regular stock saddle (a rare possession on the reservation). His
beef was probably issued early and has already been dressed and loaded
on a wagon, perhaps the one immediately behind him, for he seems
caught up with his work and ready to leave for home. The team with the
colt, in the right foreground, is also hitched to a wagon loaded with
dressed meat.

 The people in the background are either working with their beef or
awaiting their issue from the corral, on the far right. Toward the corral
a woman with a child on her back talks with someone seated on the
ground.

 Since horses are usually frightened by the smell of blood, the
aplomb of the horses in these beef-issue photographs indicates that they
have become accustomed to slaughter. (No. 312 in Anderson's num-
bering.)

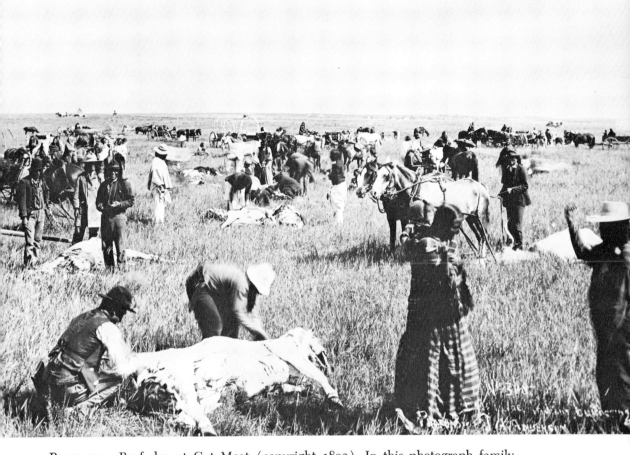

PLATE 71. Beef day at Cut Meat (copyright 1893). In this photograph family
 groups are working at various stages in the butchering process. The
 man at the right has just pulled out a carcass with a team of horses,
 which are still hitched to the steer. (No. 315 in Anderson's numbering.)

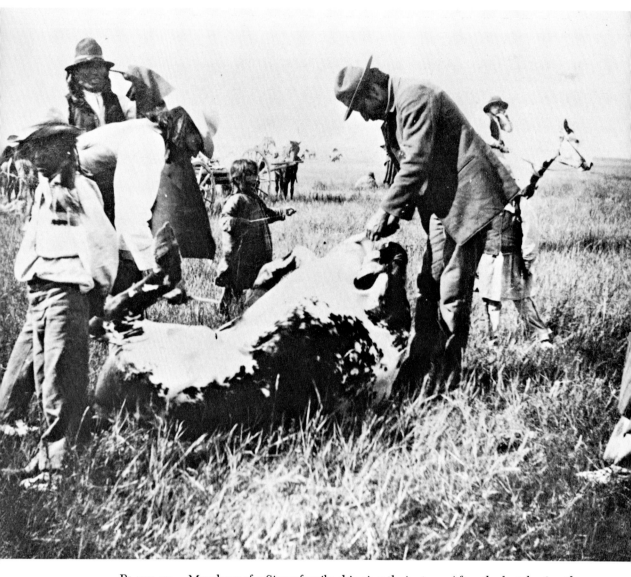

PLATE 72. Members of a Sioux family skinning their steer. After the butchering the hide will be tanned and used for various items.

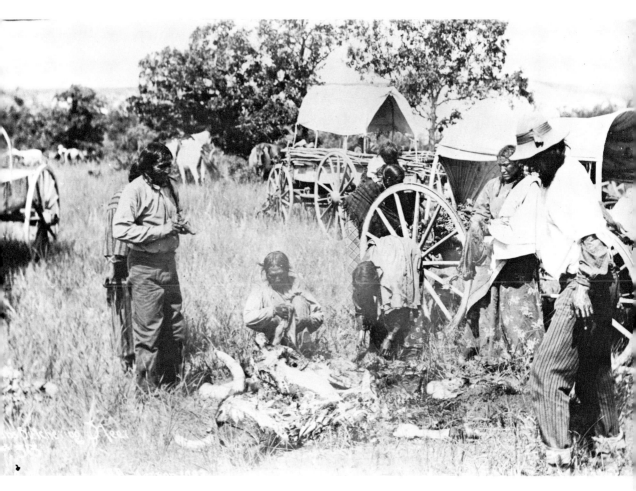

PLATE 73. Indians cutting up meat (copyright 1893). The work has almost been
completed, and the meat has been loaded on the wagon. The larger
bones of the animal, from which the muscles have been removed, are
still lying on the ground. The women are working with the last pieces,
and the men are carefully viewing the bones to be sure that nothing
edible is left. One of the men is whetting his knife, now that the work is
done.

 Although the three wagons are of standard design, the running
gears are of somewhat lighter construction than those on wagons ordi-
narily used in farming areas. Tipi poles are loaded in the wagon in the
background. (No. 313 in Anderson's numbering.)

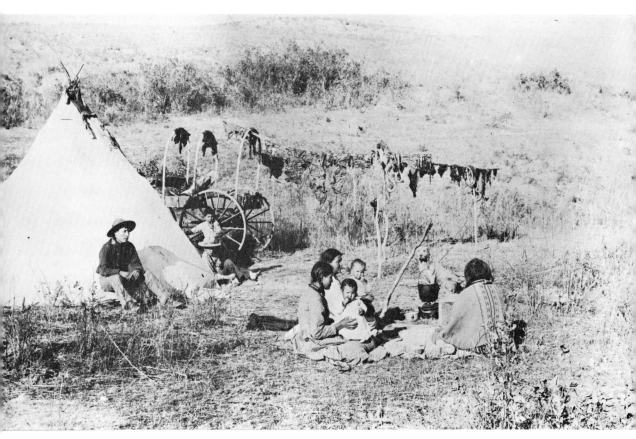

PLATE 74. Drying beef at an Indian home (copyright 1893). The meat from the beef issue has been brought home, and strips are drying on the bows of a spring wagon and on a pole rack arranged for that purpose. Preparation of meat for drying was a detailed process that took time and skill. The various muscles were separated from the carcass and then cut, with the grain, into very thin sheets to expedite drying and prevent spoilage.

This skill was perfected in the days when the Indians hunted buffalo. When many of the older people skilled in the art died and younger ones prepared the meat with less attention to the process, so much meat was lost that the people often went hungry. There also were instances in which not enough attention was given to the care and dressing of green hides, or some step in the tanning process was neglected, and the hides spoiled. (No. 320 in Anderson's numbering.)

110

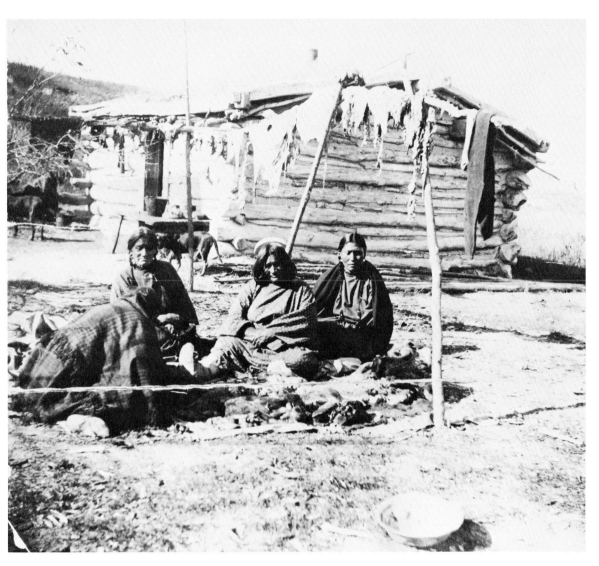

PLATE 75. Preparing *papa saka* (dried beef), photographed before 1897 (copyright 1911). The woman with braids in line with the doorway is Nancy Blue Eyes (who did, indeed, have blue eyes). She was an Oglala full blood, the mother-in-law of Colonel Charles P. Jordan, and the mother of Sarah Blue Eyes. She died on June 28, 1897, at the age of seventy-three, and is buried in the cemetery at Wood, South Dakota. The woman second from the right is Mrs. Pawnee, the agency laundress. Plate 153 was photographed at the same site.

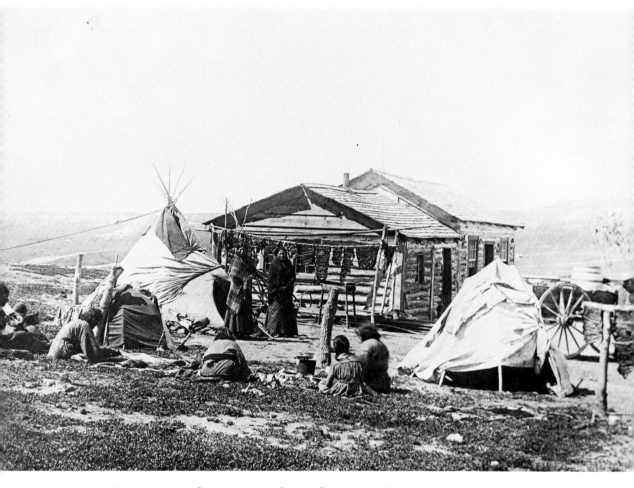

PLATE 76. Indian women jerking (drying) beef (copyright 1893). This is a comparatively affluent household, with a log house of at least two rooms built at different times and five visible windows, as well as two sweat lodges and a tipi. Extra tipi poles and a framework are stacked near the house. In the wagon is a water barrel.

 This is one of a series of pictures Anderson copyrighted on May 18, 1893, from Williamsport, labeled "Views of the North West, J. A. Anderson, Valentine, Nebraska." Each of the photographs is mounted on a black cardboard backing, 5½ by 8½ inches, with gold lettering and a gold edge. The series included pictures of an Indian travois, the Squaw Dance, the Omaha Dance, Indians butchering a steer, an Indian home, the White Buffalo Dance, the White Buffalo Feast, and others.

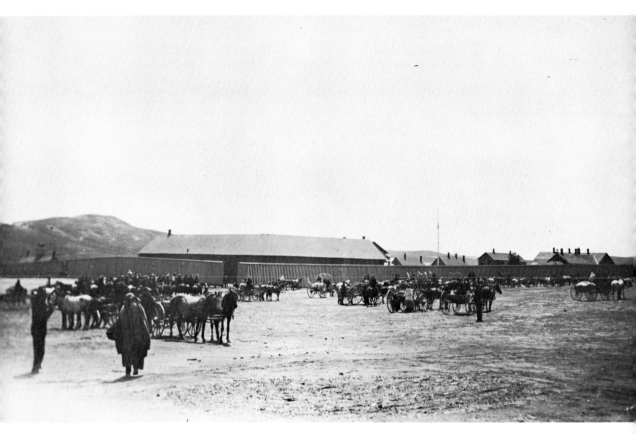

PLATE 77. Sioux receiving a domestic issue at the Rosebud stockade, 1895. The
domestic issue consisted of such staples as salt bacon, green coffee,
sugar, navy beans, rice, hardtack, flour, baking powder, and yellow
laundry soap. The *Valentine Republican* reported on June 6, 1900:
"C. E. McChesney, Indian Agent at Rosebud, came over to Valentine
Monday accompanied by his clerk, W. J. Barker, to check out three
railroad cars of flour which was hauled to the Agency by the Indians.
Formerly this work was performed by the receiving and shipping clerk,
recently dispensed of by the Department. Quite likely the new order of
doing business in this line will cause some inconvenience and much
annoyance to the Agent."

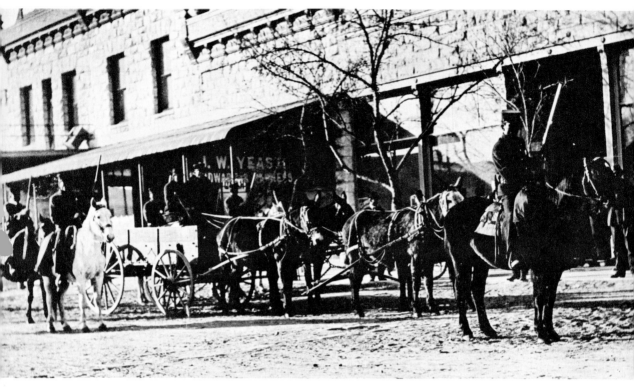

PLATE 78. Wagon containing annuity payments in Valentine, about 1895. This wagon, pulled by a four-mule team, is loaded with an annuity payment of $38,000 in silver to be hauled to the agency at Rosebud. "Vallie" (Valentine) McKenzie, a red-haired mixed blood, is riding the white horse. The payments were shipped to Valentine by rail, American Express. The depot is just out of sight on the left. The amounts of the various annuity payments, made in silver, weighed one to one and a half tons, and the distance from the railroad to the agency was forty miles. Thus the annuity payment made quite a load for a team of four good mules that had to tread the sandy trail that wound its way through the hills to the agency. (The trip from the agency to Valentine was a full day's journey for a buggy with a good team, and the Indians, using their own issue wagons and a two-horse team, were limited by the authorities to a load of about six hundred pounds.)

The payment is guarded by six mounted Indian police with rifles, the usual number used to guard these shipments. The *Valentine Republican* of February 17, 1893, reported, however: "Indian Agent Wright accompanied by 21 Indian Police came over from the Agency yesterday to receive the money for annuities and pony claims for the Sioux Indians." The May 25, 1900, edition reported: "Agent C. E. McChesney came over from Rosebud Agency last Saturday accompanied by the Indian Police after money with which to make another payment to the Indians. He returned Sunday taking with him between 40 and 60 thousand dollars."

114

8

Charles P. Jordan, Frontiersman and Licensed Indian Trader

COLONEL Charles P. Jordan, a descendant of David Cady of Revolutionary fame, went to South Dakota from Chicago. His brother, Colonel William H. Jordan, United States Army, commanded various posts in the West, among them Fort Robinson, Nebraska. He was a cousin of General George A. Custer, their grandmothers being sisters. The family name was Ward.

Jordan had been engaged to a daughter of the Pullman family (for whom the railroad car was named), an engagement his parents did not approve. In an effort to break it up, they encouraged their son to go west, where he married an Oglala girl of Chief Red Cloud's band. The Sioux called him Ptecha (Short Charley). He was a licensed Indian trader on the Rosebud Reservation when Anderson moved to the Agency District and went to work for him in 1891.

PLATE 79. Colonel Charles P. Jordan, about 1889.

PLATE 80. Anderson's home, the Jordan Trading Post, and Jordan's home in Rose-
bud, 1893. From the Left: Anderson's home (the first one he built in
Rosebud), Jordan's warehouse, the Jordan Trading Post, and Jordan's
home. This is Jordan's second trading post. His first, which burned in
1892, is shown in the background in Plate 52. Jordan also maintained a
home at his ranch on Butte Creek (see Plate 85), the nucleus of which
was his wife's allotment.

118

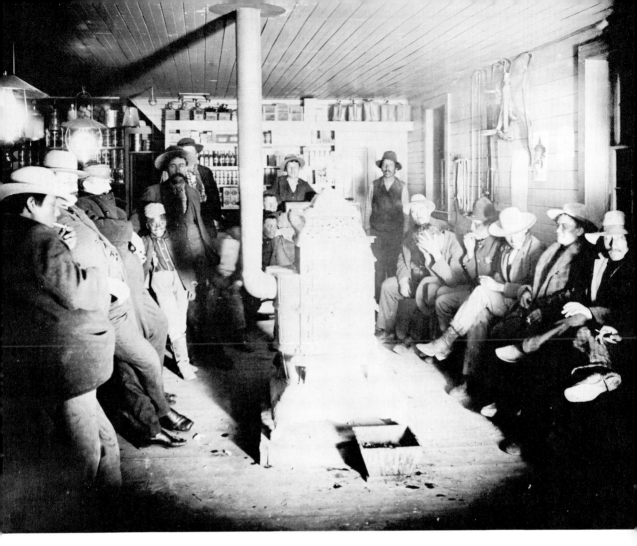

PLATE 81. The interior of the Jordan-Anderson store during a blizzard, about 1893. After the fire of 1892 had destroyed the original post, Anderson bought an interest in the company. The building shown here was later enlarged. The sign by the window warns: "Don't sit on floor or counter." Others advertise New Yucatan Gum and Arm and Hammer Soda.

A flare-sided wooden box partly filled with ashes sits on the floor to serve as a spittoon. The stovepipe, from the base-burner stove, goes straight up through the ceiling, where it is insulated from the surrounding wood with a perforated ring. No doubt the stovepipe runs to a drum that heats the room above. Coffee grinders, sprinkling cans, coal-oil lanterns, rope, boxes of goods, and canned and bottled foodstuffs are displayed for sale.

Left side, left to right: fourth from left, undersized Negro boy taken to Rosebud from Rapid City by race-horse breeder Tom Flood, who hoped to make a jockey of him; fifth from left, Tom Flood.

Right side, left to right: end, Louie Pratt; fourth from left, policeman; sixth from left, Reuben Quick Bear; seventh from left, Charlie Bordeau.

119

Indian allotments on the Rosebud Reservation, 1903 (from the Records of the Bureau of Indian Affairs, National Archives)

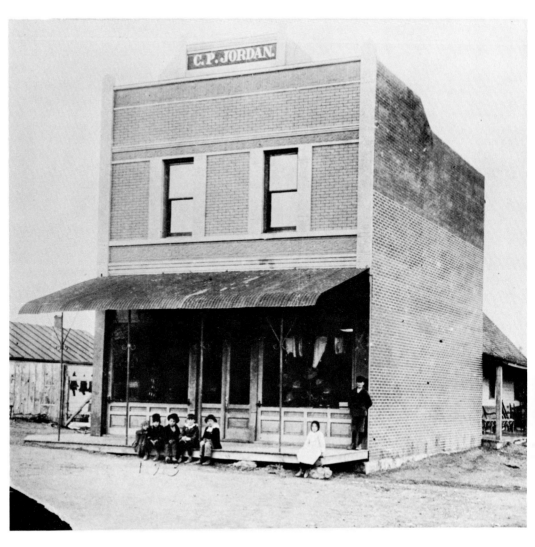

PLATE 82. The Jordan Trading Post, 1899 or 1900. By that time, besides Jordan
and Anderson, H. L. Hornby and T. C. Hornby owned interests in the
firm, now known as the Jordan Mercantile Company. The two-story
building is covered with sheet tin, pressed to resemble brick. It is at-
tached to the old frame store building at the rear. The first child from
the left seated on the porch is Roscoe Anderson, John Anderson's son.
Next to him are Collins Jordan and Everard Jordan, Charles P. Jordan's
sons. The others are unknown. Three stretched animal pelts are tacked
up to dry on the building on the left.

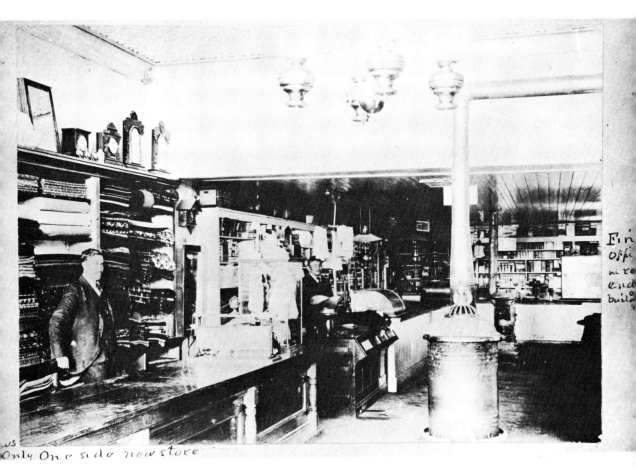

Only One side new store

PLATE 83. An interior view of the Jordan Mercantile Company, 1912. The clerk on the left, William Caton, became farmer-teacher to the Sioux under the Indian Service. Later he served as county judge at Spearfish, South Dakota. The clerk on the right, Reuben Quick Bear, later became county commissioner of Mellette County.

Notations on this print state that only one side of the new store is shown and that there is a fine office in the rear of the old building. The exterior of the store is shown in Plate 84. Minnie Star Boy Menard said that neither the interior nor the exterior had changed in 1927, when she bought clothing there to take with her away to school.

Two stoves heat the building, and the stovepipe from one goes up through the ceiling (which indicates why so many buildings burned in those days). A chandelier made of four large coal-oil lamps hangs from the ceiling and lights the front of the store. Three single lamps hang over the counter. The four mantle clocks on the shelf, the cuckoo clock on the wall, and the scales and horn phonograph on the counter help date articles bought by collectors today.

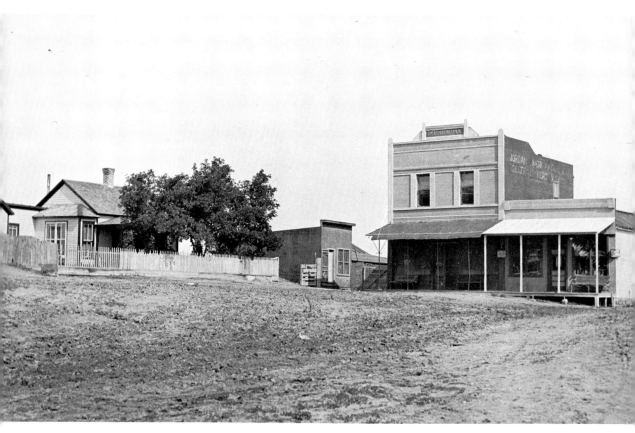

PLATE 84. The Anderson home (left) and the Jordan Mercantile Company, 1912 (photograph by Charles M. Eads, of Valentine). According to Mrs. Anderson, the picture was taken after the house was remodeled and a furnace installed. Eads took the picture while he was working for the Jordan Mercantile Company. Not only had the Anderson house been remodeled but the store had been much enlarged and improved.

PLATE 85. Orchard Ranch, Jordan's home, 1897. The ranch was established on Butte Creek, in what is now Mellette County, South Dakota, soon after the Allotment Act of 1887. The buildings were constructed on the allotment of Mrs. Jordan (Winyan-hcaka), an Oglala full blood. Her allotment adjoined the colonel's allotment, as well as those of other members of the family. Remington Schuyler said that there were only three fenced "mile pastures" in all that country in 1903 and that one of them was on Jordan's ranch. The other two were on the ranches of Bob Emery and John Neiss.

The one-story log section of the house was built immediately after the Jordans moved onto the land. Later the one-and-a-half-story frame section was built by S. H. Kimmel, who constructed many of the early government buildings on the Rosebud. This part was connected to the earlier log house, which was then faced with weatherboarding. There was an extension at the left rear (not visible from the angle of this photograph) which contained three rooms and a porch. In the heyday of the ranch the house had a living room, a library, an extremely large dining room, a kitchen, three bedrooms, and three porches.

In October, 1963, we visited the ranch. It had been almost exactly half a century since Colonel Jordan had lived there, and the log section was gone without a trace, said to have been taken down in 1926. The frame part, however, still stood plumb and firm, and not a window glass was broken, testimony to the absence of vandalism on the Rosebud.

In this photograph Colonel Jordan is sitting on the edge of the porch, holding one of his sons, John David. Another son is standing on the porch. Charlie Davis, "a Welshman and hired hand," sits in the buggy. Jordan called the place Orchard Ranch because he set out a large orchard, including berry bushes, the first fruit planted on the reservation.

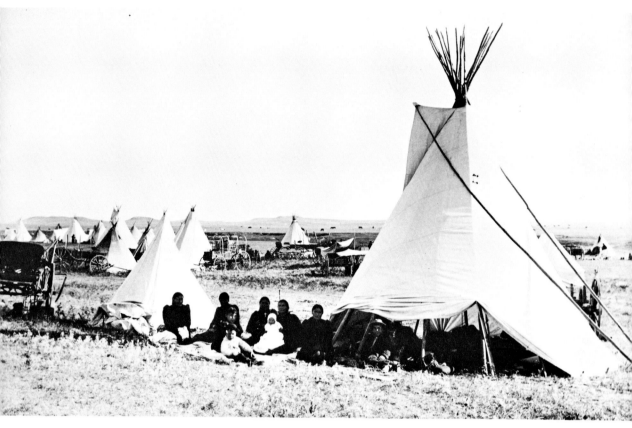

PLATE 86. The Jordan family camp at an Episcopal convocation, 1898. Mrs. Jordan is holding Ella. The boy in white is Everard. The Annual Convocation of the Niobrara Diocese was held on Antelope Creek near present-day Mission, South Dakota.

The longest trip ever made by the Jordan family was to a convocation on Bear Creek, near the Standing Rock Reservation. They took two teams and conveyances and made the trip in three days. On the way the baggage-wagon team, which was not shod, went lame from the gravel along part of the old wagon trail.

Many Rosebud people made the trip, all traveling together. During a noon stop, before they reached the convocation site, a man came by on horseback, and the group offered to buy a steer from him from a number grazing on the range nearby. The price he asked was fifteen dollars, and the amount was collected among the group. The steer was shot and butchered on the spot, and the group went on to the meeting. William Jordan said he later wondered whether the man on the horse had really owned the steer or had, in effect, rustled it.

The convocation lasted a number of days, and the people liked the site because Bear Creek had plenty of water for both people and horses. "I saw over 1,000 tipis in circle at Convocation Camp," L. M. Hardin reported during this period.

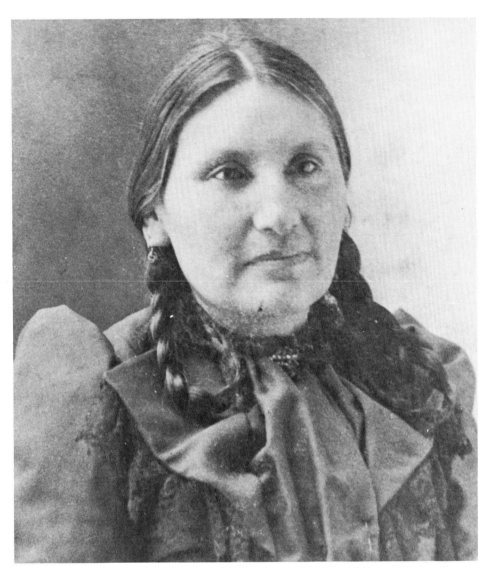

PLATE 87. Mrs. Charles P. Jordan (Winyan-hcaka, the True Woman, Julia),
Oglala full blood, 1900. Mrs. Jordan did exceptionally skillful quill- and
beadwork in the old way. She made many articles for use around the
home and among the family. It was she who made the beautiful cere-
monial clothing displayed and worn in the Indian shows her husband
took to expositions in Chicago, Atlanta, San Francisco, and Cincinnati.
She also made some of the articles owned by John Anderson.

"The first allottment on the Rosebud Reservation, #1, was to Julia
Jordan, wife of Col. C. P. Jordan," reported the *Rosebud Review* in
1913. She had selected the land immediately after the Allotment Act of
1887. It was formally allotted in 1890.

127

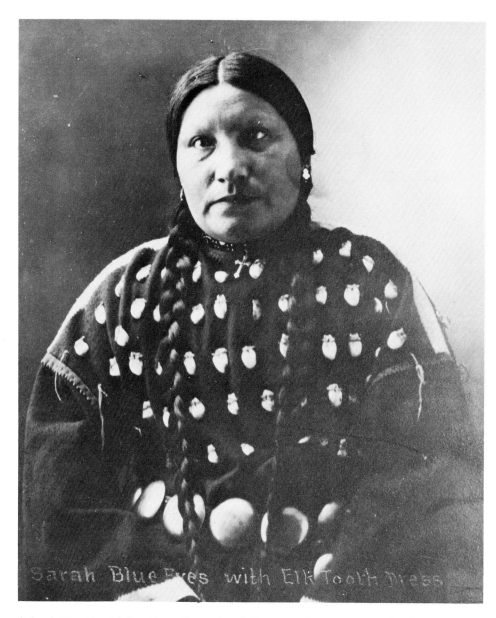

Sarah Blue Eyes with Elk Tooth Dress

PLATE 88. Sarah Blue Eyes, Butte Creek District, about 1900. Sarah Blue Eyes was Mrs. Charles P. Jordan's sister. Blue Eyes wears a handsome elk-tooth dress, a Niobrara cross, and a heavy conch belt. The Niobrara cross, one of the first crosses designed for the Sioux after they became Christians, was devised in 1880 by Episcopal Bishop W. H. Hare, who realized that a confirmation certificate would mean nothing to the Indians. On the cross are four tipis, each surmounted by a cross.

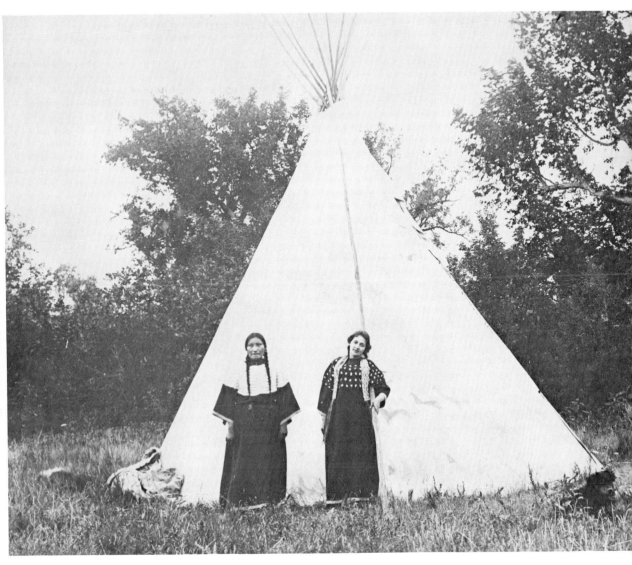

PLATE 89. Sarah Blue Eyes (left) and Mrs. John A. Anderson. The Indian consultants said that Mrs. Anderson and Sarah Blue Eyes were very close friends.

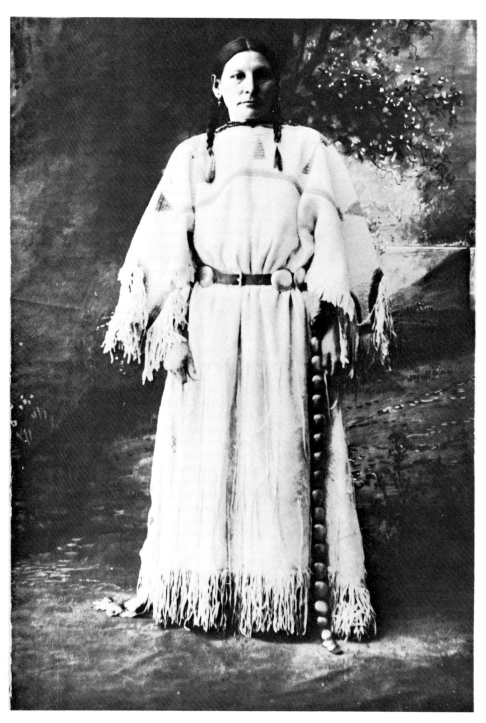

PLATE 90. Good Woman, a half sister of Mrs. Charles P. Jordan and the wife of White Mane Horse. She wears a magnificent buckskin dress with deep beaded yoke and a heavy conch belt of German silver with a conch pendant that reaches the ground. The belt is made of commercial leather studded with silver conches. Such belts are called *mazaska-ipiyoka*, money belts, or white metal belts.

130

PLATE 91. Charles P. Jordan a few years before his death in 1924.

9

Buffalo Bill Cody's
and
Charles P. Jordan's Show Indians

COLONEL Charles P. Jordan recruited Indians on the Rosebud Reservation for Buffalo Bill Cody's "Wild West Show." Mrs. Anderson wrote that John was asked to help with this job and described a scene before the departure of the recruits for a show:

"They all gathered in front of the store and strapped up their baggage before leaving for the train at Valentine. The women all had many dresses on, one slipped over the other, and sometimes as many as six. When one dress got soiled all they did was slip it off and lo, a clean dress."

A show went to Williamsport while John was visiting there, and he arrived at the show grounds about the time the afternoon program was over. As the spectators were leaving the grounds, they were astonished to see him among the "savages," conversing with them and obviously having a joyful reunion. The curious crowd, delighted, gathered around as though it were part of the show.

By 1895, Jordan was taking his own Indian shows on the road.

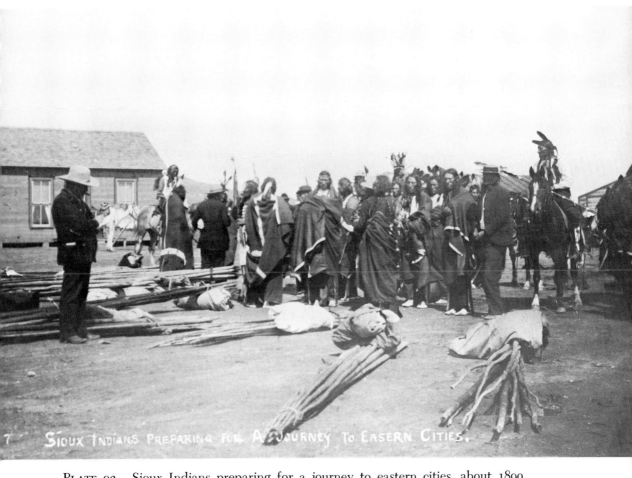

SIOUX INDIANS PREPARING FOR A JOURNEY TO EASERN CITIES.

PLATE 92. Sioux Indians preparing for a journey to eastern cities, about 1890.
These are thought to be the Rosebud Sioux recruited by Charles P.
Jordan for Buffalo Bill Cody with whom Anderson later visited on the
show grounds in Williamsport, Pennsylvania. The Anderson home is on
the left. Valentine McKenzie, the interpreter, is fourth from the left with
his back to the camera. The individual at the far left, foreground, writing
on a sheet of paper, is unknown. He is perhaps Cody's representative.
Part of the outline of Soldier's Hill is visible in the background.

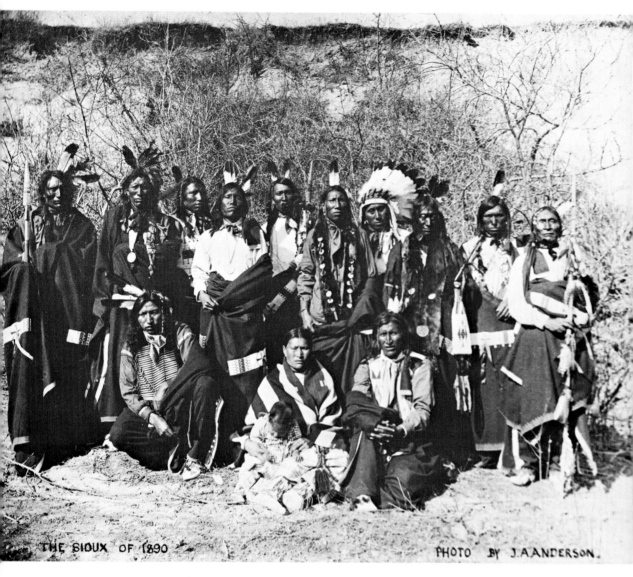

THE SIOUX OF 1890 PHOTO BY J. A. ANDERSON.

PLATE 93. The Rosebud Sioux who went with Buffalo Bill Cody's show in 1890. Standing: far left, One Star; second from left, Keeps the Mountain (Anderson's home in Atascadero, California, was called Keeps the Mountain for this man); fourth from left, William Spotted Tail; sixth from left, Aaron White Thunder; fourth from right, Sees Red; second from right, Afraid of Eagle; far right, Big Head. Seated: left, Eagle Bird; center, Pizzola's wife and baby; right, Pizzola. Pizzola was a member of the Spring Creek District near Saint Francis Mission. He and his family went with Colonel Charles P. Jordan to the Cotton States and International Exposition in Atlanta, Georgia, in 1895.

136

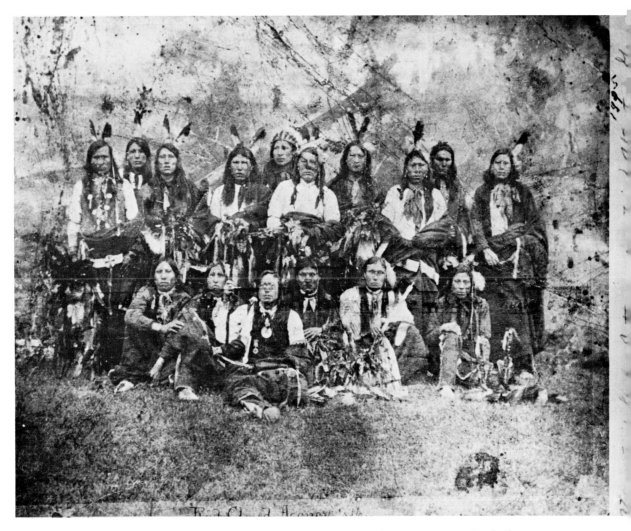

PLATE 94. Jordan's Oglala and Brulé show Indians, 1895. A notation in Jordan's handwriting on the margin of the print reads "C. P. Jordan's Show Indians Atlantic States Cotton exposition, Atlanta, Georgia." At the exposition Jordan held the concession for the elaborate American Indian Village. He took the same show to San Francisco the following year.

137

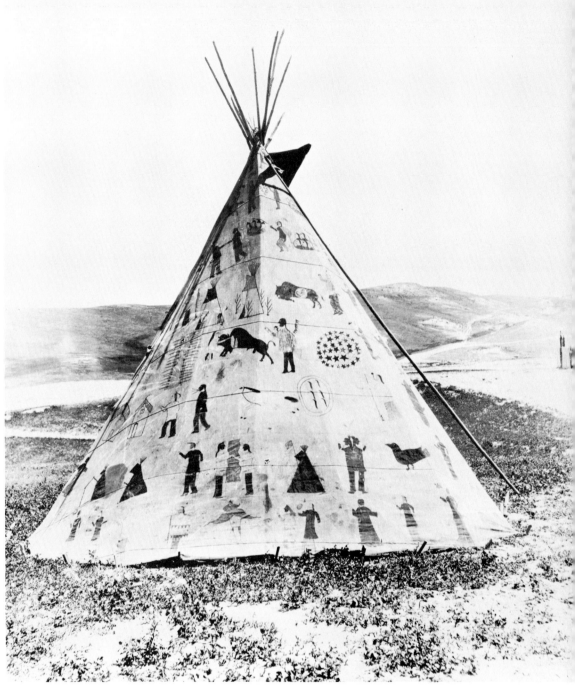

PLATE 95. A ceremonial lodge showing events in Sioux history, 1895. This tipi was used by Jordan in his show business. A tipi like this one stood just behind the Jordan Trading Post in 1892 and was used to house many trunks containing a collection of fine Indian quill- and beadwork. The tipi had just been packed for shipment to the World's Columbian Exposition in Chicago (to be held in 1893) when the store, the tipi, and the entire collection were destroyed by fire. The picture was taken in the town of Rosebud and shows, in the right background, the old freight road to Valentine.

138

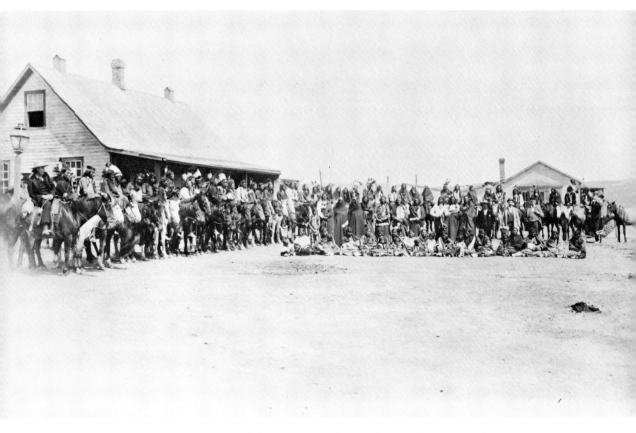

PLATE 96. Rosebud Sioux selected by Charles P. Jordan for the Zoological Garden
Exposition, Cincinnati, Ohio, 1897. The ninety-one Indians and fifty
ponies and camp equipment traveled by rail. That was the only show to
which Jordan took horses. The first man on the left is Vallie McKenzie,
interpreter. A coal-oil yard lamp stands directly behind McKenzie. In
the left background is the Jordan store; on the right, the Jordan dwell-
ing. The group is identified by a notation in Jordan's handwriting on
the margin of a duplicate print. The Anderson home stood just out of
camera range on the left. Jordan is standing toward the right end of the
line, below and slightly left of the chimney in the background. He is
wearing a dark suit and white shirt. Dr. Hardin, in his diary, stated
that "ceremonies were held in connection with the departure" of this
group. (No. 498 in Anderson's numbering.)

Location of Schools on the Rosebud Indian Res.

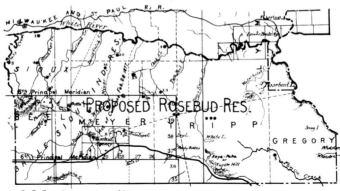

- Schools now exiting.
- Proposed new day schools.
- ••• Inspector Junkin's proposed site for Govt. Schl. & Agency on Mud Creek.
- •• Site proposed for Govt. Schl. & Agency on Cottonwood Cr.

• Schools now existing

- •1 St. Mary's Epis. Missn. Bg. Schl. Antelope Cr.
- •2 St. Francis R.C.
- •3 Pass Creek Day School
- •4 Corn Creek. ʺ ʺ
- •5 Black Pipe Creek ʺ ʺ
- •6 Red Leaf Camp ʺ ʺ
- •7 Upper Cut Meat ʺ ʺ
- •8 Lower ʺ ʺ
- •9 Agency ʺ ʺ
- •10 Little White River ʺ ʺ
- •11 Pine Creek ʺ ʺ
- •12 Ring Thunder's Camp ʺ ʺ
- •13 Big Oak Creek ʺ ʺ
- •14 Little Oak Creek ʺ ʺ
- •15 White Thunder ʺ ʺ

• Proposed new Day Schools.

- •1. On White River at White Elks Camp.
- •2. Hollow Horn Bear Camp
- •3. On Ponca Creek Swift Bears Camp.
- •4. On White River, near Mouth of Oak Creek.

Proposed new site for Boarding School.

••• Inspt Jenkins site on Mud Creek
55. Miles from Agency
35. ʺ ʺ Rose Bud Landing Mo. River.
40. ʺ ʺ Ainsworth (Elkhorn & Mo.R.R.
50. ʺ ʺ Surrey for C.M.& St. Paul R.R. north of White River.

•• Site now proposed head of Cottonwood Cr.
30-35 Miles from Agency
50 ʺ to Rose Bud Landing Mo. River.
50 ʺ ʺ Ainsworth or Long Pine.
50 ʺ · C.M.& St.P. R.R. north of White River.

The original 1877 Rosebud Reservation Survey, upon which the existing and proposed day schools, as of 1895, have been placed (from the Records of the Bureau of Indian Affairs, National Archives)

10

Day Schools

By the year 1893 six day schools and teachers' residences had been built on the Rosebud Reservation, and in that year six more were constructed, making a total of twelve. By 1895 the number of day schools had increased to twenty-one: Rosebud (or Agency), Spring Creek, Ironwood Creek, Upper Cut Meat, Cut Meat, Lower Cut Meat, He Dog's Camp, Red Leaf, Black Pipe, Corn Creek, Little White River, Pine Creek, Upper Pine Creek, Ring Thunder's Camp, Butte Creek, Oak Creek, White Thunder, Little Crow's Camp, Ponca Creek, Whirlwind Soldier, and Milk's Camp.

In addition there were two mission boarding schools: Saint Francis (Roman Catholic), about seven miles south of the agency, founded in 1885; and Saint Mary's (Episcopal), now the Bishop Hare School, known as the Mission, just southwest of the present town of Mission.

In September, 1897, the new government boarding school was opened. Its eleven brick buildings had steam heat and were lighted by electricity. It had ample water from the creek from a force pump with direct pressure. By that time the institution had a windmill, which was probably the source of power for the pump. Unbelievable as it may seem, by 1903 the boarding school had an electric pump and was installing two automatic stokers.

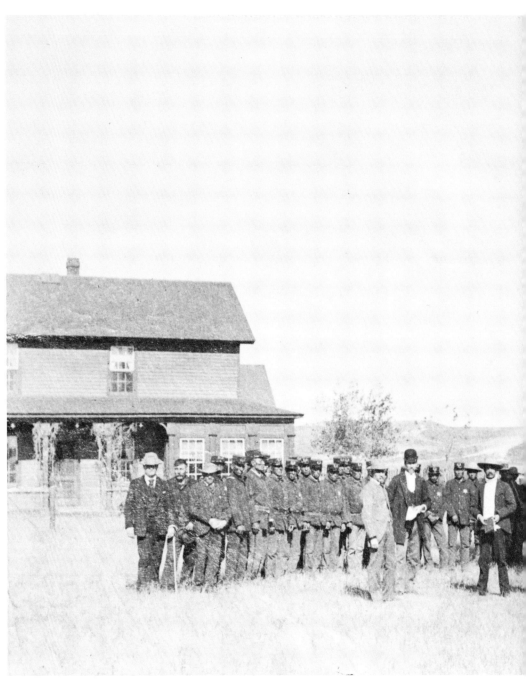

PLATE 97. A flag-raising ceremony at Rosebud. The building on the right is the
Rosebud day school. This is an early picture. None of the consultants
were able to identify the rather distinctive building to the left, and they
were able to identify only one person in the picture. The second man
on the left, without a hat, is Louis Roubideaux, the interpreter. The
white man with the beard on the far right may be Dr. J. Thomas S.
Williamson, beloved physician and teacher of the Sioux.

 The ceremony evidently included more than a flag raising; two of
the men near the flagpole are holding papers, and a third is holding a

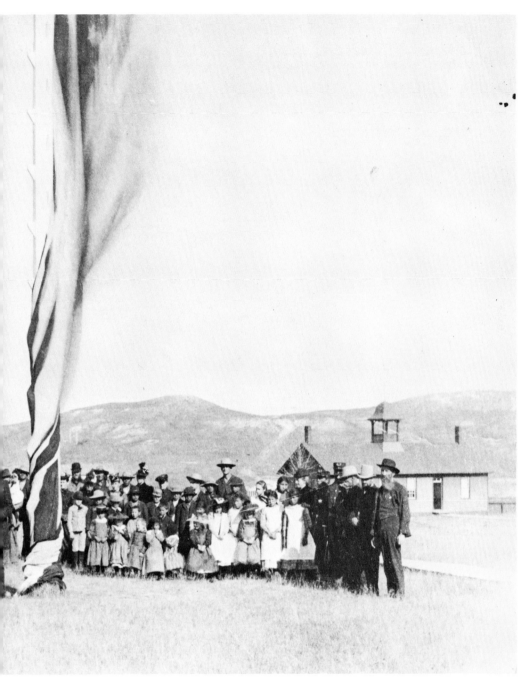

book. It may have been the dedication of a new flag and flagpole for the agency. The Indian police are in line at the left; the school children, at the right. There are at least ten formally dressed white men, probably agency officials, and five white women in the group.

The folds of an extremely large flag, not yet raised, billow in the wind. The large flagpole looks new. The triangular wooden steps up the flagpole are reminiscent of those on early-day telephone poles.

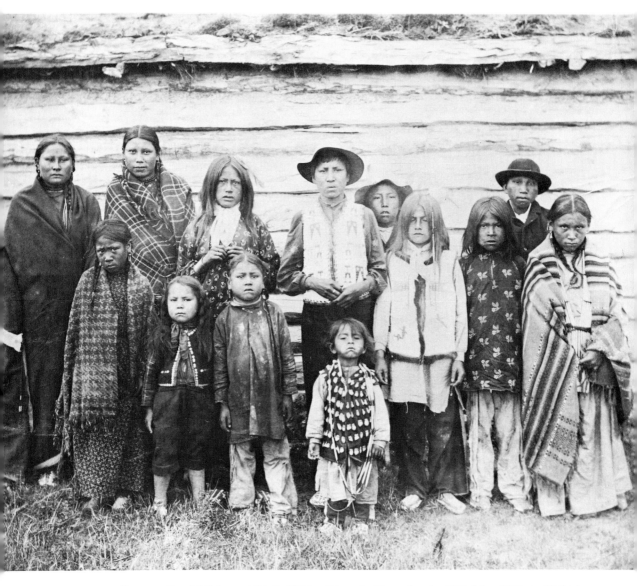

PLATE 98. Children at Little White River Indian school, 1888. Mrs. Kills in Sight is
at left. Two of the children are light-haired. The tall boy with hat and
white vest is Joe White Buffalo. In the front row the second child from
the left is Robert Brave Bird. His mother was Zoe McKenzie, daughter
of Valentine McKenzie. (No. 274 in Anderson's numbering.)

PLATE 99. Butte Creek day school, about 1890. At one time this school was taught by Mr. and Mrs. Paddock, the parents of Arch Paddock, who was a friend and fellow cowpuncher of Remington Schuyler's on the E Bar Ranch in 1904.

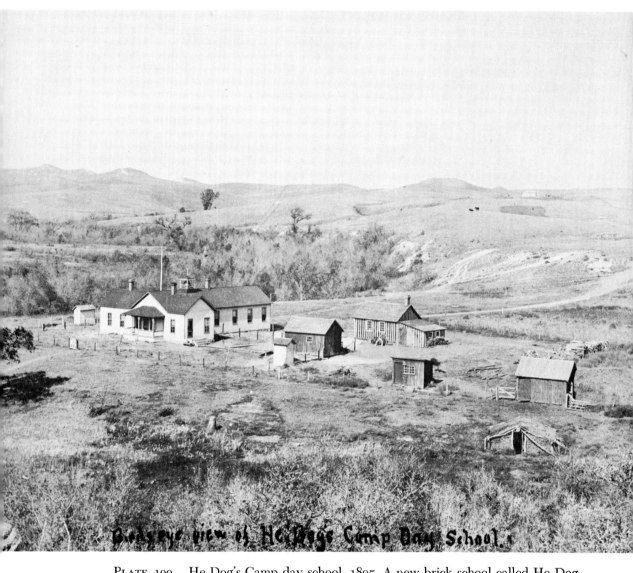

Bird'seye view of He Dog's Camp Day School.

PLATE 100. He Dog's Camp day school, 1895. A new brick school called He Dog
School stands here today, eight miles west of old Cut Meat, now called
Parmalee. It is typical of the day schools built by the Department of
the Interior for the Indians during the 1940's.

146

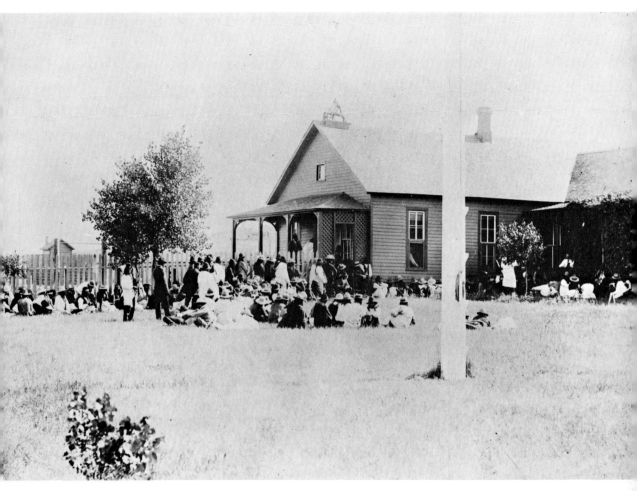

PLATE 101. The last day of school at Red Leaf day school, about 1912. The Red Leaf school was situated on Black Pipe Creek, near the border of the Pine Ridge Reservation. Henry Miller, the father of Mrs. John Anderson, taught here about 1912. His wife was the housekeeper. They lived in the teacher's quarters at right.

According to Jake Metzger, former inspector of day schools on the reservation, it was customary for the schoolteacher's wife to serve as the housekeeper. Formal school was held in the morning. In the afternoon the housekeeper taught the girls to clean, cook, and sew. The girls made most of the clothing for the children. The teacher taught the boys carpentry, blacksmithing, gardening, and dairying. He received sixty dollars a month and living quarters, and his wife received thirty dollars a month.

11

Ceremonies

THE White Buffalo Ceremony, or Dance, was held in honor of the girls of the tribe on reaching puberty. Since the important part of the rite involved a ceremonial meal, it was also often called the White Buffalo Feast.

The Sun Dance Ceremony was outlawed in its old form by the government after 1883 because it involved self-torture. This ban was still in effect in 1910, when Remington Schuyler was commissioned by Rodman Wannamaker to paint pictures of the Sun Dance on the Rosebud Reservation. "The government prohibited thongs through the flesh," Schuyler wrote, "because it was feared that this would arouse old feelings and make [the Indians] savage again."

On September 13, 1928, however, the *Todd County Tribune* reported: "A special permit from Washington has been given the Rosebud Indians to allow them to again perform the forbidden Sun Dance, a rite which for many years has been abandoned. The Department of Interior has granted special privilege to the Indians for their 50th anniversary celebration which will be held at the Agency September 18–21. They will be allowed to perform the Sun Dance and other features forbidden since the Reservation was established 50 years ago. Some of the older Indians show their scarred breasts and offer to go through the gruesome details again. Some even hint that it has been done in secret since the government prohibition of it began."

The Sun Dance in its old form was performed at Pine Ridge in 1961 and again in 1965 and 1966.

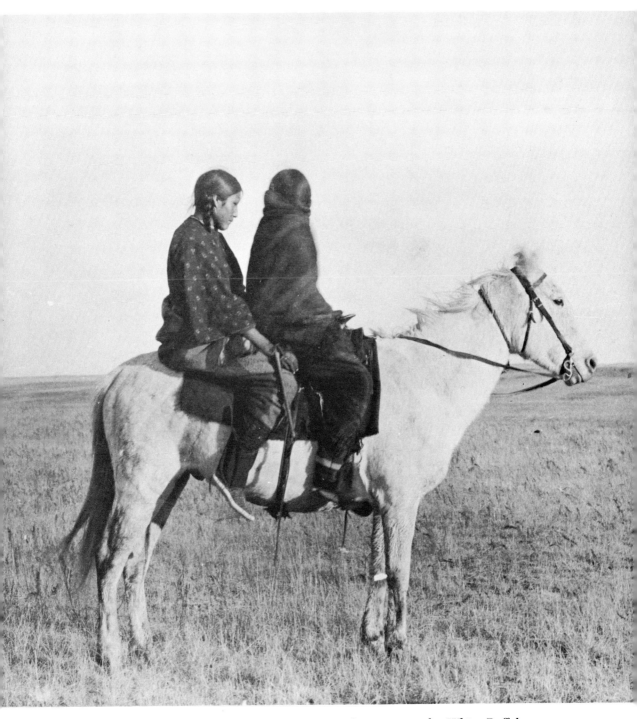

PLATE 102. Daughters of Hollow Horn Bear on their way to the White Buffalo
Ceremony, 1892 (copyright 1893). The ceremony is to be held in
their honor.

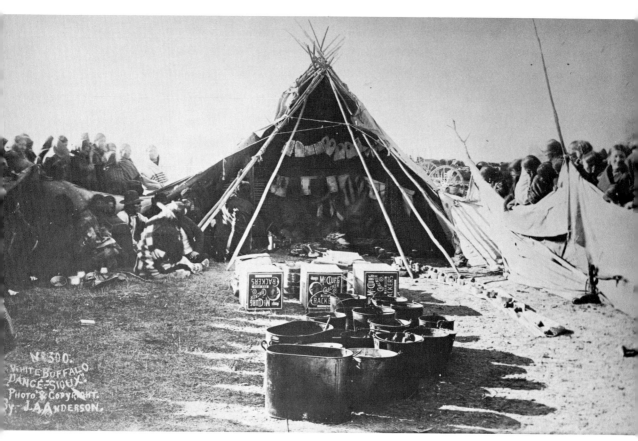

PLATE 103. The White Buffalo Ceremony, 1892 (copyright 1893). On the mount-
ing of this photograph is printed "Views of the North West, by J. A.
Anderson, Valentine, Nebraska."

Six or more people are seated around the fire at the back of the
tipi. These persons are presumably the main participants in the cere-
mony. The coverings of the front half of the tipi have been removed.
Inside the tipi hang rows of quilled moccasin tops made by the initiates
during their isolation. In front of the tipi are the materials for the feast
soon to come: three wooden boxes labeled "McClurg Cracker Co.,
XXX Soda Crackers," three parfleche bags, and sixteen large kettles
and tin wash boilers. There are pans and cups in front of the people
seated on the ground at the left of the picture, and more eating utensils
are laid out on a strip of light material stretched flat on the ground and
extending from inside the tipi out to the right of the picture. Outside
the stretched-canvas enclosure spectators watch the proceedings. (No.
300 in Anderson's numbering.)

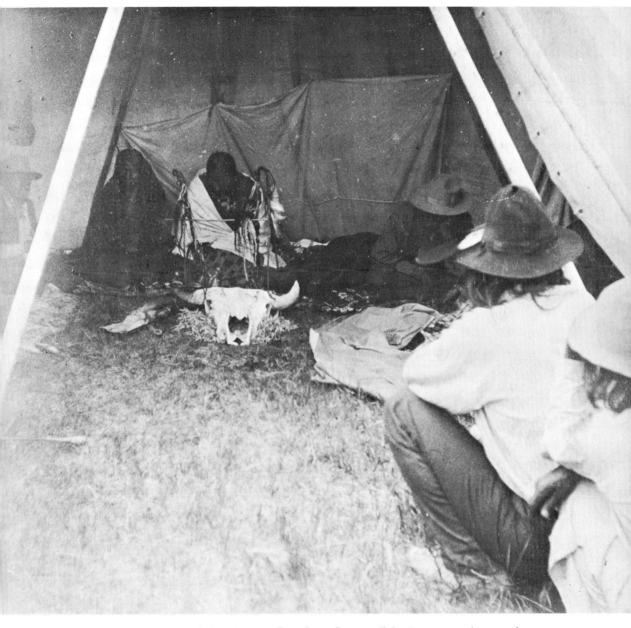

PLATE 104. Close-up of the altar used in the White Buffalo Ceremony (copyright 1893).

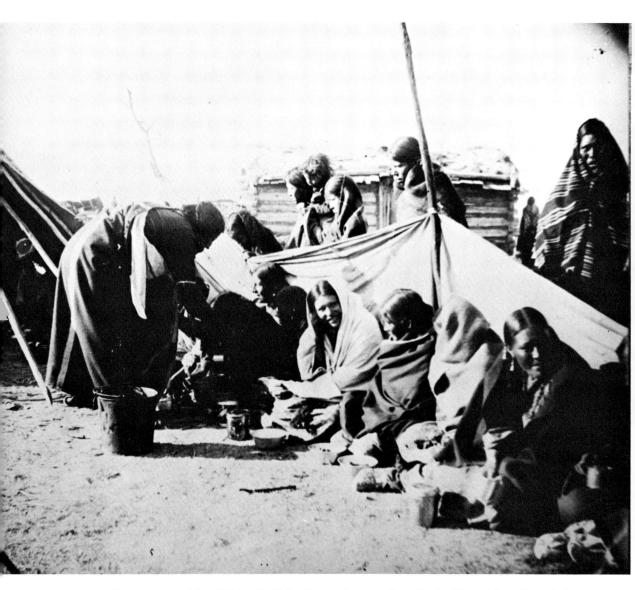

PLATE 105. The White Buffalo Feast (copyright 1893). The right side of the enclosure is now occupied, and a woman is serving the young women pots of meat with crackers. The dessert is *wojapi*, a pudding of dried fruit and mush. If the Indians did not have chokecherries or buffalo berries, they used prunes or raisins. (No. 302 in Anderson's numbering.)

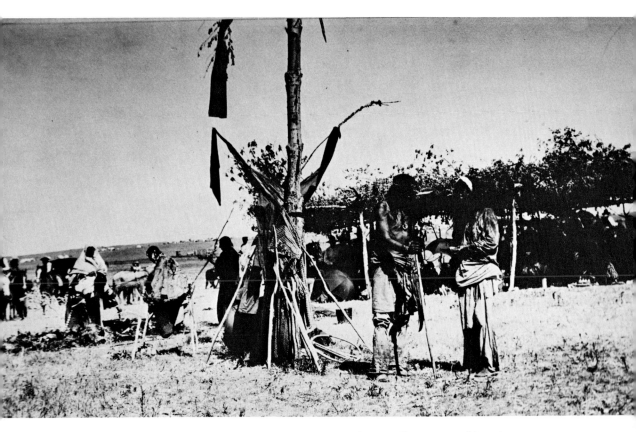

PLATE 106. Sun Dance preparation, 1910. Two men bring offerings to add to those at the pole. Food is being cooked in a skin or paunch suspended from four poles. Several people are busy at the left; others sit under the brush shelter at the right. "There was a Sun Dance at Black Pipe Creek on June 17, 1878 and also June 21, 1879," Dr. Hardin wrote.

PLATE 107. Sun Dance, 1910 (copyright 1911). The dancer on the left, Follows the Woman, is the principal. Note that the five main participants have ropes around their chests instead of thongs through the flesh of their chests. Several men and women in the group in the background are wearing sage crowns.

In 1928 special dispensation was granted to the Rosebud Sioux to perform the dance in the old way. In 1961 the Sun Dance was held at Pine Ridge, and the one participant—Bill Schweigman, a mixed blood —went through the rites with thongs through the flesh. In 1965, Schweigman and four others—Two Eagle Elks, Stands, Peter Catches, and Hogan Red Cloud—went through the rites at Pine Ridge. William W. Jordan described the ceremony, as he witnessed it in 1966, in a letter to the authors:

"The Oglala Sioux had their annual Sun Dance at Pine Ridge on August 5, 1966. I was there and watched every move the performers made, which was by the guidance of a full-blood Oglala who acted as master of ceremonies. There were thirteen participants, including a white-man. Billy Schweigman, a member of the Rosebud Sioux, was a key figure because of his Sun Dancing the past thirteen years but declared publicly that he was retiring. His grandfather was a real German. Schweigman lives in California and the white-man that took part in the dancing came with him. The white-man calls himself "Red Cloud," he was a good sport and did everything the others did. Some of the other participants were Pete Catch It, Good Weasle, Jack Bear Shield, Two Bulls, Red Boy, Eagle Elk and his son, Eagle Elk, Jr.

"When the master of ceremonies had each of them, one at a time, get down flat on their backs near the holy pole he would pierce their skin with a hard, sharp, wooden prober. With this he would stick through the skin about ¼ inch across and then tie the anchored pin with a cord, which was already tied high up on the nearby pole. Whenever one gets up he would take his position from the pole as far as the tied cord allows.

"When all of the performers have taken similar positions around the pole the signal to dance is given and each dancer starts blowing on a turkey quill whistle, which seems to give them courage or impetus to live up to the performance. The idea is to pull steadily on the fastened cord until the anchored prong is torn out of their skins. The whiteman was among the first ones to break loose, and you should have seen his facial expression as he faced the onlookers, as though to say, 'Well I did it.'"

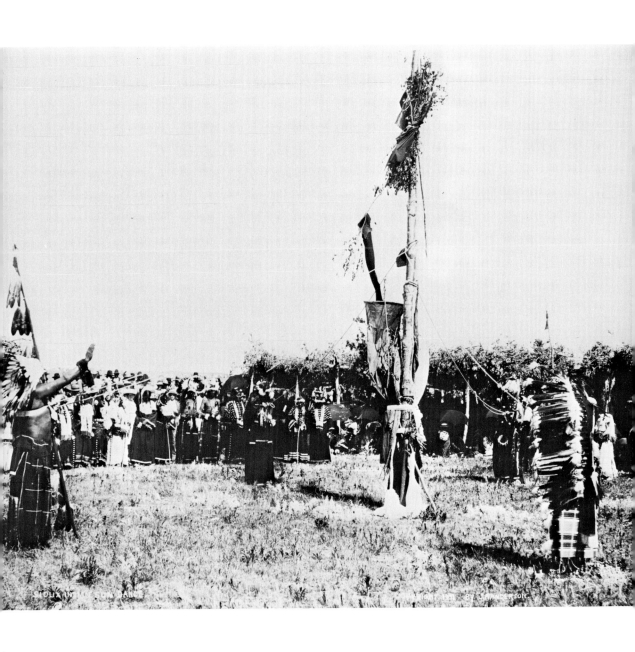

12

Dances

The Sioux danced to celebrate accomplishments as well as to entreat or appease the gods. In the olden days the scalps taken in a successful raid were featured in a dance held after the event. Each participant danced as he pleased, dramatizing in his own way what he had done or would do—track, stalk, or attack the enemy. The dance was also performed for fun, at which time it was called the War Dance.

In the Omaha Dance, or Grass Dance, a bunch of grass representing the scalps taken was sometimes fastened to the belt. When the Sioux learned this dance from the Omahas, they were unaware of the significance of the bunch of grass and called it the Grass Dance rather than Scalp Dance.

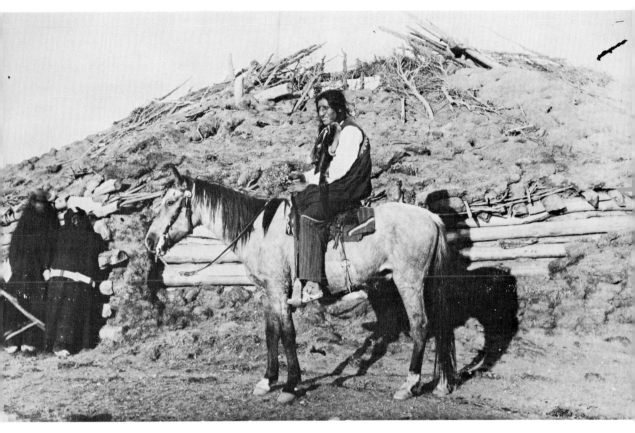

PLATE 108. The Black Pipe dance house, about 1890. This dance house was still
standing in 1962. The earlier dance houses were of logs covered with
dirt, then of logs alone, and finally of lumber. The man on the horse is
Pizzola.

PLATE 109. White Eagle dance house on White Thunder Creek. Each district of the reservation had a dance house, which was also used as a council house.

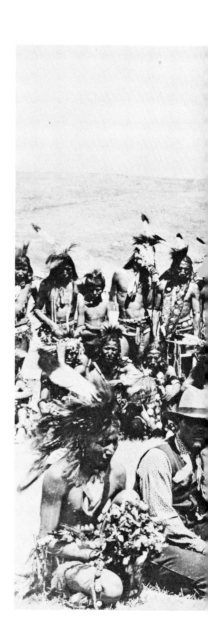

PLATE 110. A Sioux gathering, 1889. This picture was taken at the Rosebud Agency, facing east. The hill in the background is on the far side of Rosebud Creek. Several of the dancers carry Sun Dance scars on their chests. The girl fourth from left in the foreground resembles the girl in Plate 25.

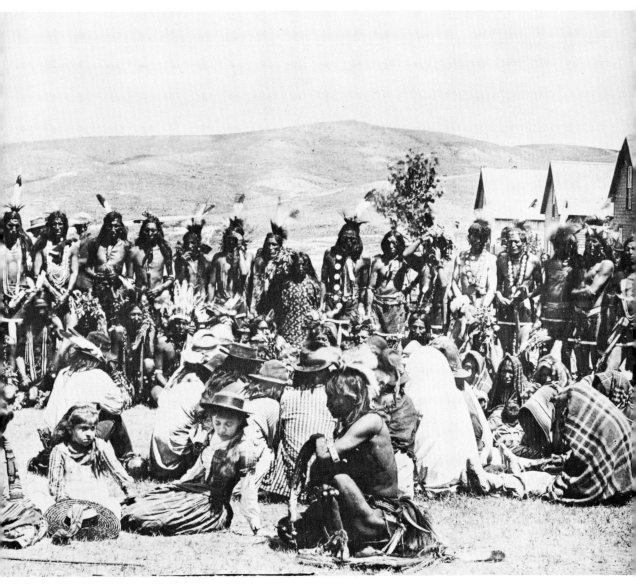

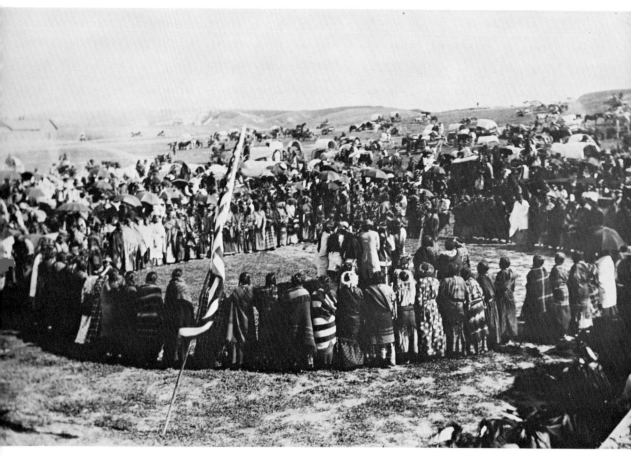

PLATE 111. Squaw Dance at Rosebud, 1889. Anderson reported in his diary that he
photographed the Squaw Dance at White Thunder's Camp on the
morning of June 2, 1889, while he was on a visit to the agency from his
Fort Niobrara "gallery." The two-story house in the distant background
on the left is the one the government built for Spotted Tail when he
was made chief.

164

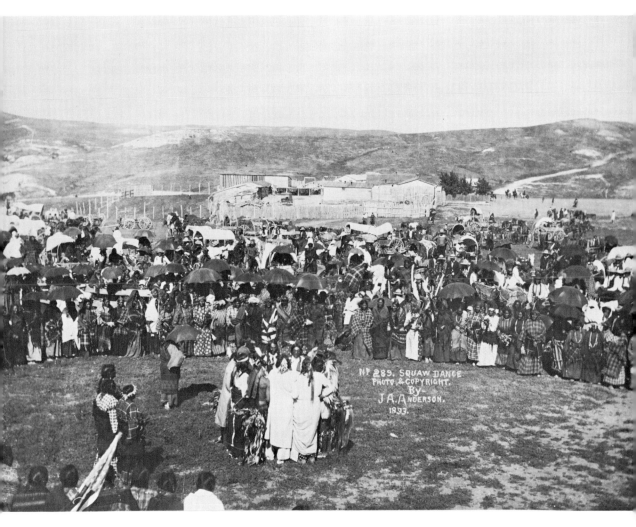

PLATE 112. Squaw Dance, June 2, 1889 (copyright 1893). Another scene of the Squaw Dance at White Thunder's Camp at the agency. Many of the dancers wear sage crowns. Note that umbrellas are very popular among the women. (No. 289 in Anderson's numbering.)

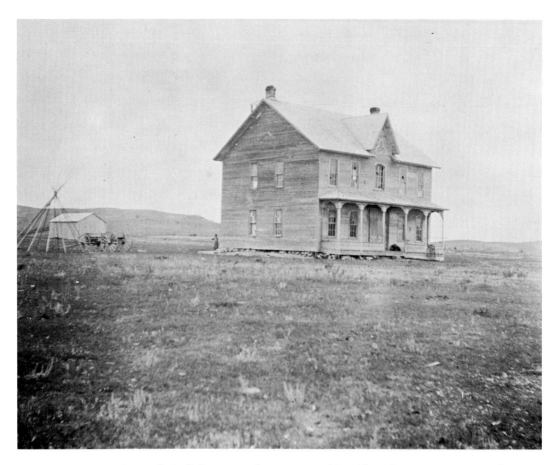

PLATE 113. Spotted Tail's house at the agency, 1889. After the government made
Spotted Tail chief, they employed S. H. Kimmel to build him this
house at a cost of eight thousand dollars.

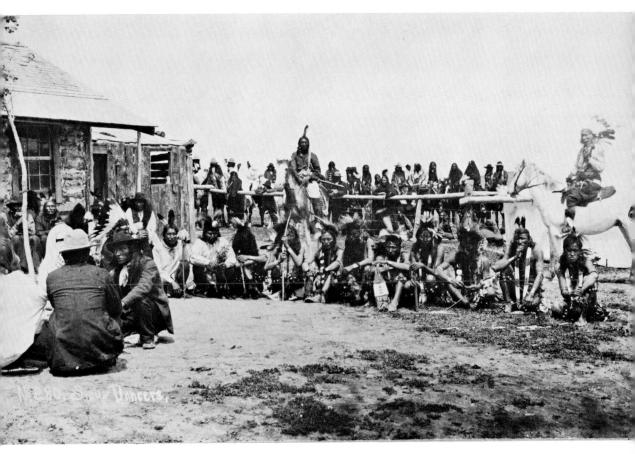

PLATE 114. Preparing for the Omaha Dance, or Grass Dance, June 2, 1889. After photographing the Squaw Dance in the morning, Anderson took a series of pictures of the men of Two Strike's band performing the Omaha Dance in the afternoon. That day's entry in his diary concluded, "Made 8 negatives all together."

The dancers are waiting beside the fence, and the drummers are in a circle at the left. The man seated on the white horse is wearing a war bonnet. (No. 280 in Anderson's numbering.)

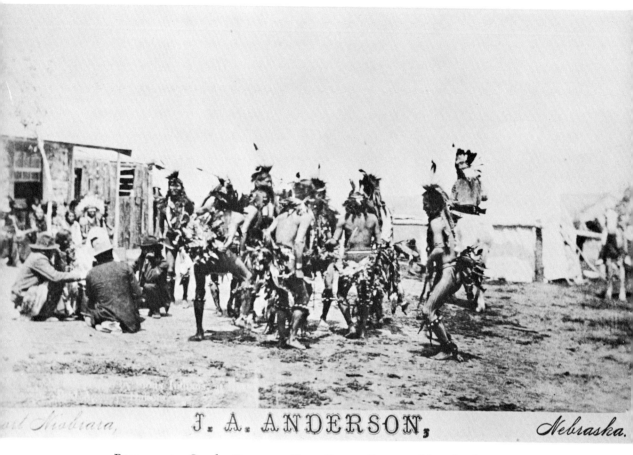

PLATE 115. Omaha Dance, or Grass Dance, June 2, 1889. The dancers are now in motion, and the spectator on the white horse has turned away. The dancers wear only breechcloths and bustles. (No. 6 in Anderson's numbering.)

PLATE 116. Omaha Dance, the start (copyright 1893). The flag has forty-four stars.

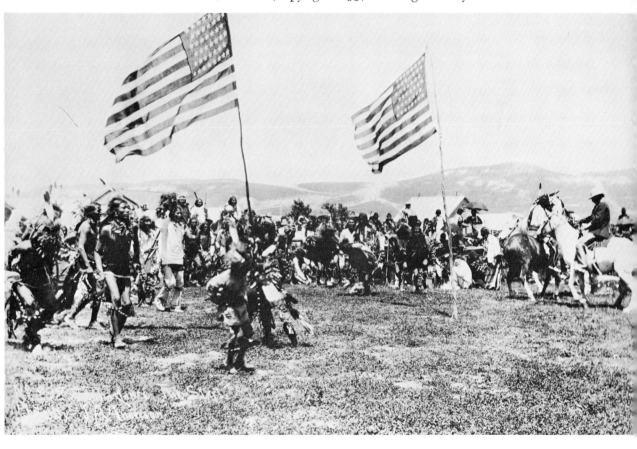

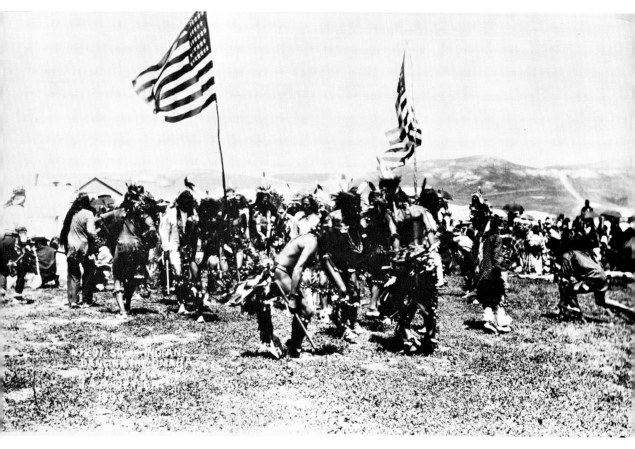

PLATE 117. Omaha Dance (copyright 1893). (No. 291 in Anderson's numbering.)

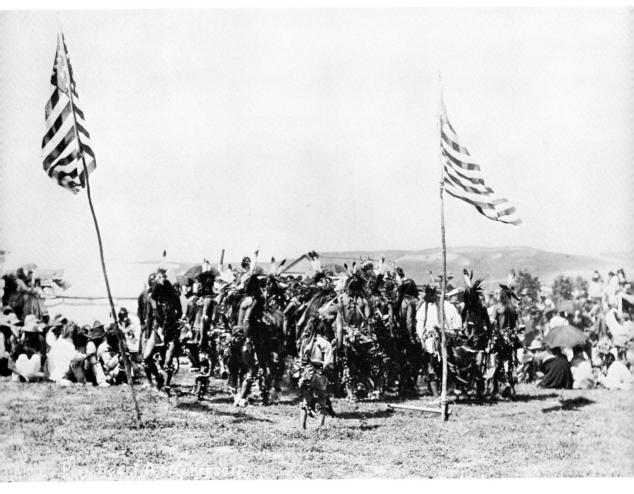

PLATE 118. Omaha Dance (copyright 1893).

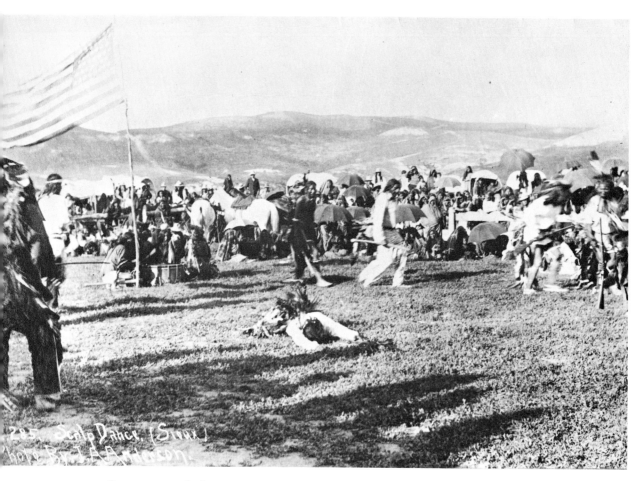

PLATE 119. Scalp Dance, or War Dance, (copyright 1893). This photograph and
Plate 120 are two views of the same event. This one was labeled "Scalp
Dance" by Anderson. (No. 285 in Anderson's numbering.)

172

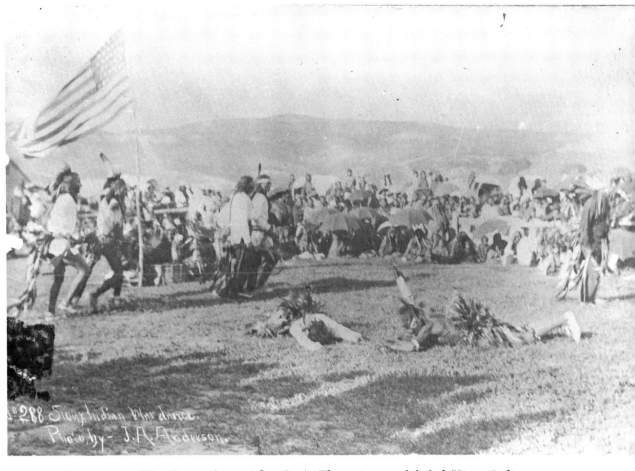

PLATE 120. War Dance (copyright 1893). The print was labeled "Sioux Indian War Dance" by Anderson. (No. 288 in Anderson's numbering.)

13

The Annual Fall Celebrations
or Fairs

THE annual fairs were held in the fall, and each district had its own fair. The nine districts of the reservation were Black Pipe, Cut Meat, Spring Creek, Agency (or Rosebud), Butte Creek, Little White River, Big White River, Ponca, and Keya Paha. Only Indians were allowed to participate. The various dances were held, and other activities were horse racing, bronc riding, steer riding and roping, and classes for the exhibition of garden products and livestock.

In that day, and for more than half a century thereafter, there were no saddling chutes or fenced rodeo areas—certainly no bleachers or grandstands. A horse was simply roped down, a surcingle was put on him, and the rider mounted. The ropes were then released, and the horse was turned loose on the prairie. In the Sioux country the young men frequently spent lively Sunday afternoons riding broncs.

By 1958, instead of rounding up a wild bunch from the Standing Rock Range, the riders rented a regular professional string from a man who supplied proved buckers to the rodeos. The horse in the 1958 string with the top bucking record was Old Fitzgerald, foaled and reared on the Standing Rock Reservation. It is said that the Old Fitzgerald Distillery gave the owner a case of their product when the horse was named. Old Fitzgerald lived up to his reputation that day. He was back home, among friends, and the center of attention. Every young Indian rider hoped to get him in the draw.

During the early years of the fair, Anderson had a stand on the grounds, where he sold such articles as ice cream, candy, gum, cookies, fireworks, and tobacco. The fairs were a natural outgrowth of the annual fall gatherings of the Sioux of earlier days, and in varying forms they remain a regular and valued part of the culture and activity of the reservation.

Remington Schuyler said that Chief Hollow Horn Bear felt it necessary for survival that the Indian people adapt to the white man's ways. He tried to set an example by regularly exhibiting vegetables and horses at the Cut Meat and Agency fairs. William W. Jordan said that his uncle Stands and Looks Back in his later years liked to grow vegetables and show them at the fair and that he sometimes won prizes for them.

Some of Anderson's photographs show fair activities in the earlier years, but the specific times and places were difficult to ascertain. In close-up scenes with little background there is almost no way to determine whether the activity was taking place in the Agency District or in one of the smaller communities.

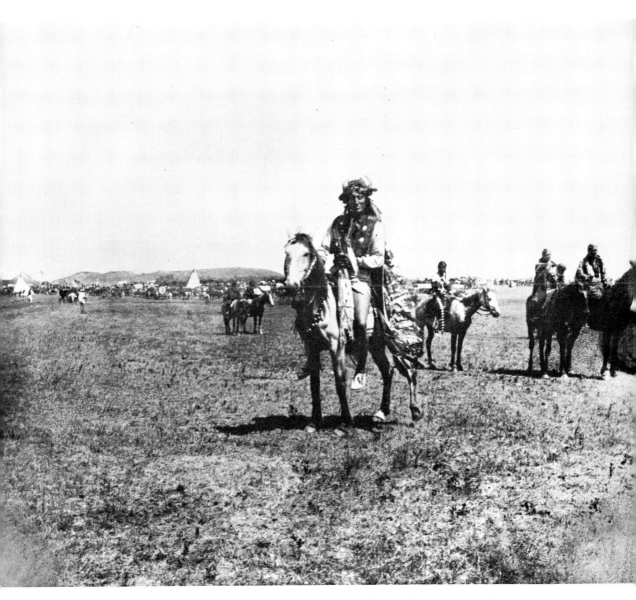

PLATE 121. Assembling at the fall celebration. The rider in the foreground wears
a breechcloth and horned headdress. The horse wears a strap with
sleigh bells around the neck. This plate was reproduced from a print
made from the original glass-plate negative.

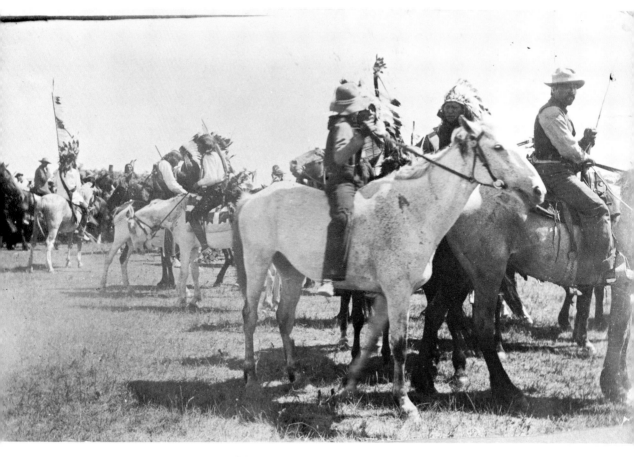

PLATE 122. Sioux celebration, 1889. The man on horseback at the far right is Jim
Claymore. Next to him, in the war bonnet, is Chief Hollow Horn Bear.

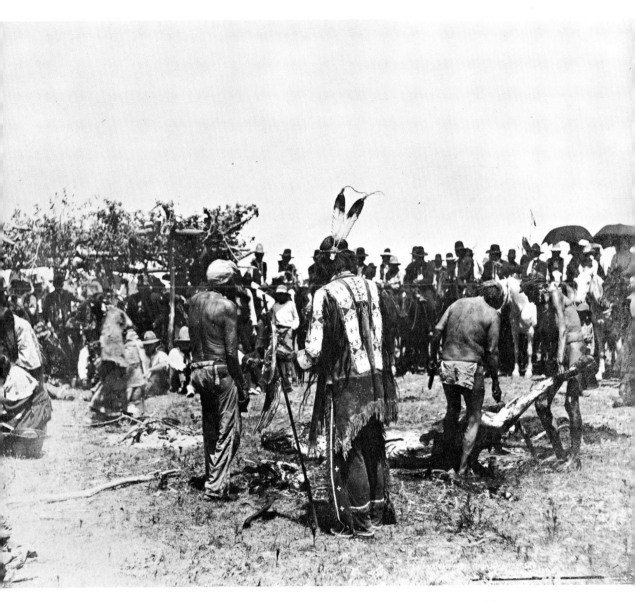

PLATE 123. Beef for the gathering. The men are preparing a carcass. An elder in ceremonial dress leans on his feather-decorated staff to watch. The women are also preparing food. The brush arbor is on the left, and a fire is burning at the middle left. Most of the spectators are mounted. Among the spectators are some white women.

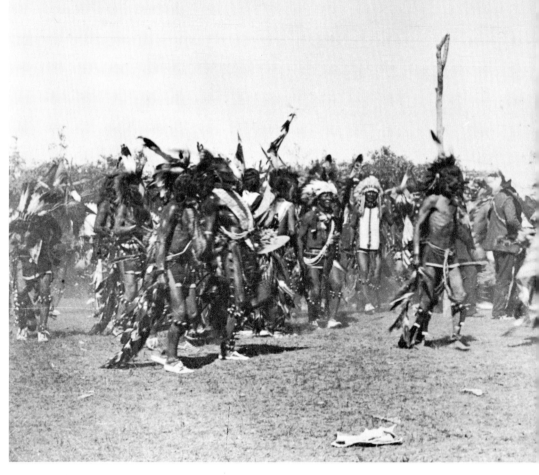

PLATE 124. The Omaha Dance at a fall celebration, about 1892. A brush arbor is in the background.

PLATE 125. Dancers outside a brush arbor. Front row, left to right: Bear Dog, Joe Frightened, Search the Enemy. Back row, left to right: Pete Iron Shell, Foolish Elk, Brave Bird. Mrs. Felix Bordeau is in the background at the right.

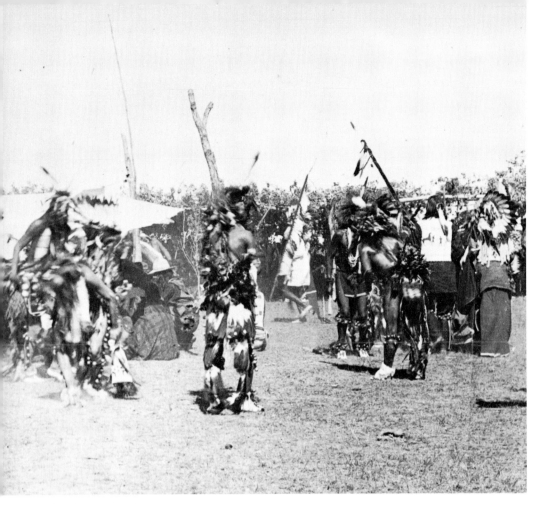

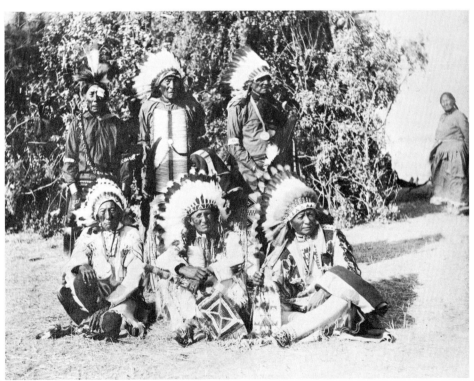

181

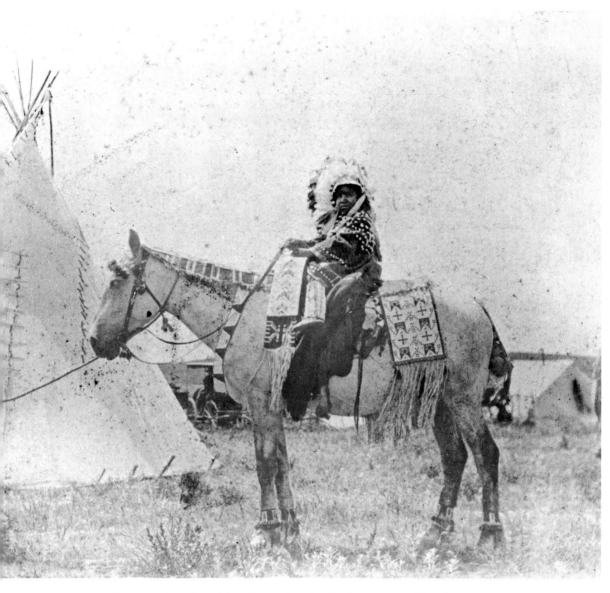

PLATE 126. Granddaughter of a chief, about 1900. The decorative strip running down the horse's mane is porcupine quillwork with yarn tassels, according to Mrs. Hattie Marcus, a present-day beadworker. The decorations above the pasterns of the horse are also decorated with quillwork. The martingale is beadwork. The girl is wearing an elk-tooth dress. She must have been wearing all the finery in the camp.

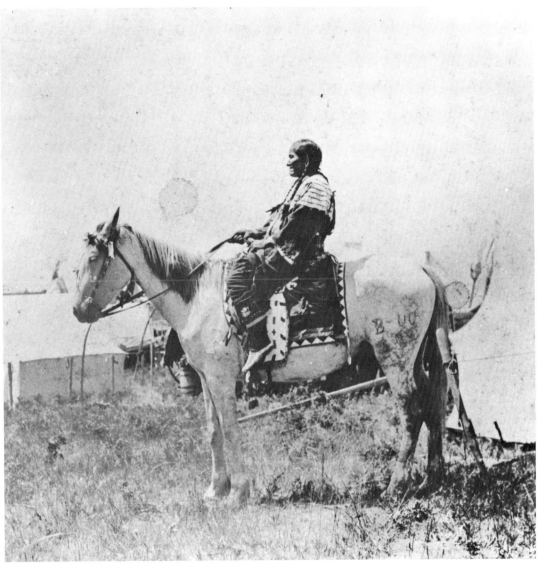

PLATE 127. Smoke Woman, ready for the parade, about 1900. Note the fine ac-
couterments and the brand on the hip of the horse. Smoke Woman was
born in 1840.

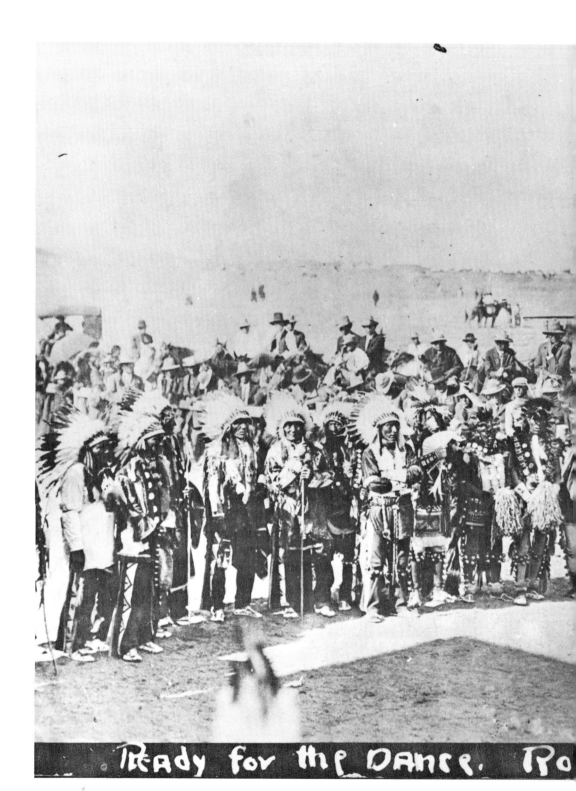

PLATE 128. Ready for the dance, Rosebud, about 1910. The dancers in their regalia
are lined up inside the railing. Behind them are spectators on foot, on
horseback, and in buggies and surreys.

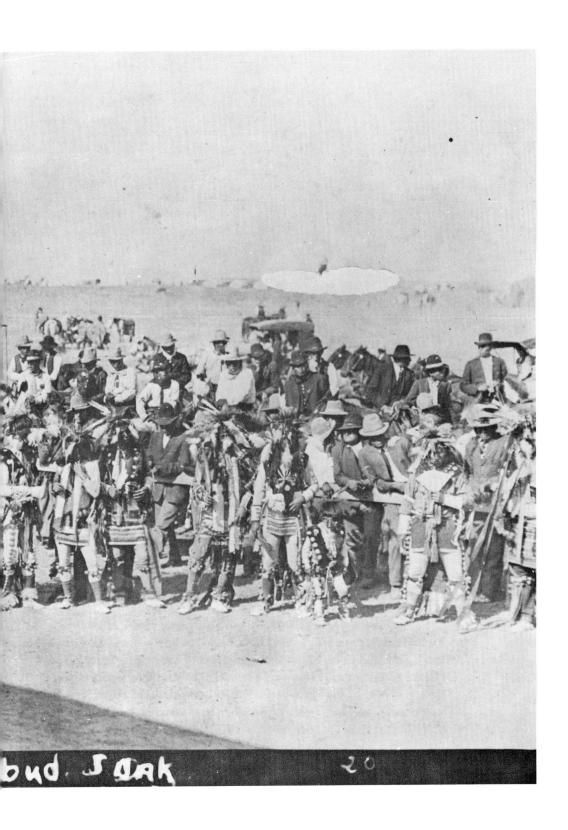

bud. S Dak 2 0

185

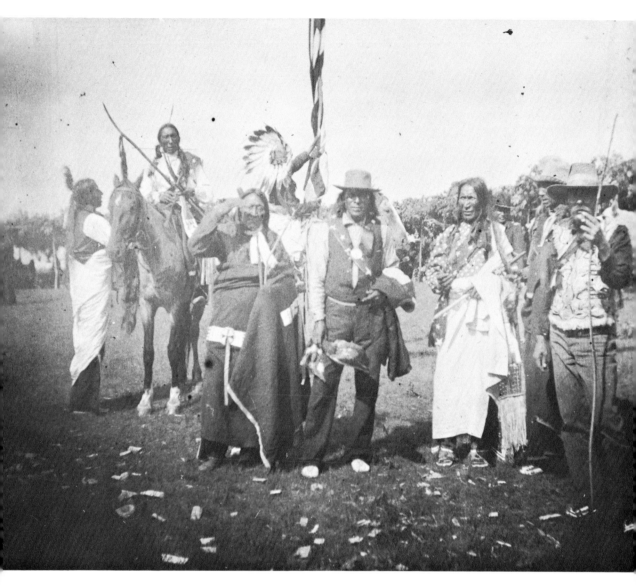

PLATE 129. Group of Rosebud Sioux chiefs. Left to right: Bear Head, High Bear, Two Strike, Scoop (Stands and Looks Back), Stranger Horse, He Dog, Swift Bear, and Louis Roubideaux, interpreter. Dr. Hardin remarks in his diary, "Roubideau [*sic*] would be interpreter for God or the Great Father at Judgement." Bear Head had an 1809 Madison Peace Medal which had been given to his grandfather Iron Man and handed down to his father, Hail Thunder. In 1902, Bear Head gave it to Dr. Hardin because the physician had cured him when he was very ill. Later he fell ill again and reclaimed the medal, but he eventually gave it back to Dr. Hardin. The chiefs are in front of a large brush arbor which curves behind them. The flagpole is just behind them.

186

14

The Fourth of July
Celebrations

For generations the Sioux performed various rites and ceremonies to celebrate matters of importance in their culture. In 1897, for the first time, the Brulés placed special emphasis on an occasion important in the white man's history, the Fourth of July. After that year the two annual activities on the Rosebud which received the greatest attention were the Fourth of July celebrations and the annual fall celebrations.

The event of 1897 was widely publicized. The manager was Reuben Quick Bear, who was born near old Fort Laramie in 1860 and was a graduate of Carlisle Indian School from Black Pipe. John Anderson was there to record the occasion for posterity. The celebration lasted for six days, and everyone, red and white, was invited. Six thousand people are said to have attended.

On July 1 the Indians went to the fairgrounds on the high, comparatively level land one mile north of the Rosebud Agency and set up their great circle of tipis. On July 2 they constructed a large brush arbor. The Squaw Dance, the Omaha Dance, and chief's dances were held on that day. July 3 was devoted to the Corn Dance and the White Buffalo Dance. Religious services for all denominations were held on July 4, and the big event and highlight of the occasion, the Grand Parade, which was more than a mile long, took place on the fifth. Various chiefs made speeches, and someone read the Declaration of Independence. In the afternoon a potato race, the greased-pig contest, and a tug-of-war for women only took place.

On July 6 the Indian police held a drill followed by a sham battle—Indian police and mixed bloods against full bloods—a re-enactment of the Battle of the Little Big Horn. (This event should not have required much coaching, since almost every Indian present over twenty-one years old had been at the original battle in 1876.) After dinner there were bronc riding, steer riding, horse races, and foot races. A cash entrance fee was charged for the horse races, and cash prizes were given in all contests. The competitive events were limited to Indians; among the Sioux, however, all the mixed bloods considered themselves Indian.

During the week the mock attack on the stockade, which was to become a Rosebud Sioux institution, was made on the agency down in the little settlement of Rosebud, and several families conducted giveaways in honor of their dead.

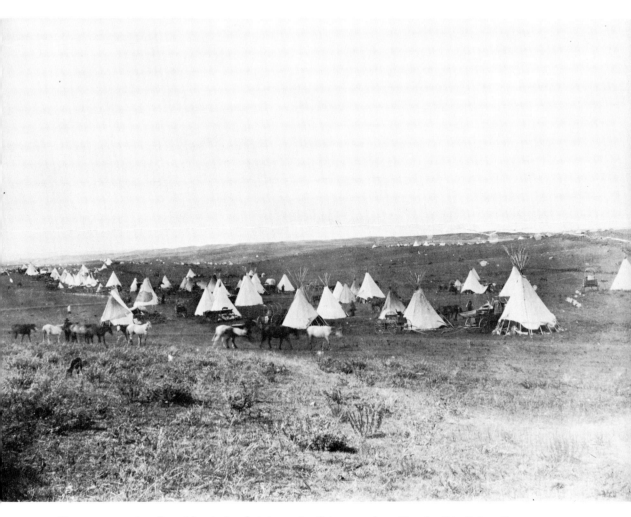

PLATE 130. A mile-wide circle of tipis on the fairgrounds at Rosebud in July, 1897. Each district of the reservation had its allotted place in the circle. The edges of the tipis were raised in hot weather to allow better circulation of air.

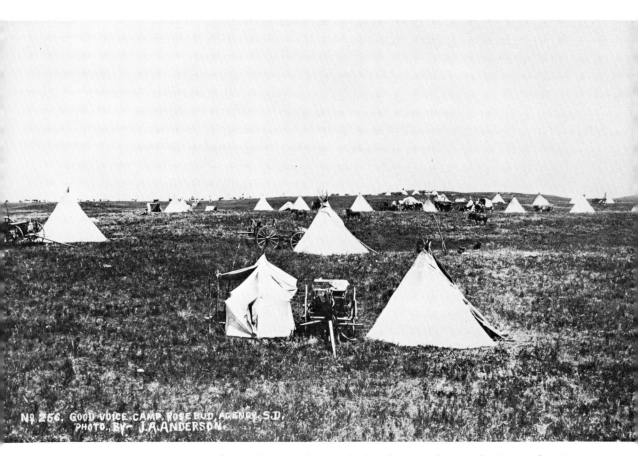

PLATE 131. Good Voice's camp, from Oak Creek, in its place in the big circle, 1897.

190

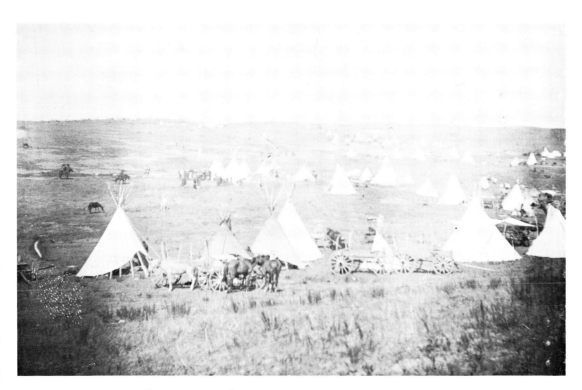

PLATE 132. Hollow Horn Bear's camp, Cut Meat District, July 4, 1897.

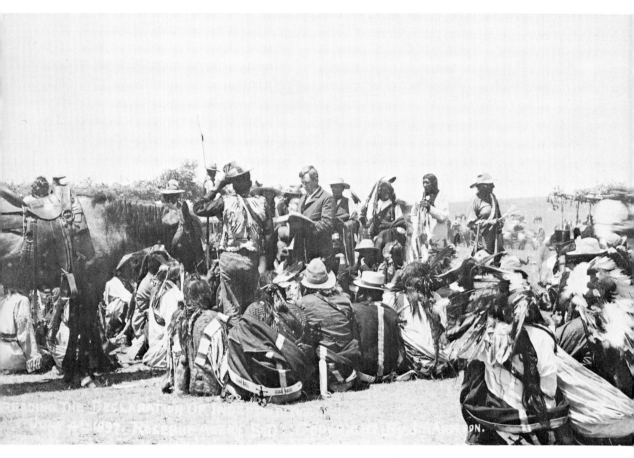

PLATE 133. Reading the Declaration of Independence, July 4, 1897 (copyright 1897). Since the schedule of events called for reading the Declaration on July 5, which was the main day of that year's celebration, apparently it was read twice.

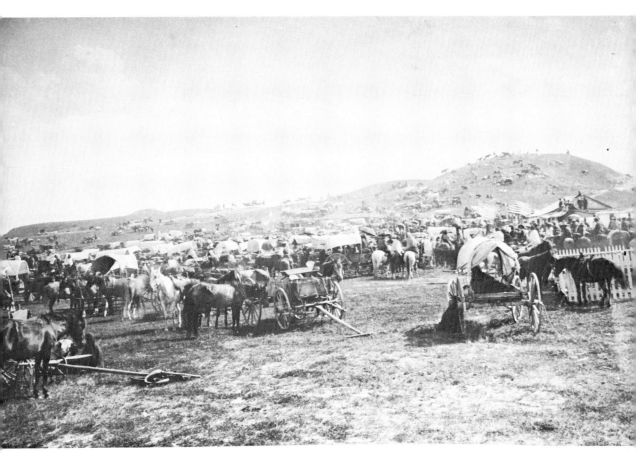

PLATE 134. Gathering for the Fourth of July parade, 1897. The parade is beginning
to form in the background.

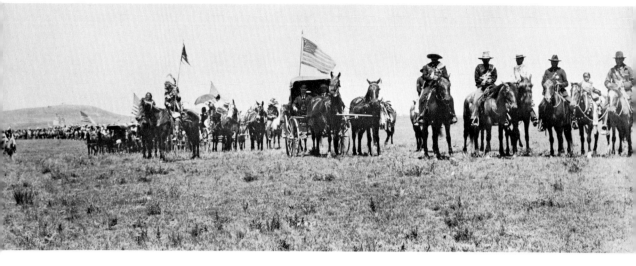

PLATE 135. Parade at Fourth of July celebration at fairgrounds, 1897. The agency superintendent and a driver are seated in a government rig (center foreground), which is pulled by two black horses. Reuben Quick Bear, with upraised banner, is at the left. It was fitting that he lead the parade since he was manager of the fair.

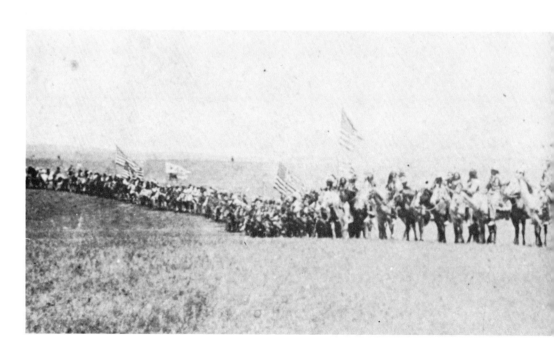

PLATE 136. Parade at Fourth of July celebration at fairgrounds, 1897. This photograph was taken farther down the line of the parade shown in Plate 135.

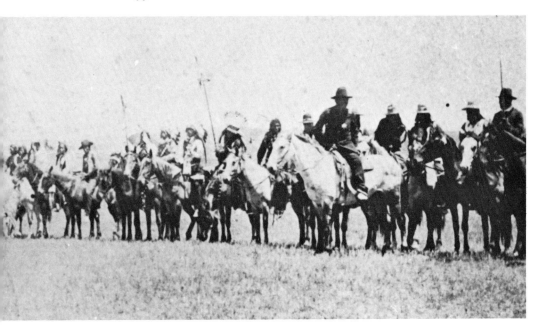

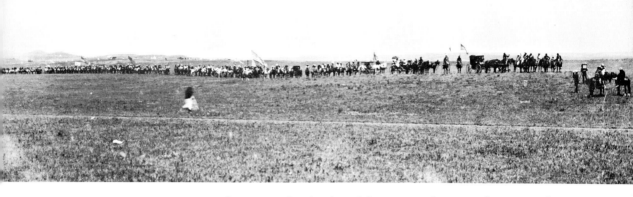

PLATE 137. Parade at Fourth of July celebration at fairgrounds, 1897. This is a distant view of the forward end of the mile-long parade. Three photographers besides Anderson were present, and two tripods can be seen at the far right. The photographers may have been A. G. Shaw, of Valentine, Nebraska, and the partners Trager and Kuhn, of Chadron, Nebraska. These men were at one time in the area. Part of the circle of tipis is visible in the distance.

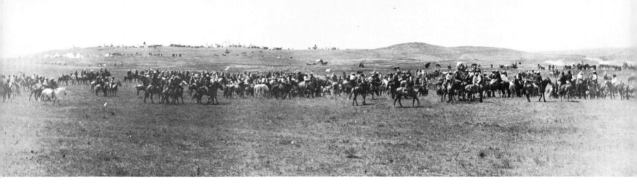

PLATE 138. After the parade, Fourth of July celebration, 1897.

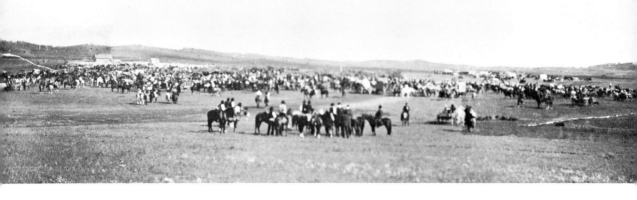

PLATE 139. After the parade, Fourth of July celebration, 1897. The riders have begun to cluster in smaller groups.

196

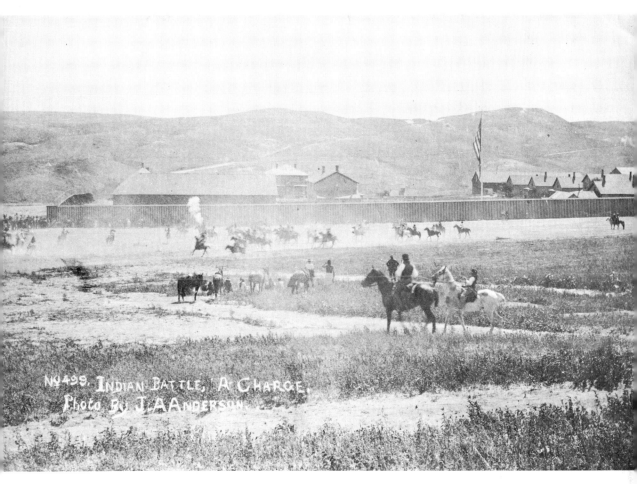

No 429. INDIAN BATTLE, "A CHARGE."
Photo By J.A.ANDERSON.

PLATE 140. A mock attack of mounted Indians on the agency stockade at Rosebud, 1897. For a number of years this continued to be an annual affair held at daybreak on the Fourth of July. Note the clouds of dust raised by the attackers.

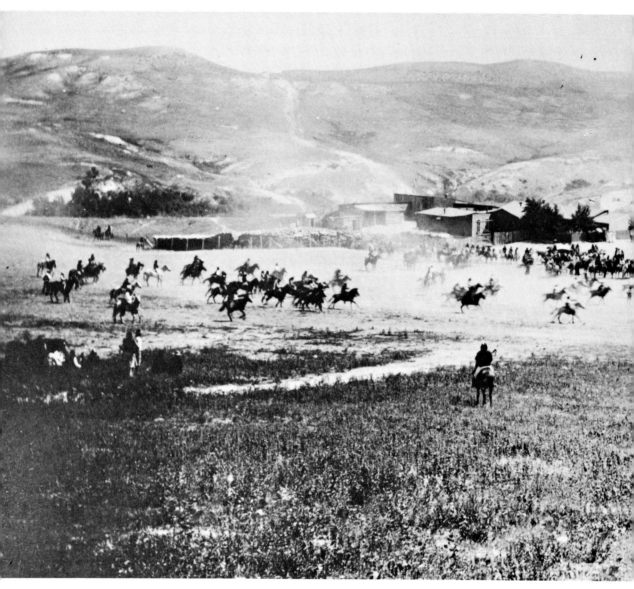

PLATE 141. Another view of the mock attack on the agency stockade at Rosebud, 1897. This view shows part of the interior of the stockade, which includes an elevated firing step, or walk. Schuyler reported that the stockade was about fourteen feet high and was constructed of planks. At one time it had been painted red, and in 1903 one could still dig lead bullets out of the wall from attacks in 1889.

In later years there was no guard on the stockade gate during the day. Anyone could come and go at will, but there was a 10:00 P.M. curfew for everyone staying overnight on the agency grounds. The curfew lasted until at least 1911. It is believed that the stockade was taken down either in late 1912 or in 1913.

According to Ben Reifel, by 1912 or 1913 the mock battle had

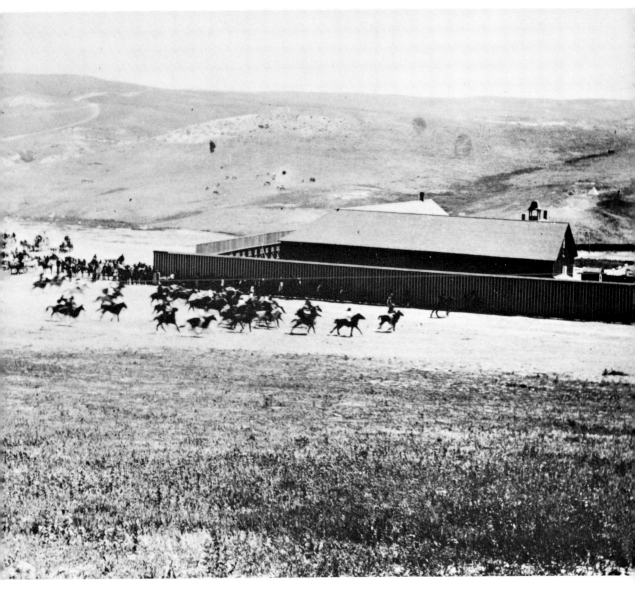

changed from an attack on the stockade to an attack on the mile-wide circle of tipis at the fairgrounds. Anyone who wished could join the attack. The participants would gather in the brush along the creek and decorate their horses with grapevines. Then they would circle the camp, riding hard and shouting. Toward the end they would slow their horses and sing songs about those who had recently died. In the meantime, the families of those who had died would be preparing a feast and a giveaway, and the women would be chanting in grief.

The mock attacks were staged in this way as late as 1916, but soon thereafter they changed as cars became more popular and fewer horses were ridden to the celebration.

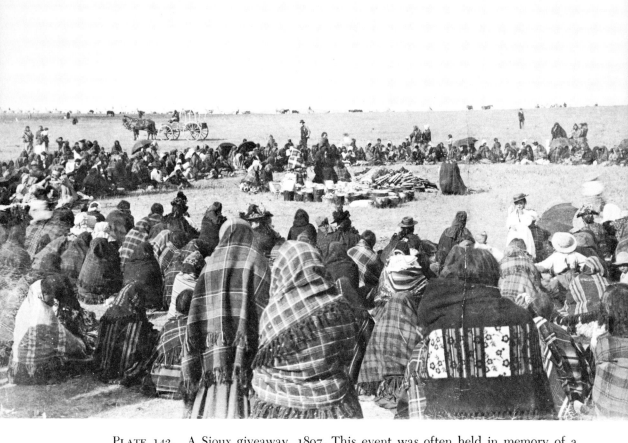

PLATE 142. A Sioux giveaway, 1897. This event was often held in memory of a
member of the family who had died. This photograph was taken on the
fairgrounds north of the Rosebud Agency. A closer view of this group
of presents is exhibited in the Rosebud arts-and-crafts shop.

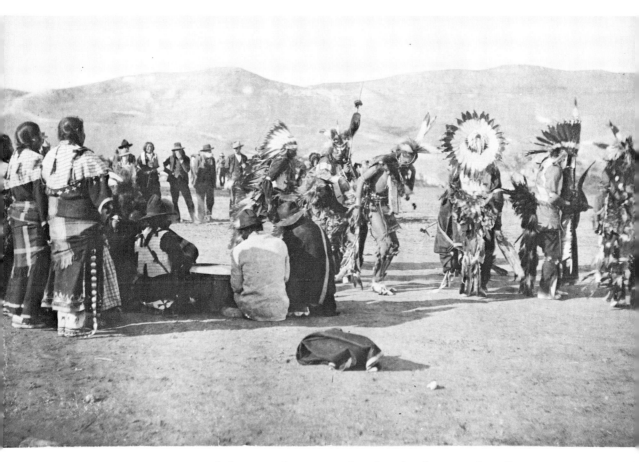

PLATE 143. Drummers and dancers, about 1900. In 1895 the drum used at Cut Meat was made from a cross section of a cottonwood log, hollowed out to a thin outer shell. The ends were covered with tightly stretched rawhide. In this picture a conventional manufactured drum is shown, resting flat on the ground, while the drummers sit around it in the customary manner. A closely similar scene—with drummers, dancers, dress, and accouterments—can be seen on occasion in Sioux country today.

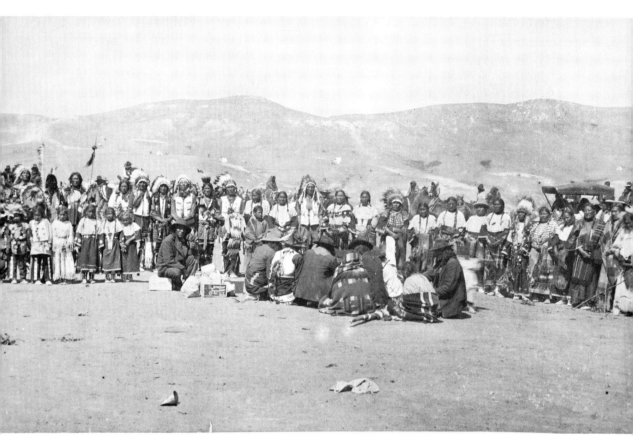

PLATE 144. Dancers stop to have their pictures taken, about 1900. This is a later
photograph of the scene in Plate 143. The same hills are visible in the
background. More people, including children in costume, have arrived,
and more drummers have joined the group around the drum.

202

15

Daily Life on the Reservation

ANDERSON began to take pictures on the Rosebud Reservation in the late 1880's, while he was still living at Fort Niobrara. He had a natural interest in and sympathy for the Brulé Sioux, and they responded to his friendship by allowing him to photograph them whenever he wished.

Some of the following photographs were posed. Others were recorded as the photographer found the people going about their daily activities, adjusting to circumstances over which they had no control, living in a captivity contrary to their nature and their history.

These are some of the people who defeated the United States Army at the Little Big Horn, defeated in turn.

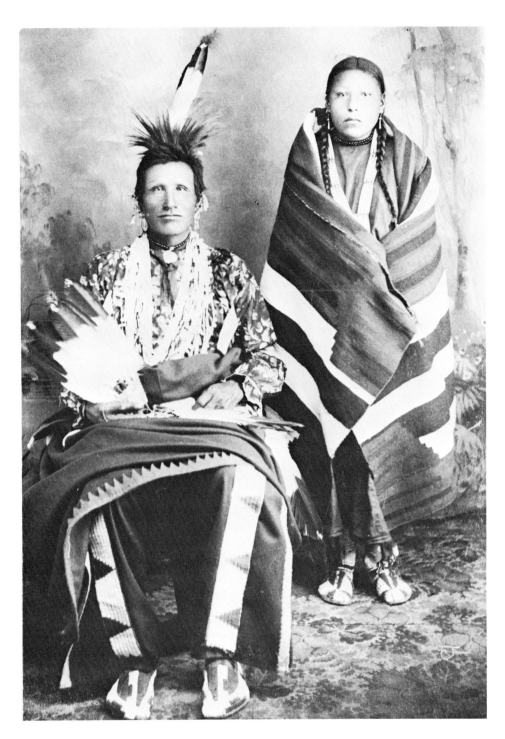

PLATE 145. Joe Frightened and his bride, Annie, Agency District, about 1889. This picture was probably taken while Anderson was still at Fort Niobrara, since Frightened, who was born in 1869, is quite young here. He was later a member of the Indian police. He is shown as a much older man in Plate 125. His bride is wearing a Navaho blanket and squash-blossom earrings, evidence of trade with the Southwest.

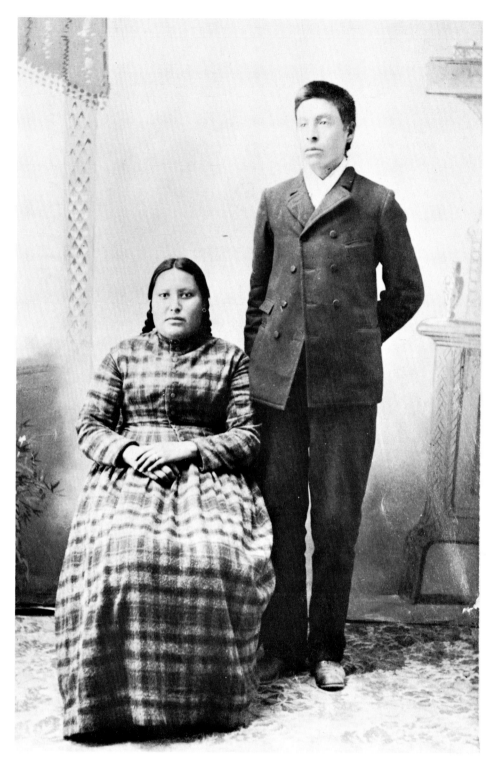

PLATE 146. A newly married couple, Millie Steed, a mixed blood, and her husband.

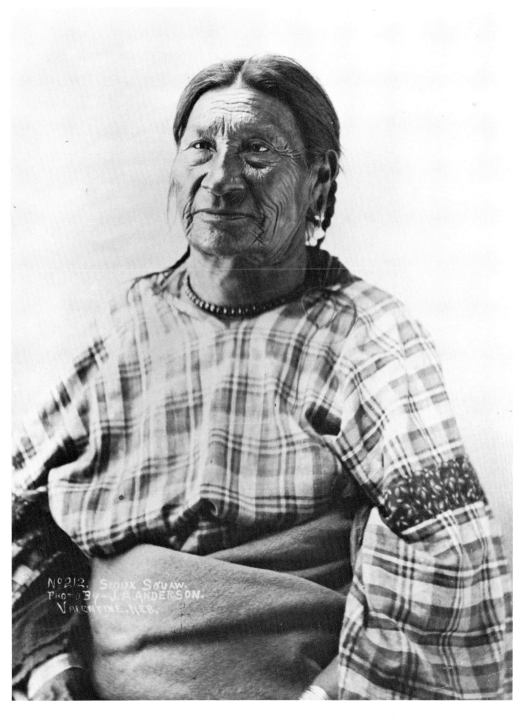

PLATE 147. Nellie Good Shield, photographed before 1890. Nellie is wearing what the Sioux call a squaw dress, a one-piece garment commonly worn by the women. Nellie Good Shield died in 1890. (No. 212 in Anderson's numbering.)

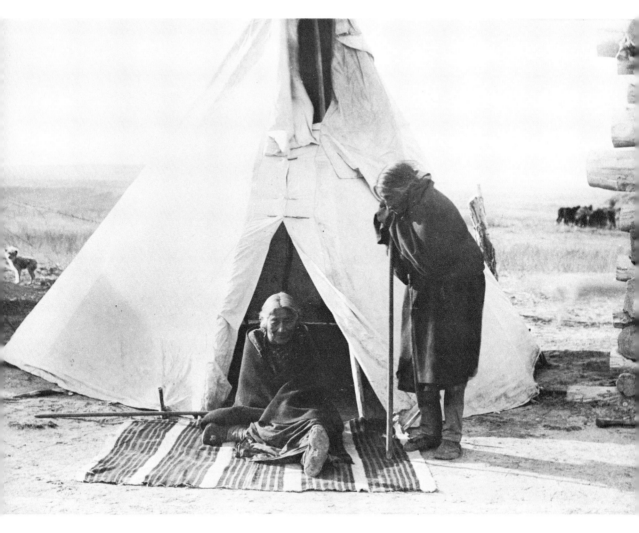

PLATE 148. Two old women in front of a tipi, 1890. The seated woman was the
great-great-grandmother of Peggy Bent and William Colombe.

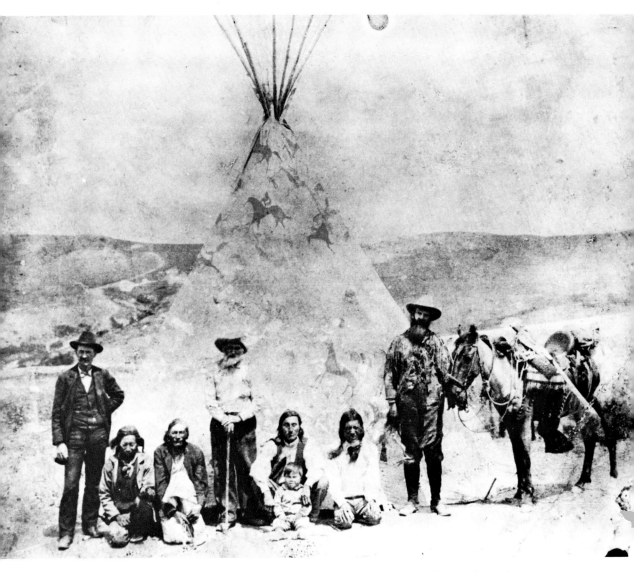

PLATE 149. Group beside a decorated tipi, about 1892. Second from left, Picket
Pin; third from left, Castaway; fourth from left, John Claymore; fifth
from left, Blunt Arrow with little Everard Jordan. The others are un-
known. John Claymore, a trusted mail carrier for the military and the
United States government, once made a trip in a time of stress, walking
at night to avoid detection, to carry a message from Fort George to
Fort Laramie.

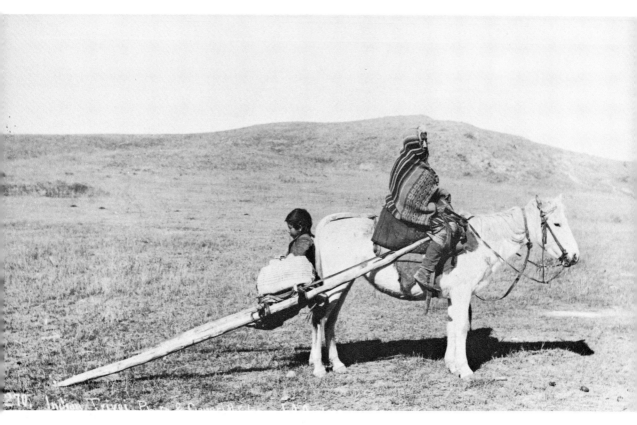

PLATE 150. Indian travois, 1892 (copyright 1893). The rider is wrapped in a trade blanket and sits on a comfort. A child, Oliver Jack, and a parfleche bag trimmed with quillwork are on the travois. (No. 270 in Anderson's numbering.)

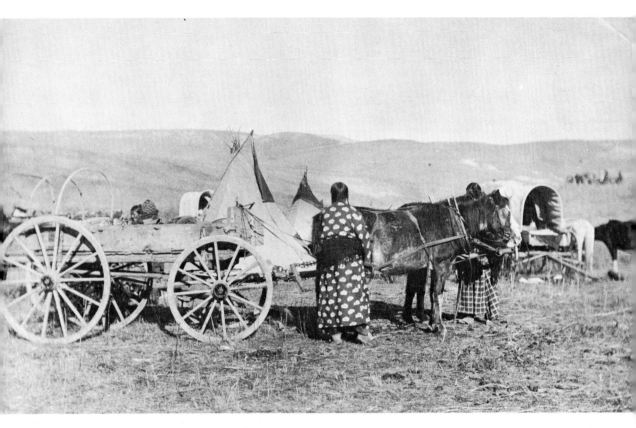

PLATE 151. Indian women hitching up a team, 1892 (copyright 1896). This scene is in a temporary camp or village. Two tipis, as well as canvas-covered wagons and horses, are visible in the background. The *Searchlight* (published in Valentine) reported on February 6, 1914, that "500 farm wagons, besides other farm machinery, are being issued at Rosebud to Indian allottees who have not previously received these prerequisites." (No. 268 in Anderson's numbering.)

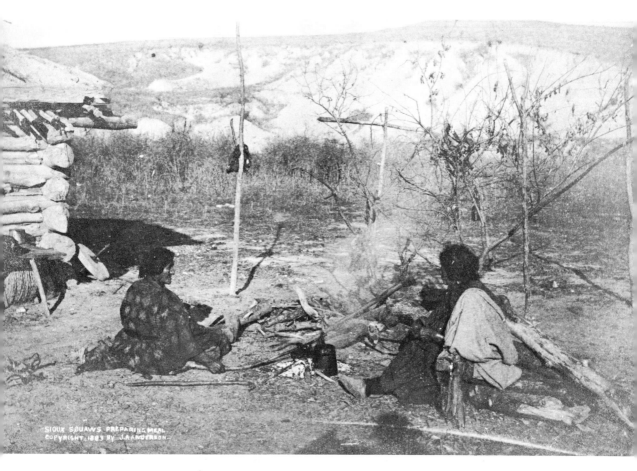

SIOUX SQUAWS PREPARING MEAL
COPYRIGHT 1893 BY J.A.ANDERSON

PLATE 152. Sioux women preparing a meal (copyright 1893). This is the same site as that shown in Plate 75. It was the home of Nancy Blue Eyes (the mother-in-law of Colonel Charles P. Jordan) near the agency. She was evidently quite willing to be photographed; Anderson took at least three pictures of her.

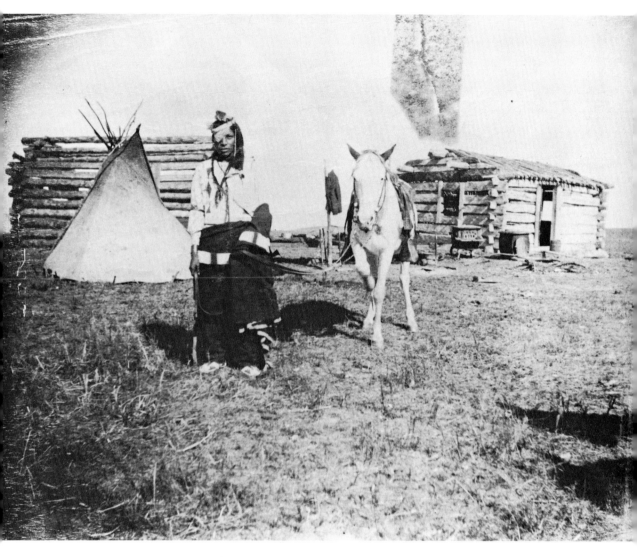

PLATE 153. Lame Dog and his horse, about 1893. An iron heating stove and an iron cookstove, both of standard design, stand near the log cabin. A tipi and an unfinished log cabin are on the left. The Sioux evidently stopped using leather thongs as soon as bridles became available. All the horses close to the camera seem to be wearing riding bridles with bits. Saddles, however, are rare. This one seems to have stirrup covers.

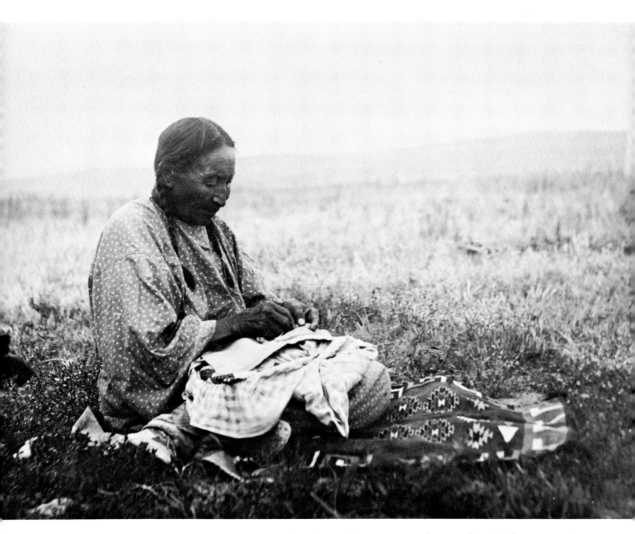

PLATE 154. A porcupine quillworker, about 1893. The unidentified woman is decorating a moccasin top with porcupine quills.

214

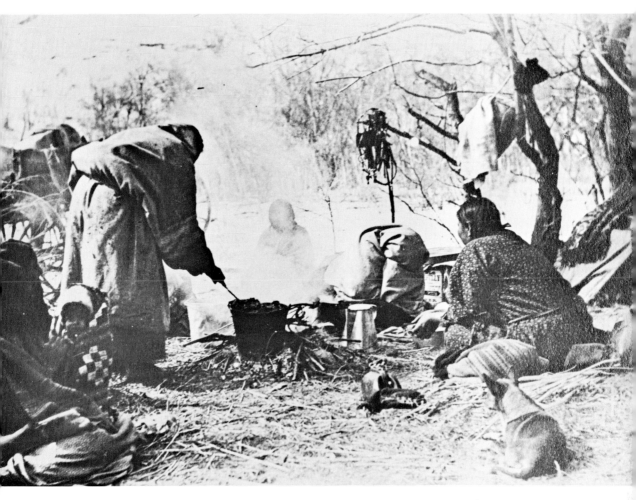

PLATE 155. Women preparing a meal near the Rosebud Agency (copyright 1893). Mrs. Sophie Dyer and her dog, Rags, are on the right. She was the mother of Rose Dion, the wife of Bob Emery, Sr. At least five women and a child are in the group around the fire, over which they are cooking something in a bucket. A coffeepot and a second bucket are near the fire. A wagon is in the background on the left, and various belongings, including what seems to be a bundle of bedding and possibly food supplies, are in the right background. A blind bridle complete with checkrein and a leather halter hang on a broken limb. This group is probably camped on the bank of Rosebud Creek, near the site of a present-day dam.

PLATE 156. Four Indians helping a team pull a wagon up a steep slope, about
1894. Anderson probably came upon this scene while photographing
in the Bad Lands. Such steep slopes are not encountered on the reser-
vation itself.

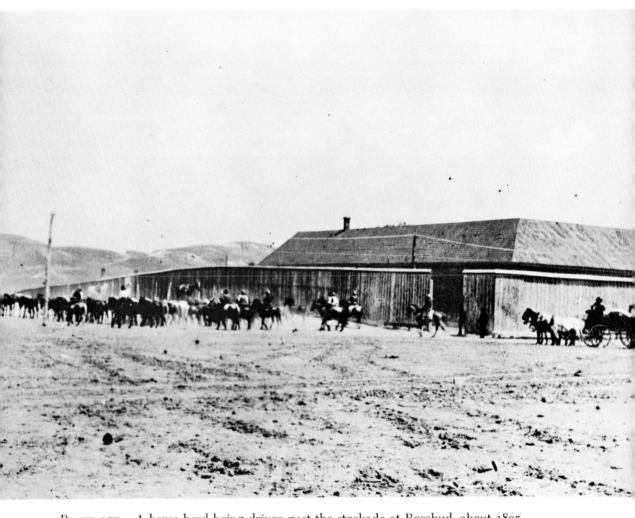

PLATE 157. A horse herd being driven past the stockade at Rosebud, about 1895.
Seven men on horseback are driving the herd, followed by loaded
wagons. Note the telephone line, which ran from the agency to
Valentine.

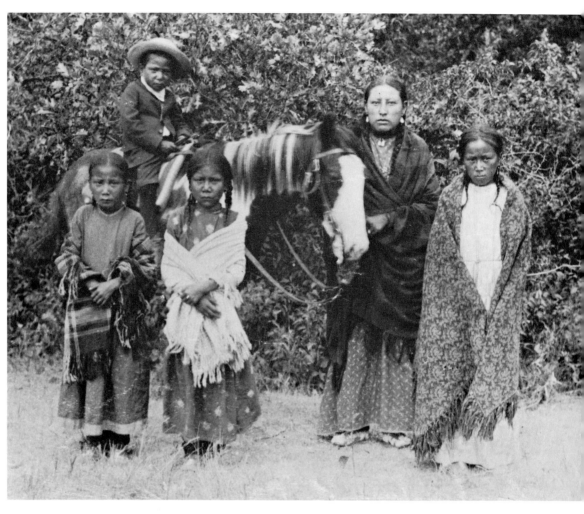

PLATE 158. Sioux woman and children, about 1895. The woman, three girls, and a boy are dressed in white man's clothing, including commercially manufactured shawls. All are wearing moccasins. The little boy on the pony had his hair cut at school. When children entered school, they were dressed in white man's clothing, the boys were given haircuts, and all the pupils were given Christian names. They were allowed to retain their fathers' names as surnames—for example, Dan Hollow Horn Bear. Little girls did not have their hair cut, but at some schools they were required to wear it in one braid rather than in the traditional Indian style, parted down the middle and plaited in two braids.

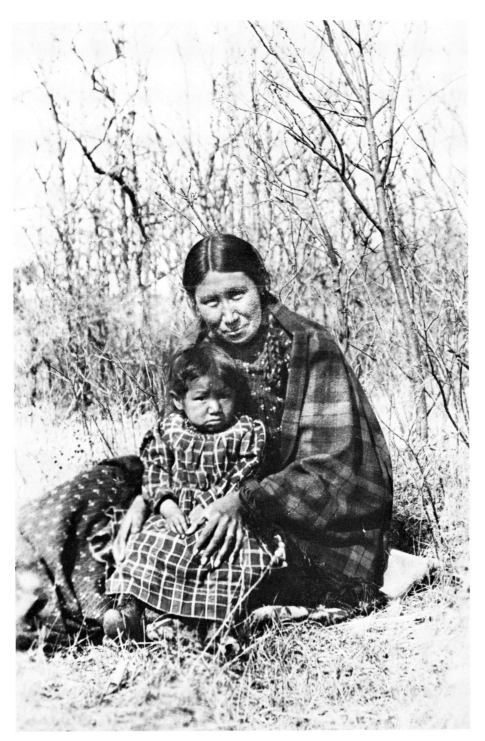

PLATE 159. Mother and daughter. The child appears apprehensive. The mother holds her protectively and seems pleased. This is the most pleased expression shown on the face of any of the individuals in the portraits. In one or two instances an expression of pleasure can be detected in a group picture. This photograph was placed on a postcard. A letter from Anderson to Remington Schuyler in 1921 implies that for ten or eleven years Schuyler had been arranging for Anderson's prints to be made into postcards in the East.

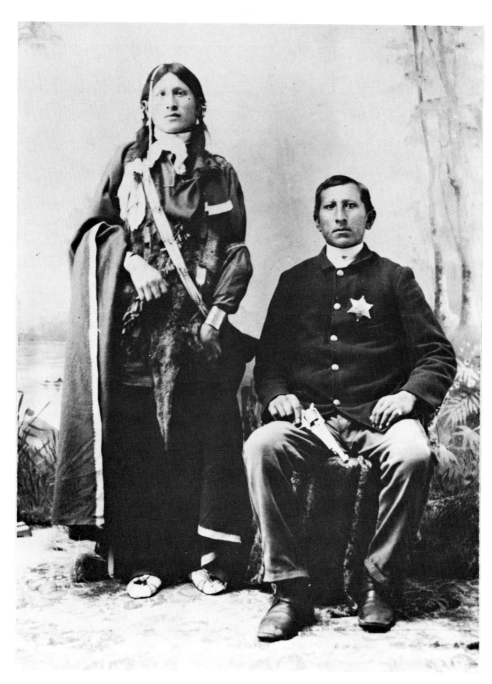

PLATE 160. High Bear in police coat, about 1896. None of our consultants could
identify the individual on the left. By 1902, High Bear was police cap-
tain. He was photographed several times, and in later years he demon-
strated Indian activities for Anderson's camera (see Plates 168 and
169).

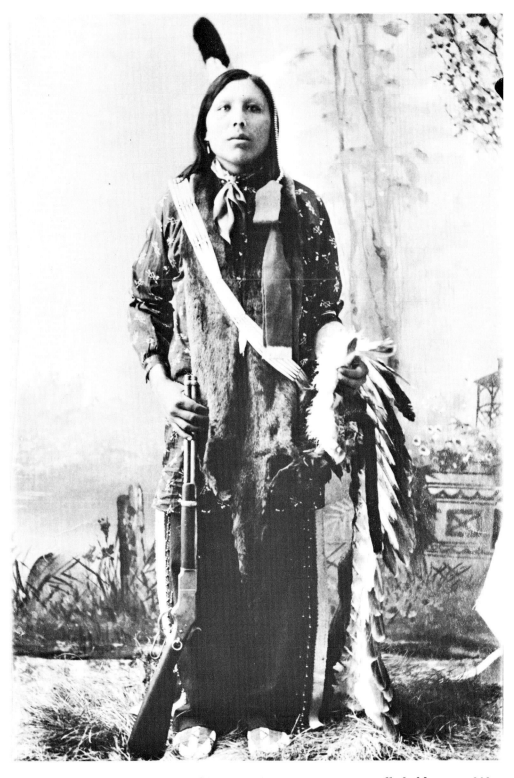

PLATE 161. Young Indian and his gun, about 1896. He is proudly holding an 1868 Winchester carbine.

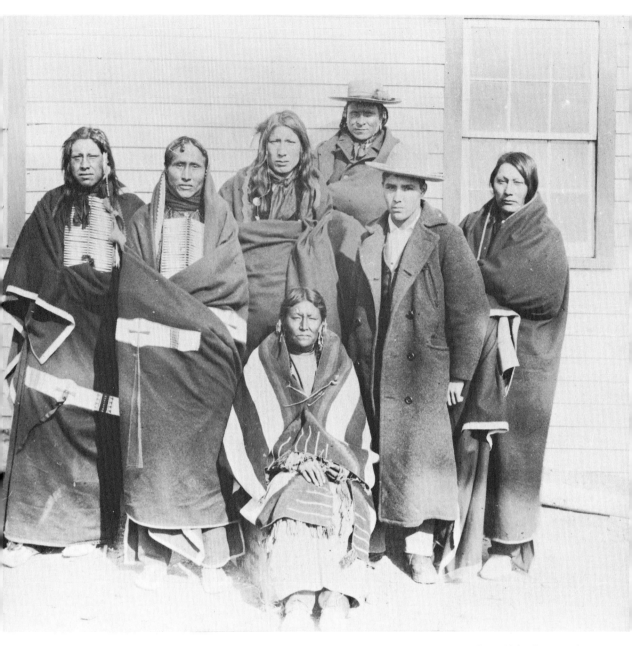

PLATE 162. Indian group. The two men on the left are wearing chiefs' blankets with beaded stripes. The seated woman wears a Hudson's Bay Company trade blanket that cost four beaver skins, according to the markings in the corners.

222

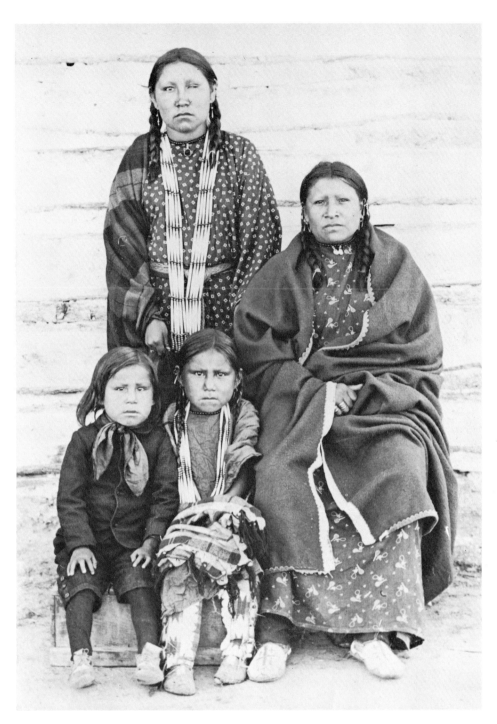

PLATE 163. Three generations, about 1897. The group is shown in front of a log building. The children are sitting on a wooden box. The little girl is wearing typical Sioux clothing, the little boy is dressed in white man's attire, and the women are dressed in both Indian and white clothing. The three in front are wearing moccasins. The younger woman appears to have lost her left eye.

223

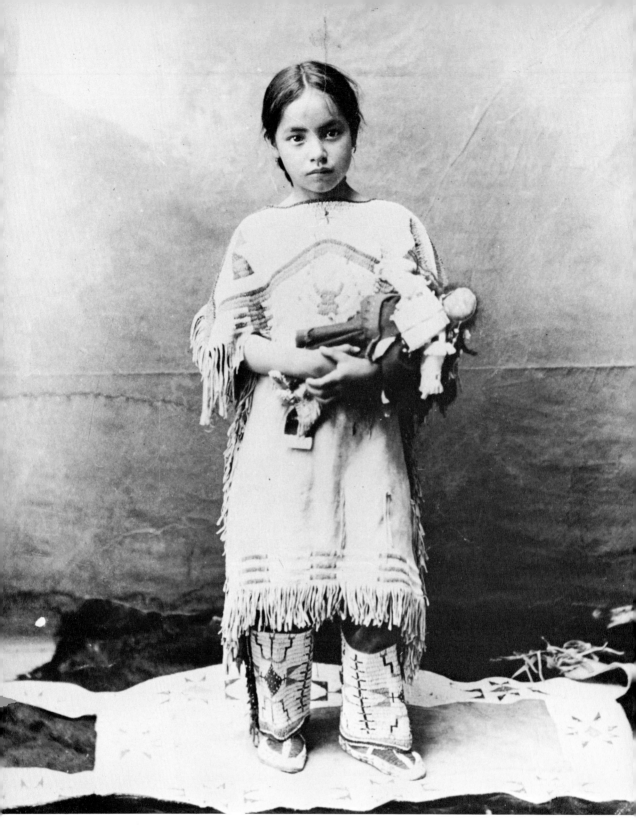

PLATE 164. Katie Roubideaux, the daughter of Louis Roubideaux, at the age of eight, 1898. Today she is Mrs. Blue Thunder, of Rosebud. Katie is wearing a beaded dress, leggings, and moccasins. She stands on a saddle blanket which is lying on a buffalo robe. Behind her is a tipi.

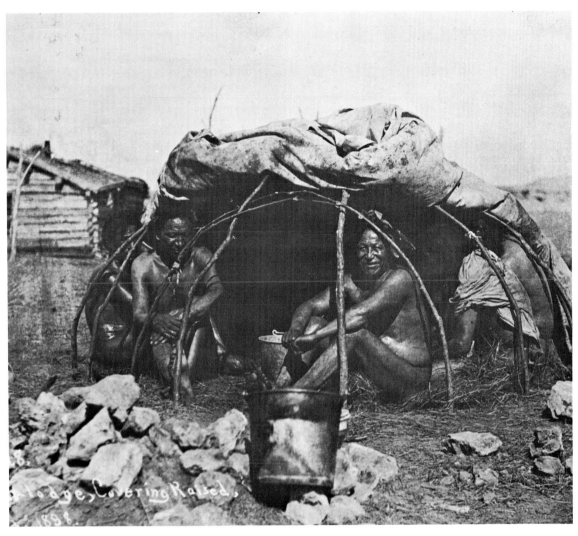

PLATE 165. A sweat lodge, covering raised, 1898. Sweat lodges have been in use by the Sioux and other Indian groups for a long time. (They continue to be popular: behind some of the conventional houses newly erected by government aid on the Crow Reservation in 1968 were the frames for sweat lodges, their recently cut poles, divested of bark, shining in the sunlight.) In this photograph the covering of the lodge has been raised and thrown back to allow a view of the interior and the pole support. Rocks to be heated in the fire and passed into the lodge with forked sticks have been gathered, and two tin buckets hold water the participants will sprinkle on the hot rocks to make steam.

225

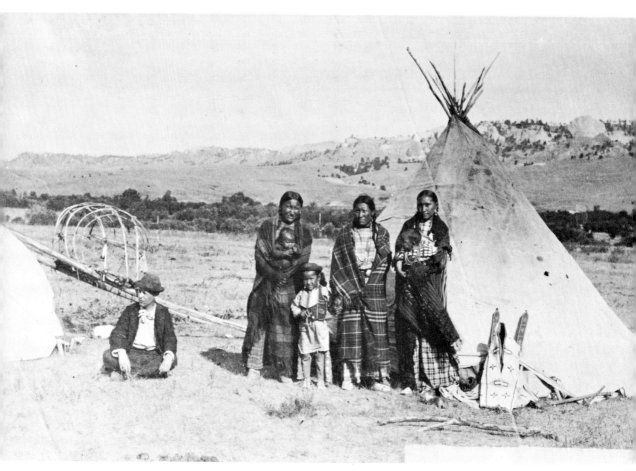

PLATE 166. Ella Turkey and friends, about 1899. The woman at left, holding the tiny baby, is Ella Turkey (Red Faced Woman), the wife of Henry Turkey. The baby is Jessie Turkey. The Rosebud Census of 1926 reports that Jessie was born in 1899. Ella was born in 1874 and died in 1926. The other persons in the photograph, including the white man, who appears in another Anderson print, are unknown. A cradleboard, from which one of the babies has no doubt just been removed, rests against the tipi at the right; a travois is on the left.

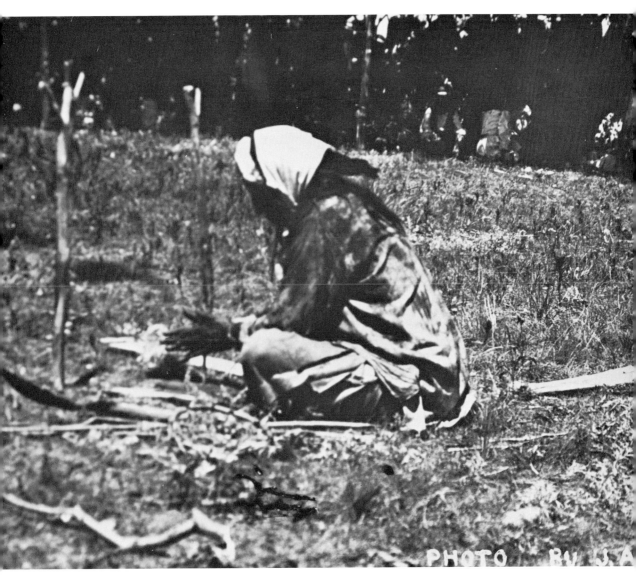

PLATE 167. An elderly man building a fire by friction. This may be a ceremonial fire for an important occasion, for in the shadows in the background are many witnesses.

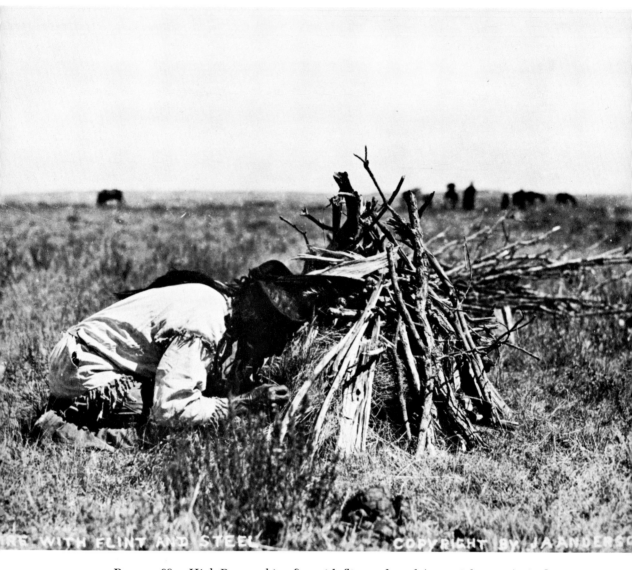

PLATE 168. High Bear making fire with flint and steel (copyright 1911). Anderson
used High Bear to demonstrate old skills and customs before the
camera.

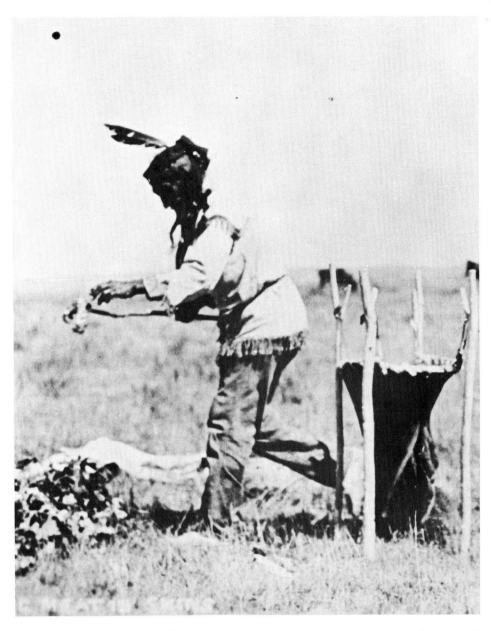

PLATE 169. High Bear cooking meat in a paunch (copyright 1911). Before metal
kettles and buckets were available, the Brulés frequently cooked their
food by the stone-boiling method. A buffalo paunch was suspended
from four sticks and partly filled with water. The meat was cut into
thin strips and placed nearby. Stones were heated in the fire and
dropped into the water. It did not take many stones to make the water
boil, and while it bubbled, meat was dropped in the paunch to cook
for a few minutes (the Indians preferred their meat rare). When the
meat was served, the liquid—which was quite palatable, having drawn
juice from both the meat and the paunch—was given to those without
teeth. The paunch itself, now thoroughly cooked, was also eaten.

229

16

Burial Customs

Of the burial customs of the Brulé Sioux, Mrs. Anderson wrote:

"One evening I heard the loud cry of an Indian woman wailing and going about the hills. I asked someone what was wrong. They told me that an Indian woman had just died and she was mourning for her. The next day John came in the house and said, 'Remember the mourner on the hill last evening? Well she is very angry. She said that she mourned harder than anyone and all they gave her was a bedquilt.' I learned then that it was a custom at that time to pay their mourners."

The Sioux had a horror of placing their dead in the ground, fearing that the soul could not escape. At first they used trees or scaffolds to hold corpses. Later, bodies were placed on the ground in boxlike structures, and eventually the Sioux conformed to the white man's way and buried underground.

Dr. L. M. Hardin wrote in his diary: "Short Thigh's child died and was buried above the coffin of the grandparent. This had been done in the same family once before."

According to Remington Schuyler, it was customary for the Indians to leave the coffin in its shipping box for burial.

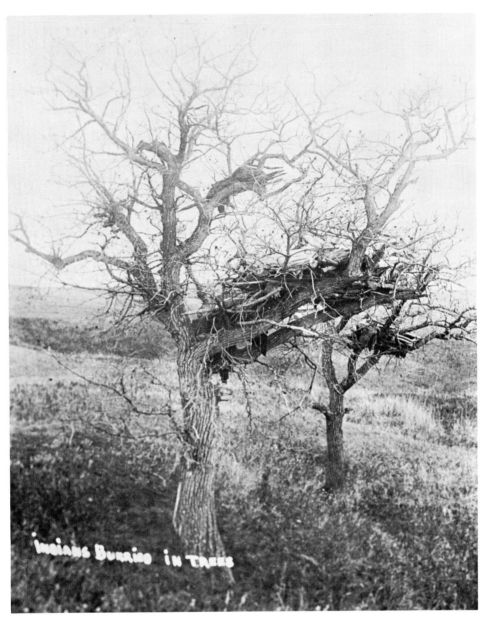

PLATE 170. Indian burials in trees, 1886. There are at least four burials in the two
trees shown. The one at the upper left is probably the body of a baby
in a carrier with his wrappings.

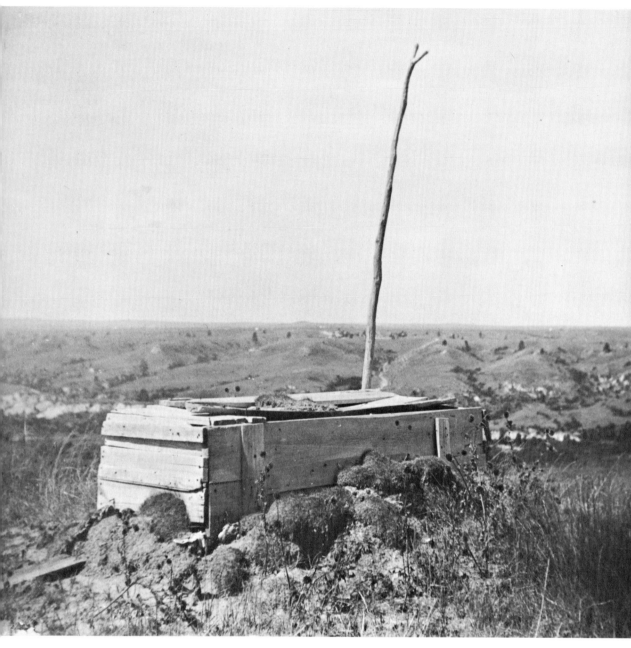

PLATE 171. Crow Good Voice's grave. Crow Good Voice, who was a member of the Indian police, is buried in a coffin, still in its shipping box, placed on top of the ground and held in place with clods of dirt.

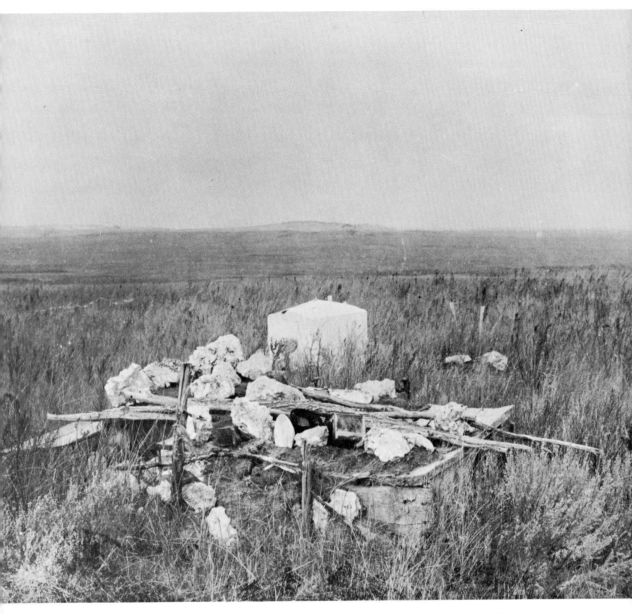

PLATE 172. Sioux graves on Black Pipe Creek at the edge of the Bad Lands, about
1886. A notation in Anderson's handwriting on the back of the original
print states that a child is buried in the light-colored trunk in the back-
ground. In the foreground is a coffin with rocks piled around and on
top of it. (No. 249 in Anderson's numbering.)

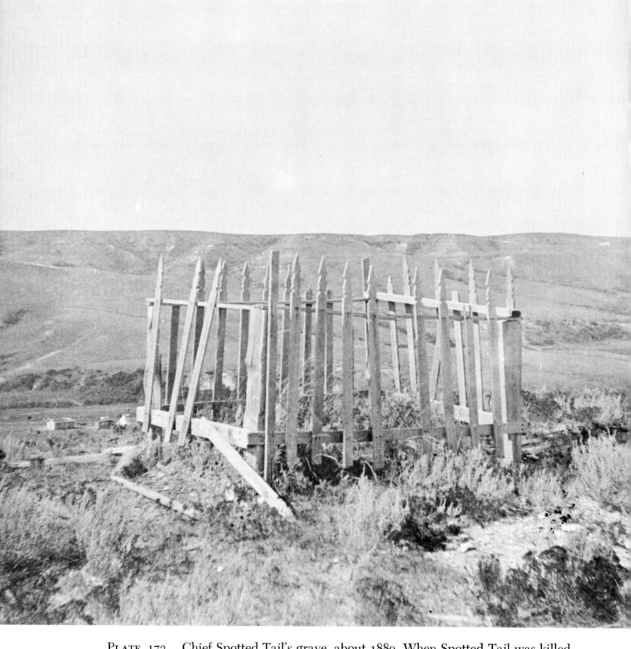

PLATE 173. Chief Spotted Tail's grave, about 1889. When Spotted Tail was killed in 1881, he was buried in the ground. One wonders whether he would have disliked the white man's method of interment as much as he disliked the white man's house.

17

The Bad Lands

THE Bad Lands of South Dakota is an arid plateau about 120 miles long and 30 to 50 miles wide lying northwest of the Rosebud Reservation, between the White and Cheyenne rivers. The spectacular scenery of the region is the result of erosion, and a great many prehistoric fossil deposits are found there.

Mrs. Anderson stated that in 1889 John spent a week in the Bad Lands taking pictures. Some or all of the photographs in this section could have been taken at that time, but they were not copyrighted until some years later.

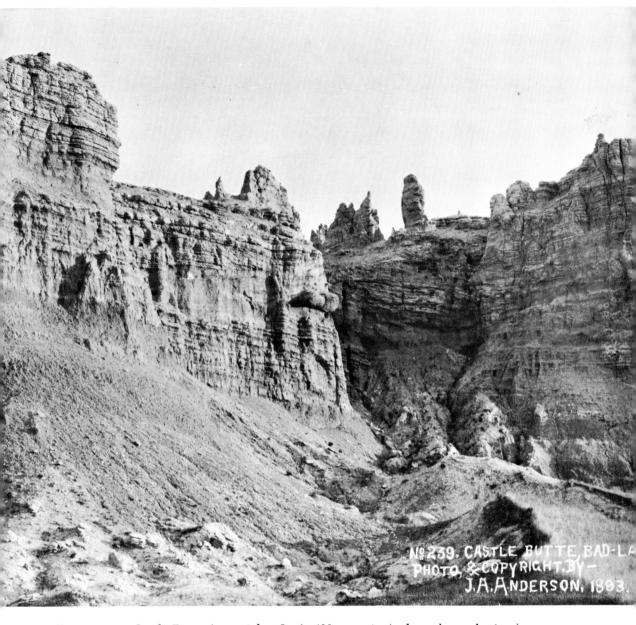

PLATE 174. Castle Butte (copyright 1893). (No. 239 in Anderson's numbering.)

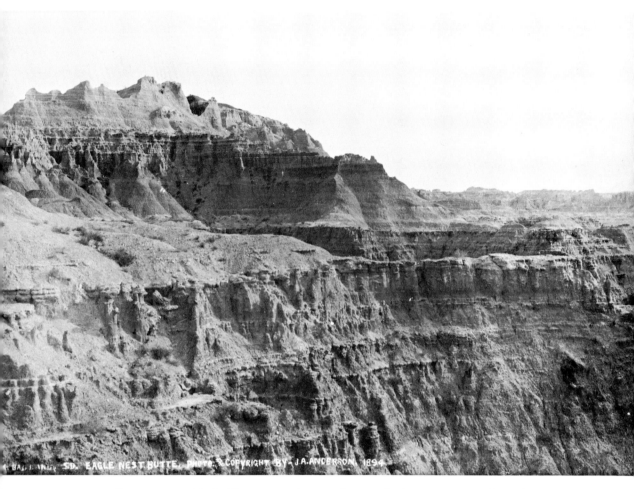

PLATE 175. Eagle Nest Butte (copyright 1894). (No. 234 in Anderson's numbering.)

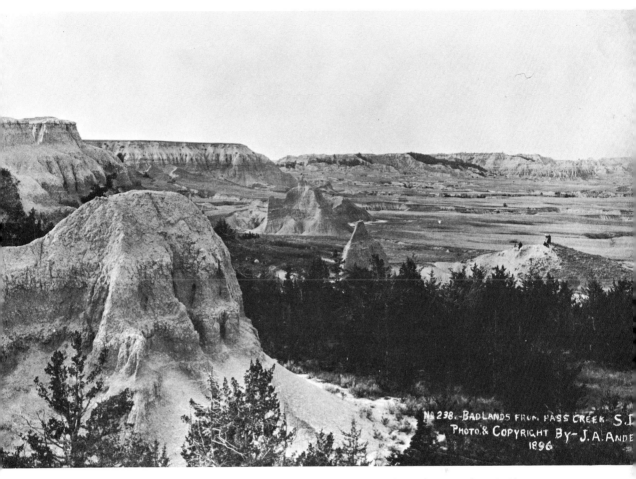

In the image: No 238.- BADLANDS FROM PASS CREEK S.D / PHOTO.& COPYRIGHT BY J.A.ANDE / 1896

PLATE 176. The Bad Lands from Pass Creek, South Dakota (copyright 1896).
(No. 238 in Anderson's numbering.)

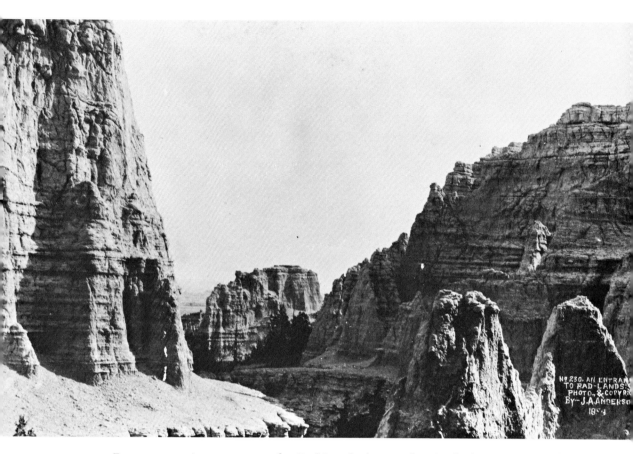

PLATE 177. An entrance to the Bad Lands (copyright 1896). (No. 230 in Anderson's numbering.)

PLATE 178. Balancing Rock (copyright 1897).

PLATE 179. Twin Buttes. (No. 228 in Anderson's numbering.)

244

PLATE 180. The Bad Lands.

18

Ranchers and Cattle

I̵f you wanted to butcher a beef you shot him in the head and then you began to skin him," wrote Remington Schuyler, and continued:

"If it was your neighbor's cattle that you were skinning, and he came along, he wouldn't ask to see the brand, he'd just say, 'Hi, Boys!' he'd go on. Then he'd get one of your steers a little bit later in the winter.

"He'd come in and tell you, 'awfully sorry, but one of your steers broke his leg and we had to shoot him. It was too far to drag the carcass over here, so we ate him.'

"And then everybody knew that they'd squared up for the beef that we had gotten earlier in the season. You never ate your own beef out in that country. It was understood that that's the way you got it.

"Then you would take the beef in and hang it from the long roof pole, if it was winter. And then you would go out with an axe and chop off a hunk of meat.

"It might be tenderloin, porterhouse, or whatever it is, whatever you were chopping off.

"You'd just get up on a barrel and chop off a hunk and take it in the house, and thaw it out. Then cut it up, and cook it, and eat it. Whatever it happened to be didn't make much difference, it was meat."

In the annual reports by Indian agents on conditions on the reservations, agent after agent stated that two of the greatest troubles were rustling of

Indian-owned cattle by whites and trespassing on Indian range by cattle from outside the reservation. The Rosebud roundup of 1902, without doubt one of the largest roundups of all time, was held for the purpose of cutting out cattle owned by outsiders to stop the cattle from eating the reservation grass.

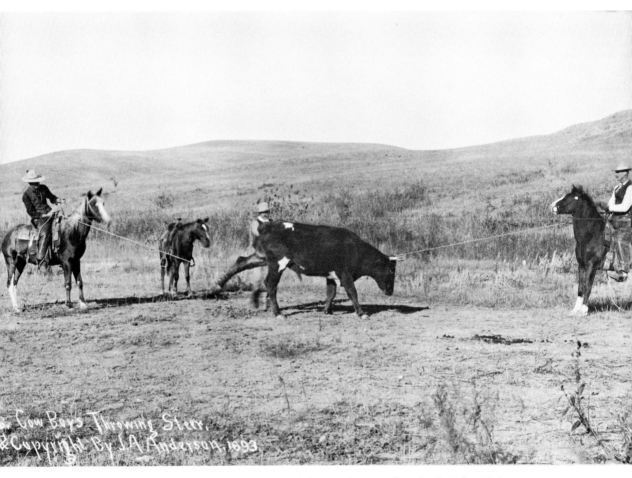

Cow Boys Throwing Steer.
Copyright By J A Anderson 1893

PLATE 181. Cowboys holding a steer with lassos (copyright 1893). John Neiss, a prominent rancher and issue-beef contractor, is riding the horse at the right.

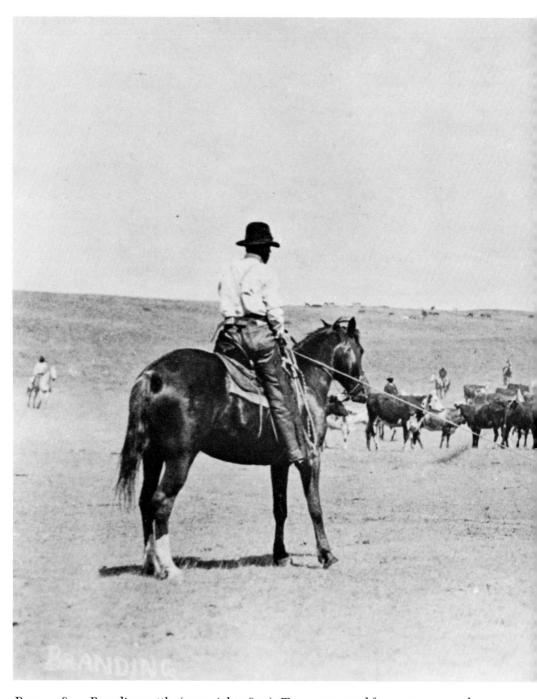

PLATE 182. Branding cattle (copyright 1893). Two ropers and four men are work-
ing with the animal that is down. Eight men who are helping to hold
the herd can be seen on horses in the background. The man on the

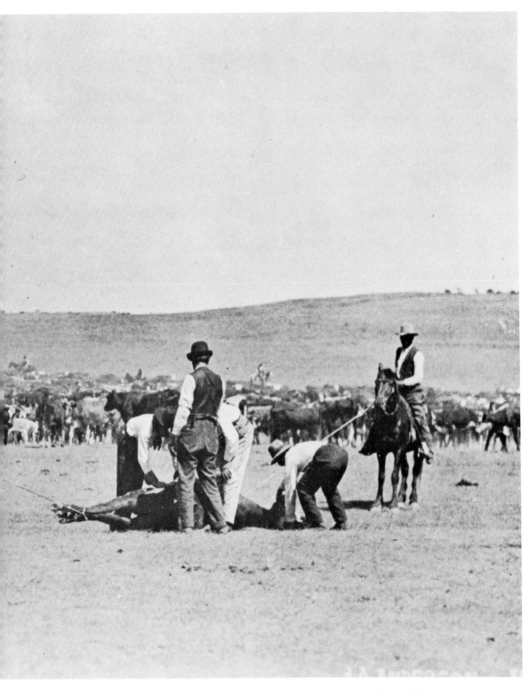

horse in the left foreground, holding a lariat on the steer's hind legs,
is Jules Sandoz.

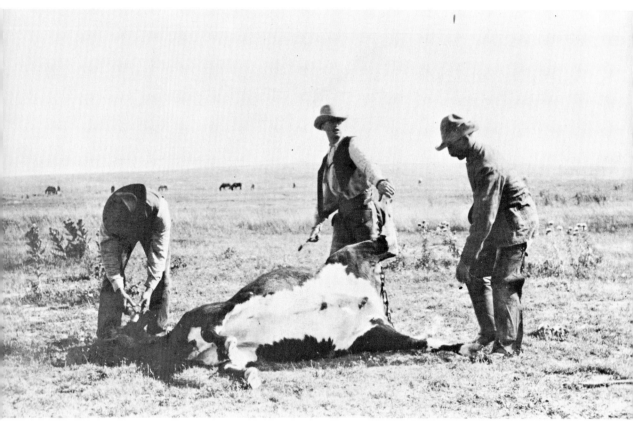

PLATE 183. Ranchers butchering cattle on the prairie (copyright 1893). A steer
has been shot, and the men are skinning him. The man in the dark
vest (center) is John Neiss. The others are undoubtedly ranch hands.
The man on the left seems to be examining an earmark. A number of
horses are grazing in the middle background.

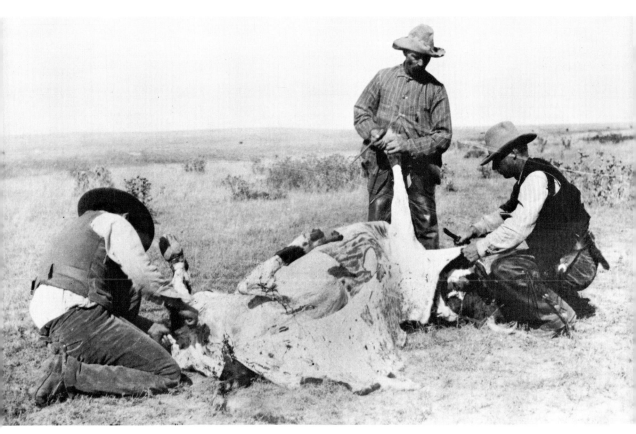

PLATE 184. Ranchers butchering cattle on the prairie (copyright 1893). The job of skinning is now about half done. The carcass will be left on the hide to keep it clean until the work of skinning and dressing is complete. Then it will be divided, probably into quarters, and loaded onto a wagon to be hauled to ranch headquarters, where it will be hung up. The hide will be rolled up, and if it is not soon sold to the trading post, it will be salted.

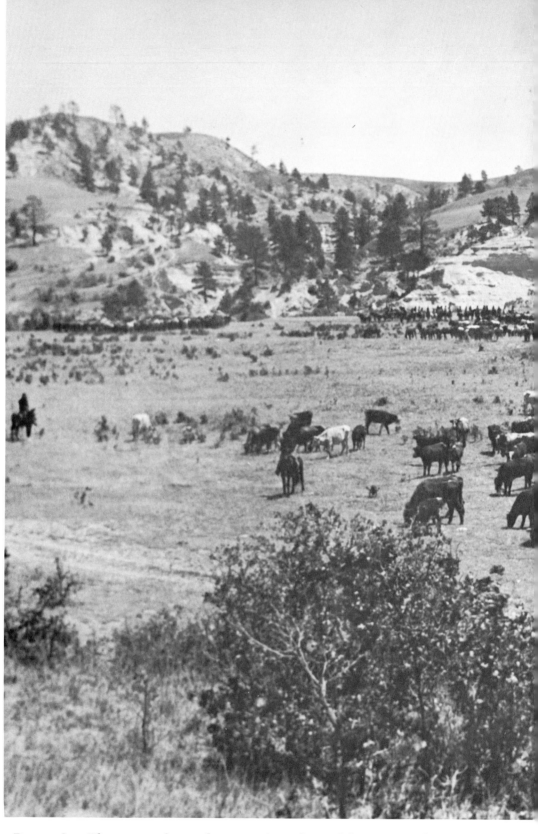

PLATE 185. The great cattle roundup, 1902. According to Jake Metzger, there were
sixteen wagons in the roundup and 60 riders to each wagon, making a
total of 960 riders. Each rider had a string of 10 horses; thus 9,600

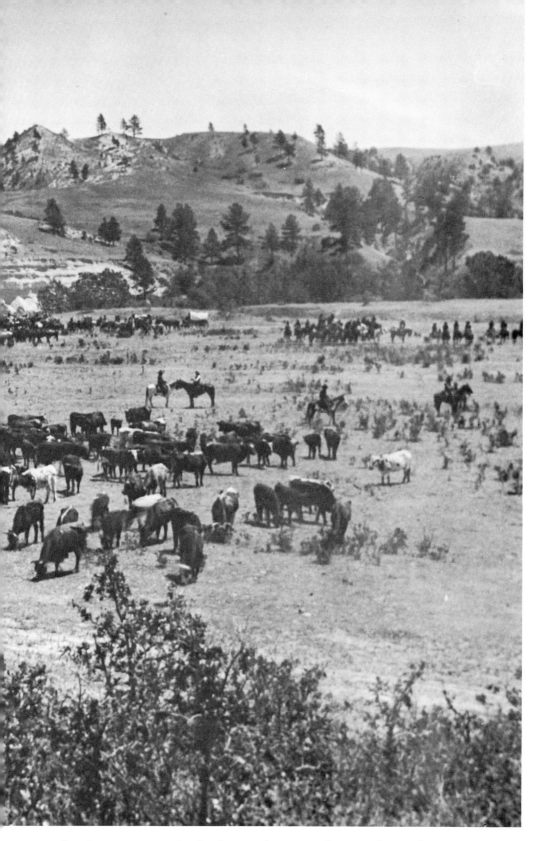

riding horses were involved. The roundup covered an area larger than
some of the eastern states.

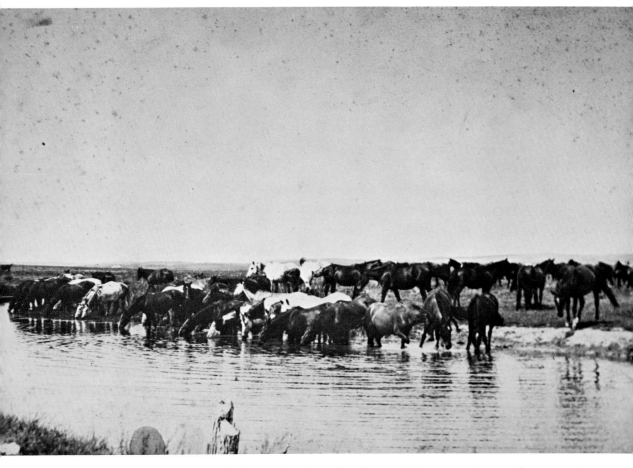

PLATE 186. Part of the roundup horse herd, 1902. The trespassing cattle were cut out from the cattle belonging on the reservation and counted. Alex Bordeaux, Jr., who witnessed the counting, reports that there were 62,000 head. The owners had to pay $1.25 a head to reclaim them. In later years cattle owners outside the reservation were allowed to rent grazing rights there for $1.00 a head a year.

19

Indian Portraits

Anderson maintained a workroom and studio in his home in Rosebud. Indians sat in this room before a painted scene or a plain screen backdrop, as others had done earlier in his studio at Fort Niobrara. Some of the clothing and regalia displayed in these pictures belonged to the people photographed; others were owned by Anderson (see Plate 232).

The faces of the Indians in these portraits are invariably severe and unsmiling. It is true that Anderson worked during a particularly serious period in the history of the race. The Brulé Sioux had recently lost many of their number in war and had been forced to give up their land, their natural food supply, and their very way of life. But the real explanation for their solemnity had more to do with long-established customs than with immediate circumstances. Just as the various Indian celebrations and dances required that "Headmen and Chiefs dance sedately and with dignity," a posed photograph was an occasion that demanded dignity on the part of its subject. To be photographed was an awesome experience, and it is evidence of the Indians' high regard for Anderson that they allowed him to take their pictures. Even today some of the women on the Rosebud Reservation will not permit anyone to photograph them.

The various chiefs and subchiefs in these pictures were not always accurately ranked by Anderson in his notations on the prints. He sometimes gave a man the title of chief when the man did not in fact bear such a title, and at other times Anderson omitted the title when it would have been proper to use it. The titles used in the legends for these portraits were supplied by our identification consultants.

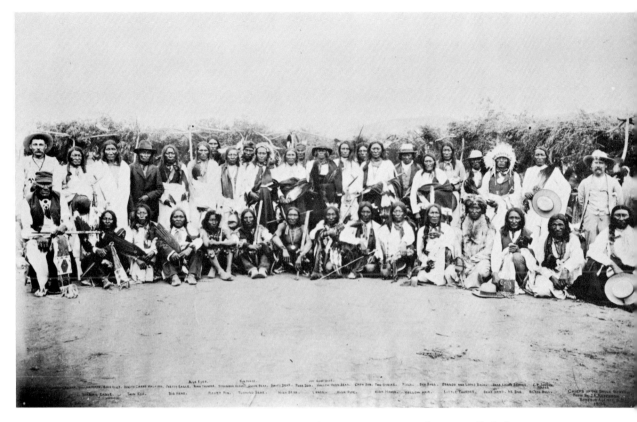

PLATE 187. Men of the Brulé Sioux, Rosebud Agency, 1894. Anderson called this large group of identified men "Chiefs of the Brulé Sioux," although not all of them are chiefs—or even Indians.

Front row, left to right: Tall Mandan, Turning Eagle, Thin Elk, Big Head, Picket Pin, Turning Bear, High Bear, Lance, High Pipe, High Hawk, Yellow Hair, Little Thunder, Bear Head, He Dog, Black Bull.

Second row, left to right: Louis Roubideaux, interpreter; Whirlwind Soldier; Yellow Horse; Good Voice; White Crane Walking; Pretty Eagle; Ring Thunder; Stranger Horse; Quick Bear; Swift Bear; Poor Dog; Hollow Horn Bear; Crow Dog; Two Strike; Milk; Sky Bull; Stands and Looks Back; Bear Looks Behind; Colonel Charles P. Jordan.

Third row, left to right: Blue Eyes, Big Horse, Joe Good Voice.

Individual portraits of some of these men follow.

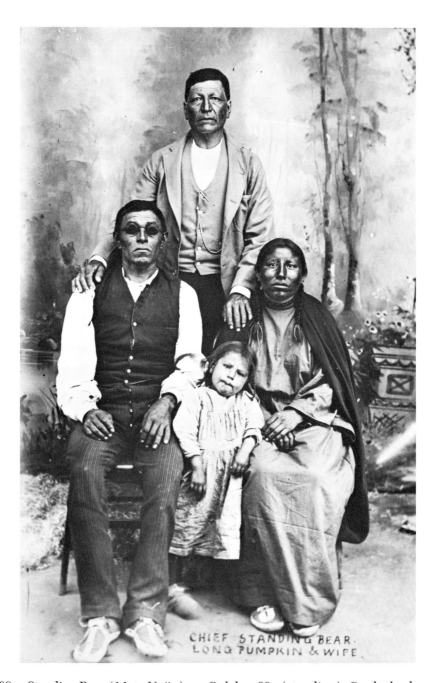

PLATE 188. Standing Bear (Mato Najin), an Oglala, 1887 (standing). On the back of the print in the Sioux Indian Museum, is a notation in Anderson's handwriting: "Standing Bear at Fort Niobrara in 1887." Standing Bear was from the Wamblee District, Pine Ridge. Long Pumpkin and his wife and child are seated in front.

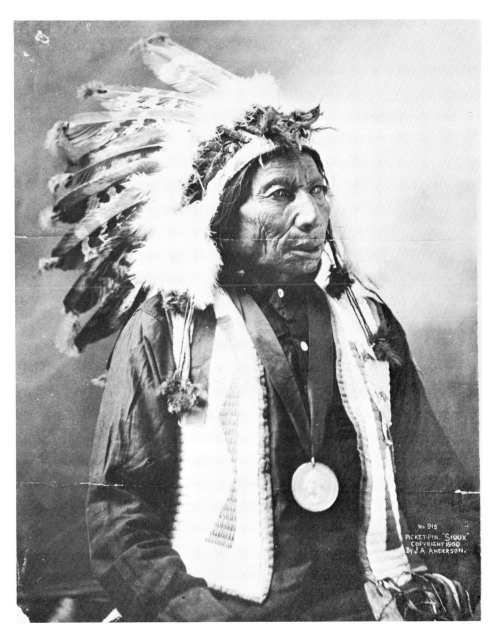

PLATE 189. Picket Pin (Wihinpaspa), Cut Meat District (copyright 1900). Picket Pin was especially competent in making bows, bow cases, arrows, and shields, which he traded to the trading posts and to individuals. He died of starvation at his home on the reservation, probably in 1904. His death was reported by Remington Schuyler, who wrote: "Often in the winter Indians died right out on the Rosebud Reservation from starvation. I do not know whether it is so today [1921], but it was up to 1904." (No. 915 in Anderson's numbering.)

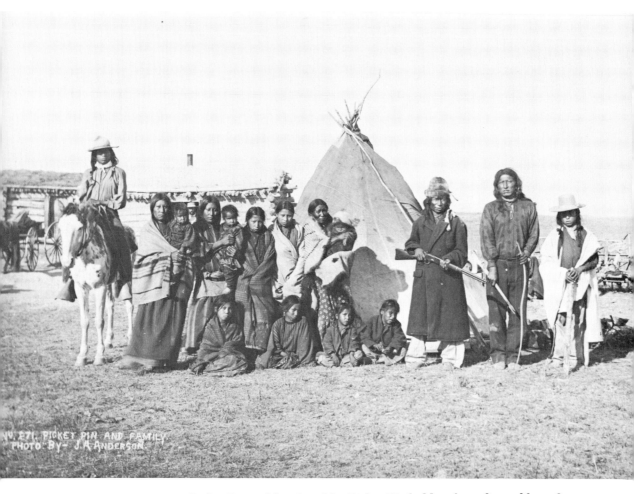

PLATE 190. Picket Pin and family, 1889. Picket Pin holds a forty-five-caliber 1873-
model Winchester, "the gun that won the West." His son William, at
his left, holds a strung bow and arrows. A sulky rake and part of a
mower are visible in the right background. These unused pieces of
machinery were often seen around the homes. (No. 271 in Anderson's
numbering.)

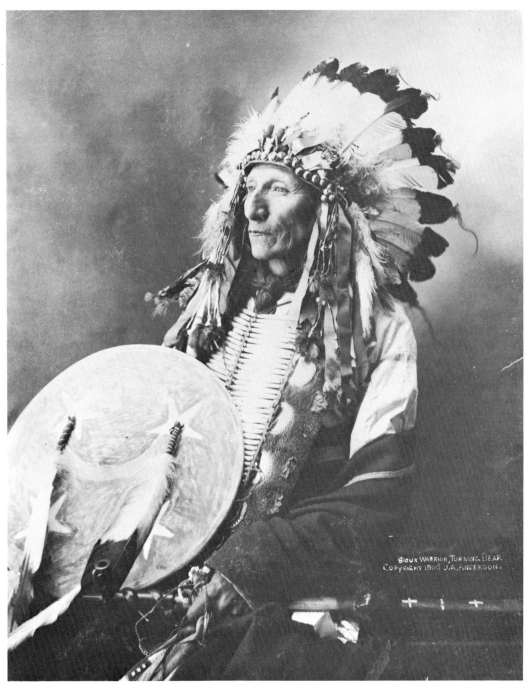

PLATE 191. Turning Bear (Mato Kawinge), Agency District (copyright 1900).
Turning Bear was killed by a train at the depot in Valentine in 1910.
This event is recorded in the winter count of Sam Kills Two, who was
also called Beads. Of another winter count Dr. Hardin wrote: "High
Hawk says that he has a great history of the people kept by his father
and grandfather and himself that extends back many years. Their pic-
ture painting represents their tribal history. At their dance houses the
walls are often hung with painted curtains representing historical
events." (No. 900 in Anderson's numbering.) See also frontispiece.

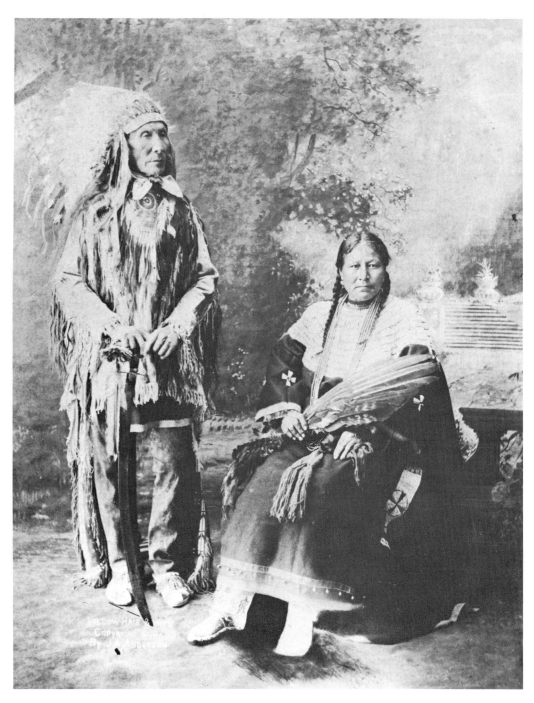

PLATE 192. Yellow Hair (Tapehin Jila) and his wife, Plenty Horses (copyright
1900). Yellow Hair was of either the Ring Thunder or the Soldier
Creek Camp, Agency District. He was born in 1835 and was still living
in 1910. (No. 908 in Anderson's numbering.)

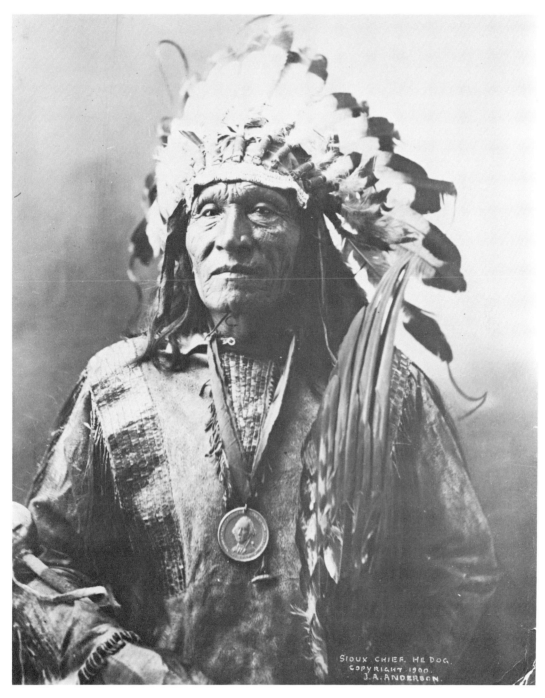

PLATE 193. He Dog (Sunka Bloka), a subchief, Cut Meat District (copyright 1900). He Dog was a prominent Sioux for whom two schools were named, one a modern brick building. The home that the government built for him was visible for many years from the road west from Parmalee. (No. 918 in Anderson's numbering.)

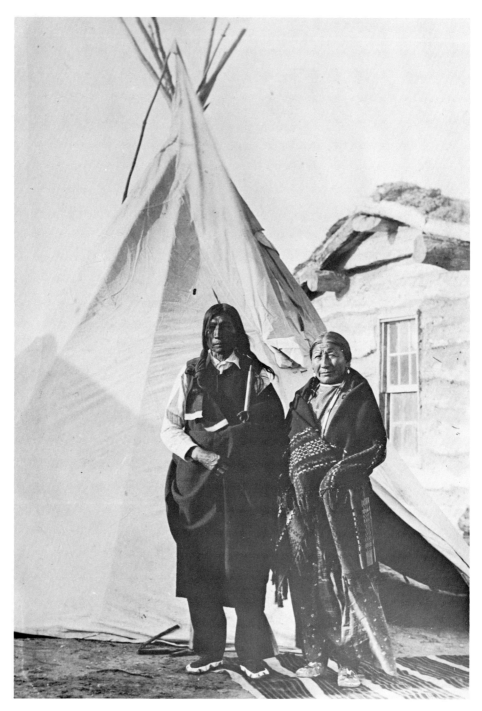

PLATE 194. He Dog and his wife, 1889.

PLATE 195. Good Voice (Ho Waste), a subchief, Oak Creek District (copyright
1900). Good Voice was a scout for the United States Army. The *Todd
County Tribune* reported on June 20, 1929: "On July 9 and 10 the

266

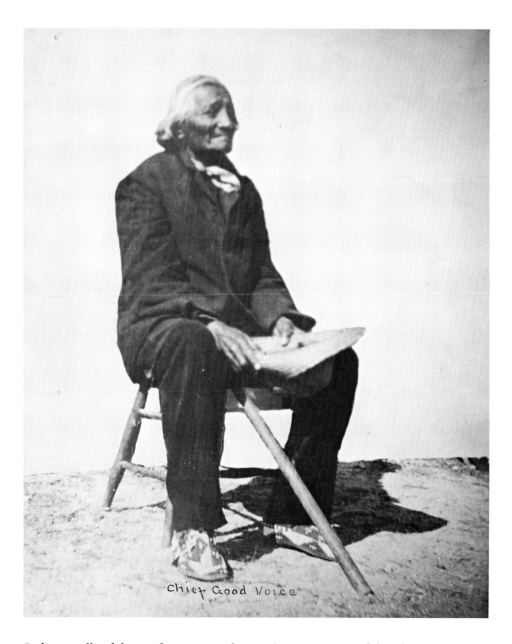

Chief Good Voice

Indians will celebrate the raising of a tombstone presented by the Government as commemorating his service as a U.S. Army Scout to Chief Good Voice. Good Voice was known as a chief who induced his Indians to stay away from the Ghost Dances and to work their land and care for their stock and it was through his efforts that the first church and school were built at Okreek."

Oak Creek and Okreek are the same district. When it applied for a post office and mail service, the Post Office Department reportedly replied that it would not accept any town name which consisted of two words (an interesting example of centralized authority in action). The people then suggested Okreek, which was accepted.

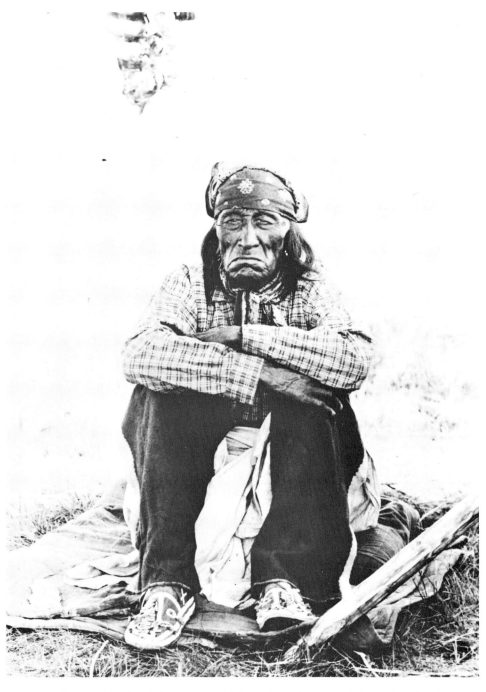

PLATE 196. Chief Ring Thunder (Wakinya Can Gleska), Ring Thunder Camp, Agency District. Ring Thunder was born in 1841. His wife was Look at Her.

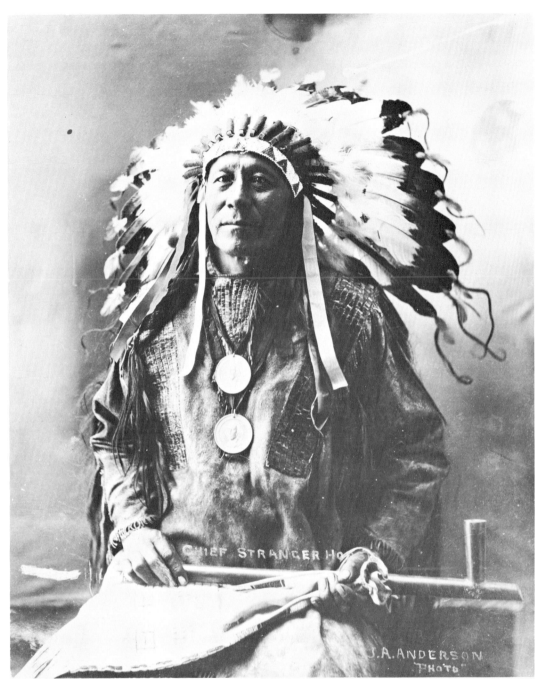

PLATE 197. Chief Stranger Horse (Tasunke Tokeca), Butte Creek District (copy-
right 1900). Stranger Horse wears two Washington Peace Medals. He
sold one medal to Anderson, and today it is owned by a member of the
Anderson family. In the Anderson collection at the Sioux Indian Muse-
um is a Washington Peace Medal which may be the other medal in
this portrait.

(Continued on page 270.)

The obiturary for Stranger Horse in the *Mellette County Pioneer* (Wood, South Dakota), reflects the esteem in which he was held:

"Chief Stranger Horse, 78 years old, died Friday morning May 19, 1922 . . . of tuberculosis which developed from a cold contracted last fall when he was a guest of President Harding in Washington. A noted warrior and diplomat, this was the last of many trips to Washington in the interest of his people.

"During the early part of his life he was noted as a warrior and in many wars with other Indian tribes he gathered many scalps from his enemies, but he was never known to raise disturbances against the whites.

"He served in the U.S. Army as Indian Scout in Co. A under Gen. Crook in 1876–77, in an expedition against the northern Sioux and Cheyenne in one of the worst winters known in this country. The Chief would have been a pensioner had he lived a month longer. He applied under the Survivors of Indian Wars Act but the usual red tape in such matters delayed it so he did not enjoy that privilege."

PLATE 198. Quick Bear (Mato Oranko), a subchief, Black Pipe District (copyright 1900). Quick Bear was prominent in efforts to fend for the Indians during the era of Spotted Tail and is still held in high esteem today. His wife was Looks at the Road. Their son, Reuben Quick Bear, carried on the family tradition. He attended Carlisle Indian School in Pennsylvania, returned to clerk in a trading post, and later owned his own store. He believed that the Indians needed to adapt to the white man's ways in order to survive and did what he could to bring this about. He was the manager of the first big Fourth of July celebration on the Rosebud in 1897. He served as postmaster at Norris, South Dakota, and was one of the first commissioners of Mellette County.

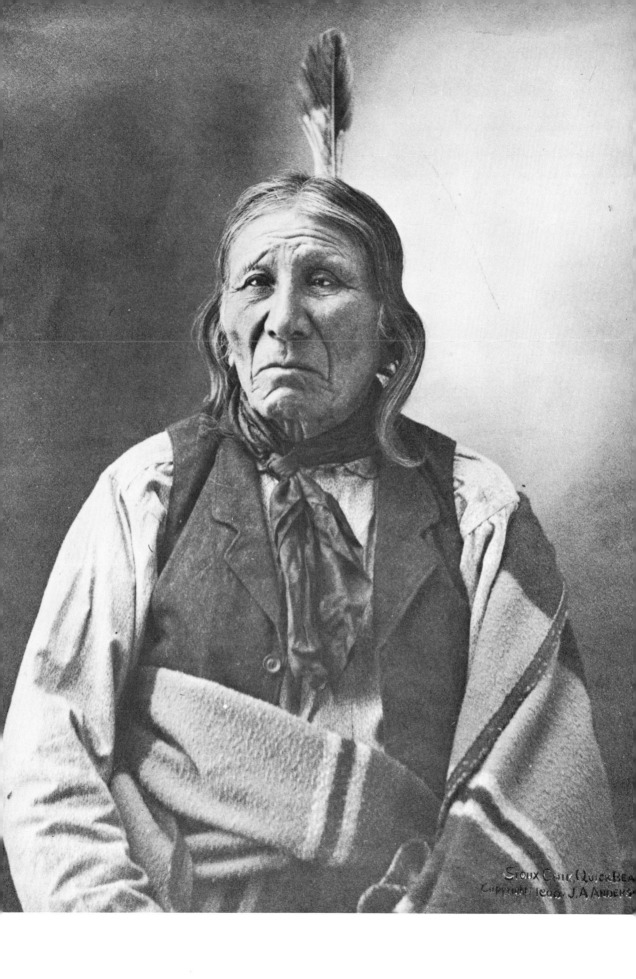

Sioux Chief (Quick Bear)
Copyright 1900. J. A. Anderson

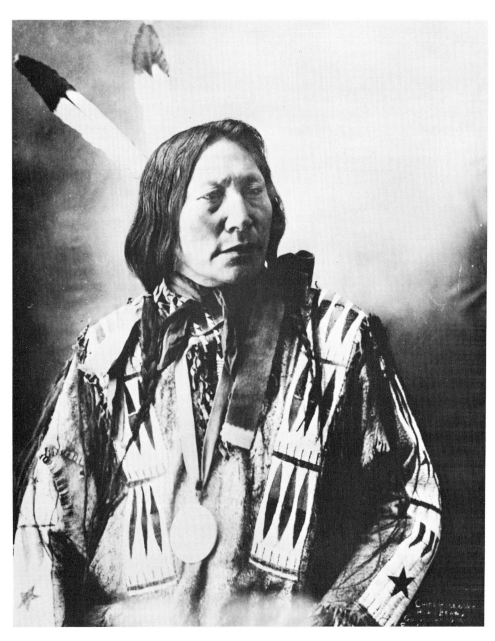

PLATE 199. Chief Hollow Horn Bear (Mato He Oklogeca), Cut Meat District
(copyright 1900). Born in 1850, he was one of the great Brulé leaders
in war and peace. An orator of unusual ability, he was chosen by the
Sioux to speak before the Crook Commission at Rosebud in 1889. He
represented the Indians in delegations to Washington, and his likeness
has appeared on American money. His picture was on the fourteen-
cent United States postage stamp of 1923, several of which are in the
L. M. Hardin Collection. Of him Dr. Hardin said: "Hollow Horn Bear
is one of the brainiest Sioux Chiefs. He looks like a thoroughbred
among a herd of ponies. In the Omaha dance he is proud, haughty, and
a fine specimen of physical humanity."

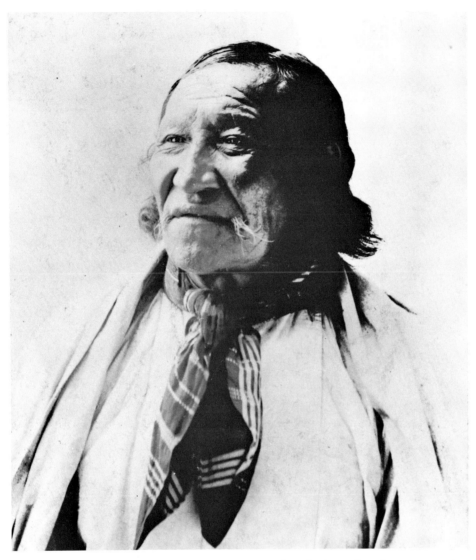

After the Sioux lost their land and were placed on reservations, Hollow Horn Bear tried by example and experimentation to help his people adjust to the new way. He was from a family of aristocrats. His brothers were Goes To War, Kills in Sight, Old Bearman, and Iron Shell. His sisters were Brave Bird, Blanket Long, and Pheasant.

PLATE 200. Crow Dog (Sunka Kangi) (copyright 1894). Crow Dog, born in 1832, was very active in tribal affairs. His wife was Catch Her. He is best known today for killing Chief Spotted Tail on August 5, 1881. Schuyler quotes Bob Emery, Sr., as saying that Crow Dog killed the chief because he believed that Spotted Tail was not working for the best interests of the people. Crow Dog did not accept an allotment until 1910, exactly twenty years after the first allotment had been made in 1890. (No. 214 in Anderson's numbering.)

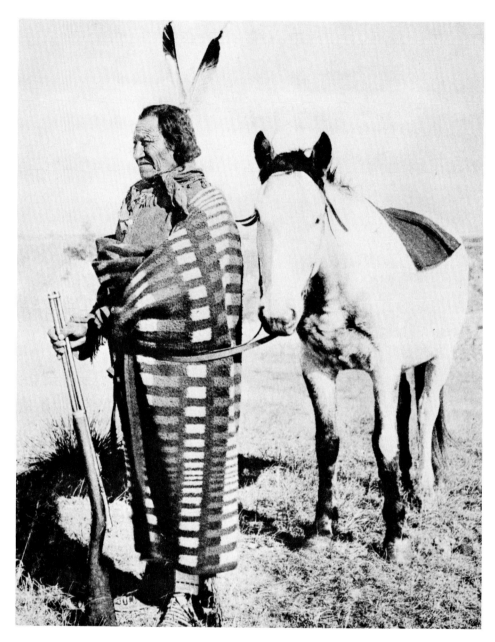

PLATE 201. Crow Dog with his horse and gun, about 1898. Mrs. Anderson took this picture one morning after waking Crow Dog and calling him out of his tipi. She brought some of the clothing he is wearing especially for the picture. The gun is a forty-four-caliber 1866-model Winchester, a popular weapon among the Indians. It was the first repeater made by Winchester and the first repeater the Indians obtained in quantity.

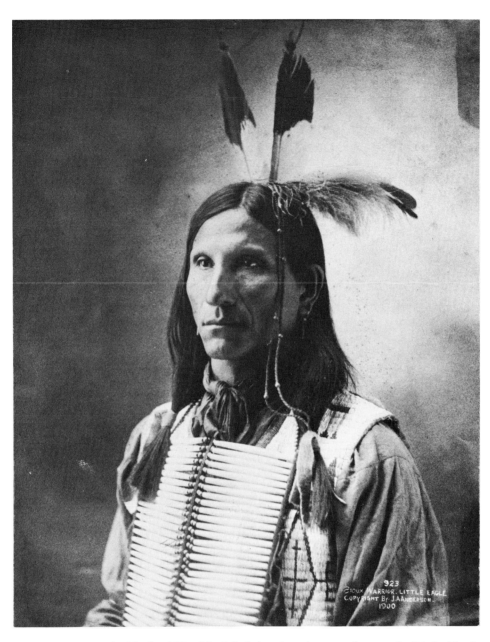

PLATE 202. Little Eagle (Wanbli Cikala), 1895 (copyright 1900). Little Eagle was born in 1863. His wife's name was Josephine. It is said that he loved to sing and was also quite a talker. This man should not be confused with the Hunkpapa chief of the same name. (No. 923 in Anderson's numbering.)

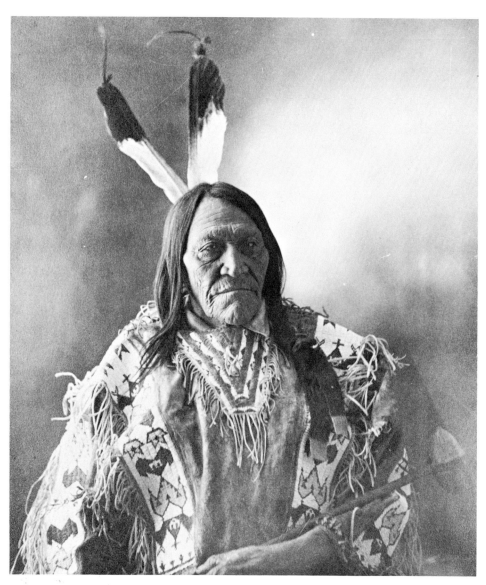

PLATE 203. Chief Two Strike (Nomp Karpa), Two Strike's Camp, Agency District, 1896 (copyright 1897). Two Strike received his name (also translated Knocks Off Two) when he killed two soldiers who were riding together on one horse. In his lifetime he counted twelve coups, including those he made at the Battle of the Little Big Horn. He was a leader of a group that attacked the Pine Ridge Agency during the chaos just after the Wounded Knee Massacre.

In April, 1893, he expressed concern about the corruption of his people by the white man. The *Valentine Republican* of April 7, 1893, reported:

"Two Strike, a Sioux Indian Chief of much notoriety called at this office last Friday in company with Father Lechleitner. His visit to the press was to publicly announce that parties have been furnishing the Indians of the Rosebud Reservation with liquor, which Chief Two

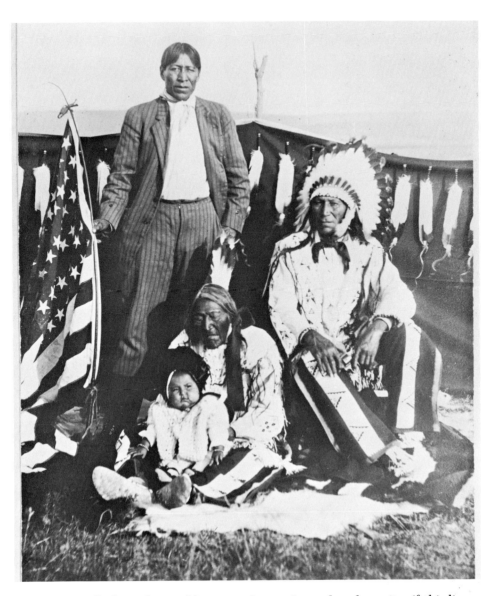

Strike is thoroughly opposed to and stated to the writer if this liquor business continued he would give the names of the parties who furnished it and he claims and so does Father Lechleitner that there are several guilty of the crime. Take warning, Gentlemen!"

Two Strike was one of a group of Sioux who went to the Cotton States and International Exposition in Atlanta, Georgia, with Colonel Charles P. Jordan in 1895. Born in 1819, he lived to be quite old. His wife's name was Brown Eyes. (No. 213 in Anderson's numbering.)

PLATE 204. Four generations of the Two Strike family, about 1906. Two Strike is holding his great-grandson. His son, Little Hawk, is wearing a war bonnet. His grandson, in the suit, is Poor Boy. The baby is Poor Boy's son.

277

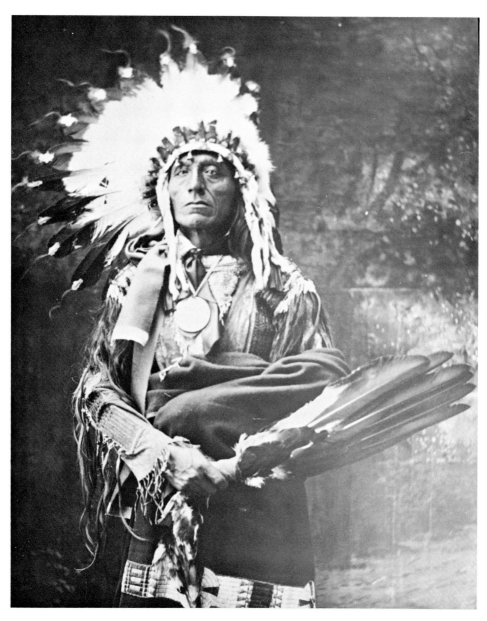

PLATE 205. Stands and Looks Back (Hakikta Najin), an Oglala, Butte Creek District (copyright 1900). Stands and Looks Back, the brother of Mrs. Charles P. Jordan, was an Oglala but lived all of his later life on the Rosebud and had a land allotment there. As a young man he had been one of Red Cloud's warriors in Montana. He was also known as Scoop.

Stands and Looks Back had the light eyes (sometimes referred to as yellow eyes, or even blue eyes) characteristic of some of the Red Cloud band. He was a close friend of Remington Schuyler. The Schuyler oil portrait of Stands and Looks Back hangs in the library at Bacone College, Muskogee, Oklahoma. In his last years the Indian spent long hours watching Schuyler work. He died in 1913 and is buried in the cemetery at Wood, South Dakota.

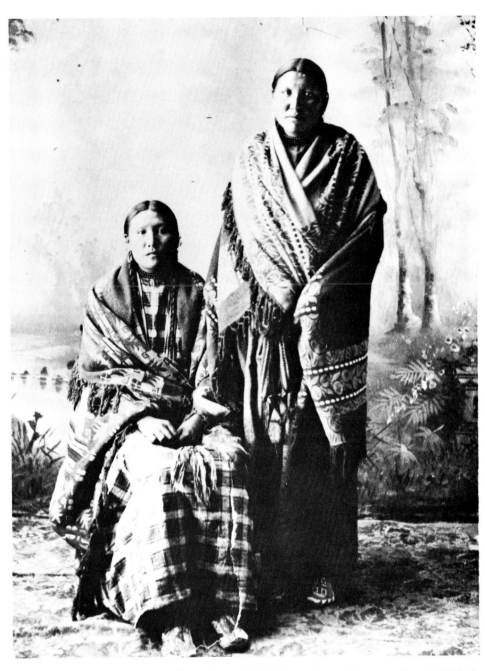

PLATE 206. Mrs. Stands and Looks Back (left) and Mrs. Turning Hawk (right), about 1896. Mrs. Turning Hawk was of the White River District.

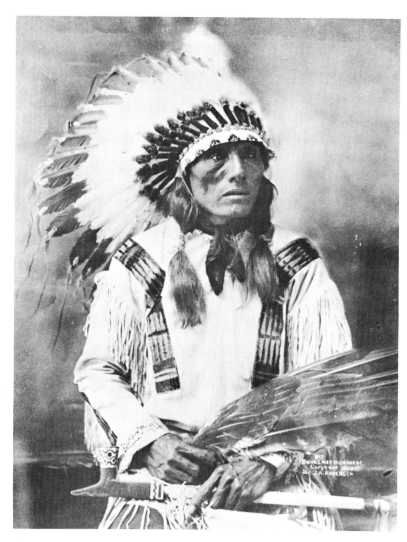

PLATE 207. High Horse (Tasunke Wankatuya), Two Strike's Camp, Agency District (copyright 1900). In 1922, at a party given by the Indians in honor of the Andersons, High Horse and Bull Man were the spokesmen, according to the *Todd County Tribune* of February 10, 1922. High Horse, who was born in 1852, was quite a friend of the whites. In his old age he made his home at police headquarters in Rosebud and often played at inspecting the clerks in the agency. His wife was Red Tail. (No. 917 in Anderson's numbering.)

PLATE 208. Eagle Man (Wanbli Wicasa), Black Pipe District (copyright 1900). This is one of several portraits of Eagle Man taken in this "ghost shirt," which probably belonged to Anderson. In writing about the Wounded Knee Massacre, Mrs. Anderson said:

"Five Ghost Shirts were found on as many dead. There are many Ghost Shirts in the country and claimed as having been worn in this

280

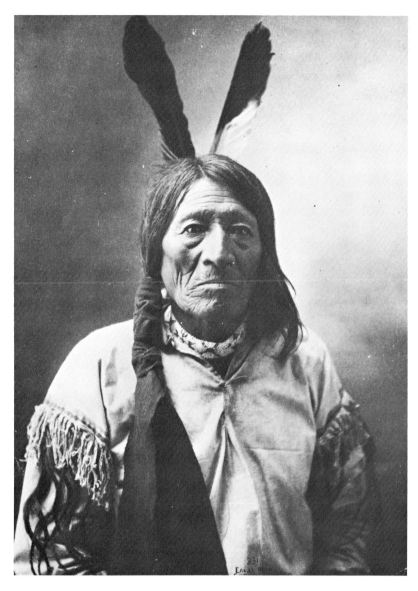

battle. This is false. These shirts were worn only while the Indians were dancing, but these had not been removed when the soldiers attacked. Of these five shirts, one was given to the Agent, Mr. Wright, one to the Colonel, two sent to the government and Mr. Anderson got the last."

This shirt is now in the Sioux Indian Museum at Rapid City.

Eagle Man was born in 1851 and was a cousin of Turning Bear and Red Fish. His wife's name was Singing Woman. He was a fine singer, and he sang war songs of the Sioux, which Anderson recorded on Edison cylinders. Night Pipe, another acomplished singer, sang Sioux love songs, which Anderson also recorded. The whereabouts of these recordings are now unknown. (No. 931 in Anderson's numbering.)

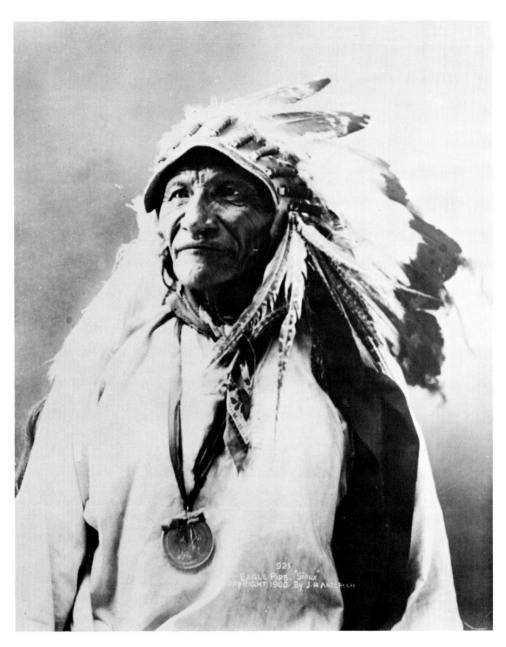

PLATE 209. Eagle Pipe (Wanbli Canompa), Two Kettle band, Little White River
District (copyright 1900). Eagle Pipe, Turning Bear, Crow Dog, and
Two Strike led groups of Rosebud Sioux as they fled from the United
States Army to the Bad Lands for a time during the trouble in 1890.
(No. 921 in Anderson's numbering.)

282

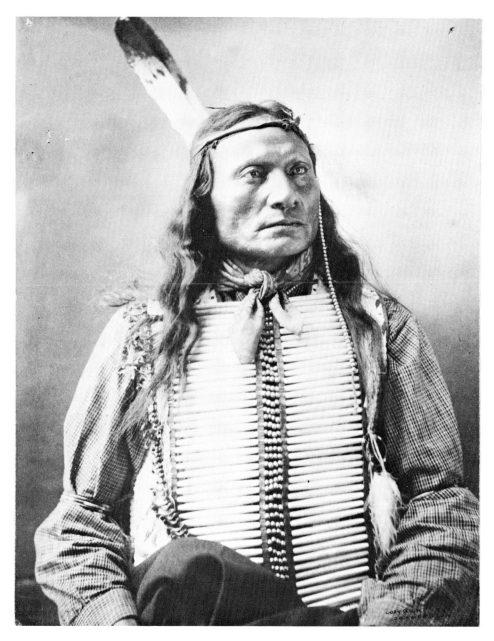

PLATE 210. Goes to War (Zuya Hiyaya), Cut Meat District (copyright 1900).
Goes to War was a brother of Hollow Horn Bear. He was born in
1855. His wife's name was Comes Amongst Them.

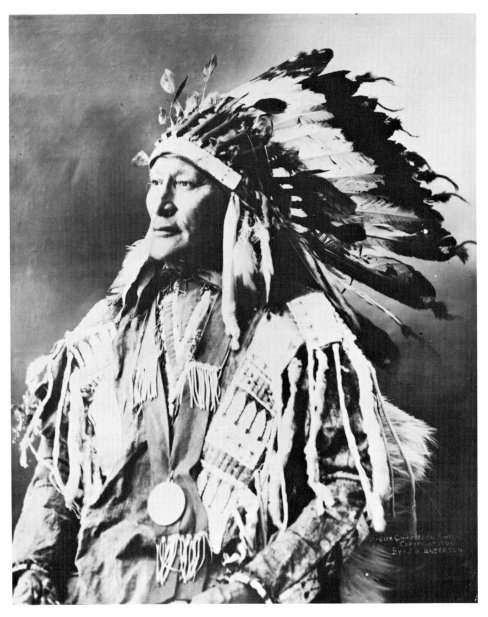

PLATE 211. Iron Shell (Maza Tanpeska), Cut Meat District (copyright 1900).
Iron Shell was a younger brother of Hollow Horn Bear. (No. 901 in
Anderson's numbering.)

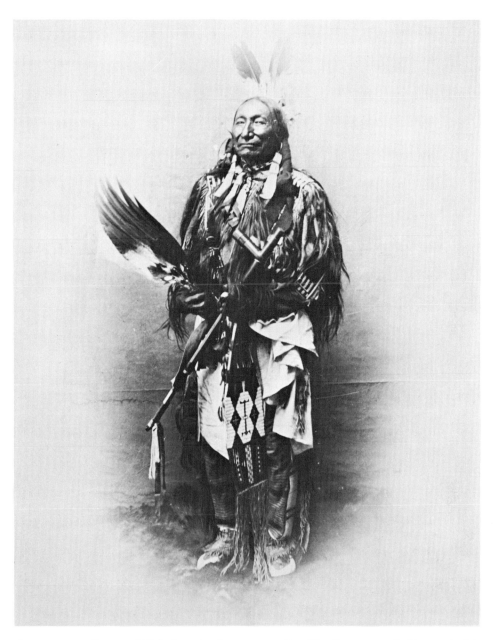

PLATE 212. Lance (Wahukeza), about 1900. Dr. Hardin reported, "Lance in his desire for deer skins will swap beaver skins for deer." He was born in 1834. His wife's name was Looks at Her Horses.

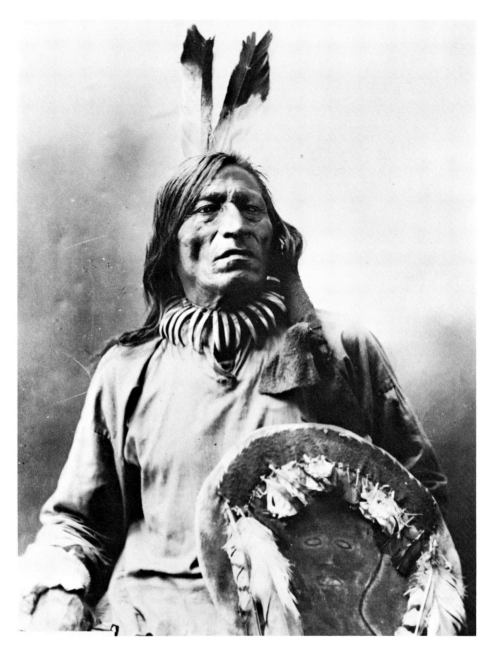

PLATE 213. Fool Bull (Tatanka Witko), Agency District (copyright 1900). Fool
Bull was a medicine man. He was born in 1844, and his wife's name
was Red Cane. On the back of the original print is a note in Mrs.
Anderson's handwriting saying that the shield is of buffalo hide and
that it was carried by Fool Bull in the Battle of the Little Big Horn. A
face is painted on the shield, which is now in the Sioux Indian Museum.
(No. 922 in Anderson's numbering.)

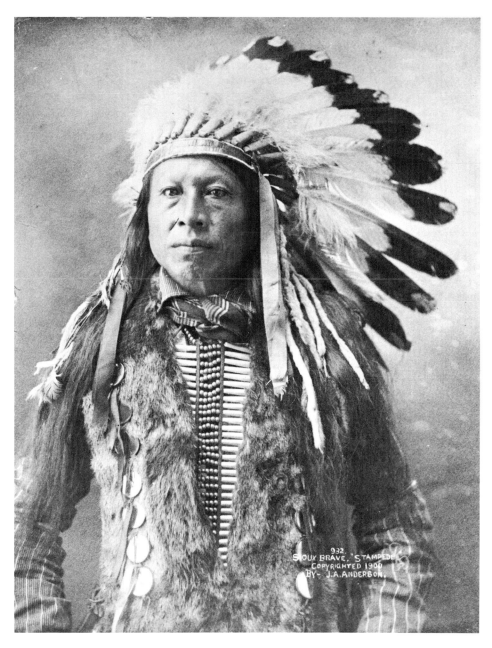

PLATE 214. Stampede (Najinca) (copyright 1900). Stampede wears an otter-skin
vest and a bone "hair-pipe" breastplate. His war bonnet is trimmed
with weasel. He was born in 1859. (No. 932 in Anderson's numbering.)

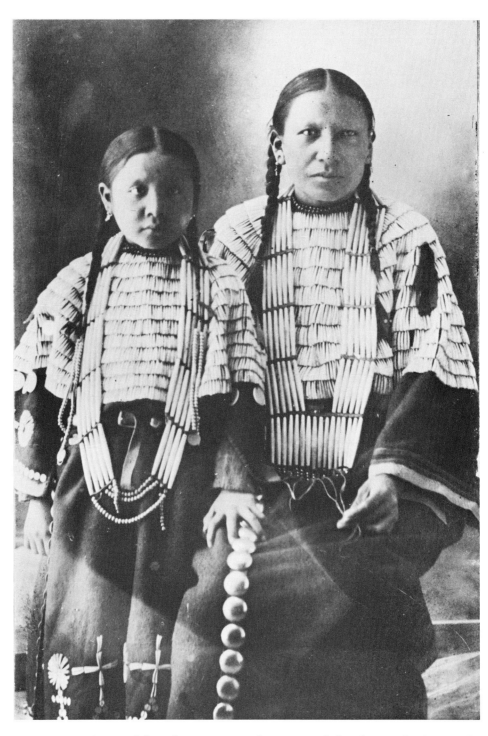

PLATE 215. Stampede's wife, New Haired Horse, and daughter, Ada (copyright
1900). Anderson took three pictures of this family in his home studio.

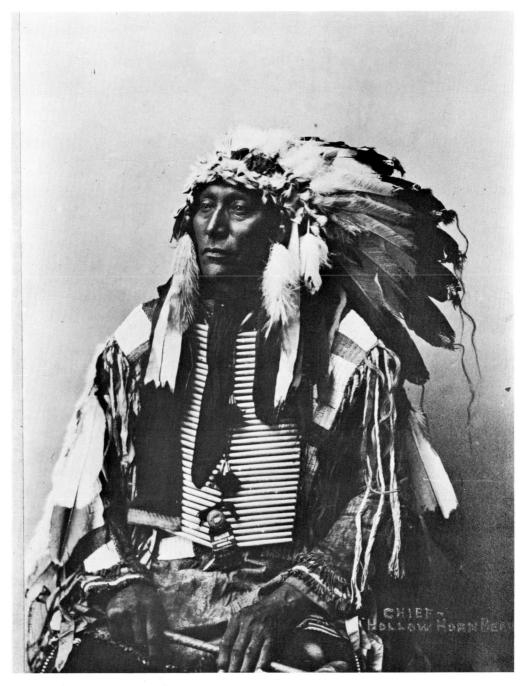

PLATE 216. Chief Hollow Horn Bear (Mato He Oklogeca), Cut Meat District.
This chief was one of the great Brulé leaders (see Plate 199). His wife's
name was Good Bed.

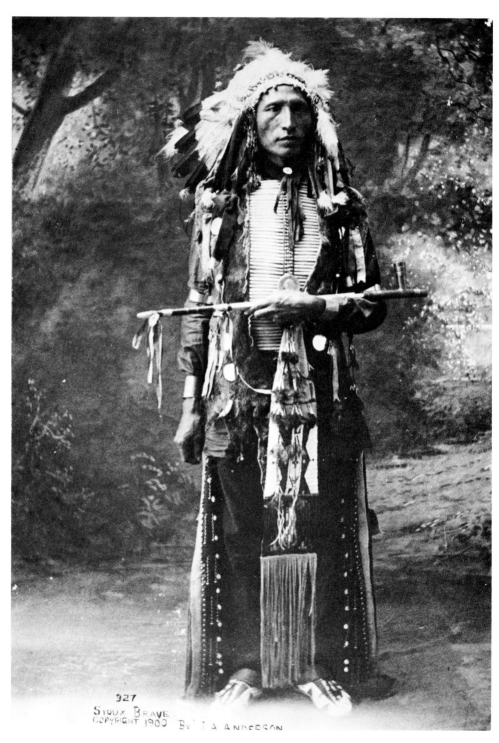

927
SIOUX BRAVE.
COPYRIGHT 1900 BY A ANDERSON

PLATE 217. Good Voice Eagle (Wanbli Ho Waste) (copyright 1911). Good Voice
Eagle was born in 1862. His wife's name was Mollie. This same studio
backdrop scenery was used in Black Horn's portrait (Plate 218). (No.
927 in Anderson's numbering.)

290

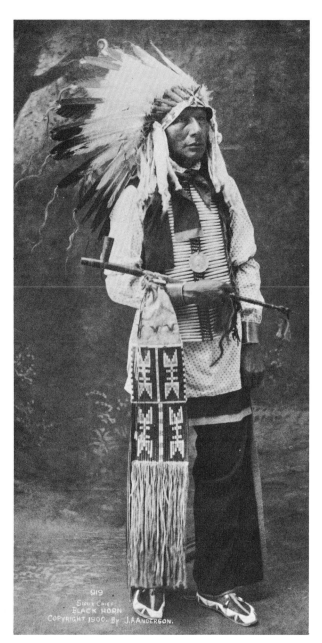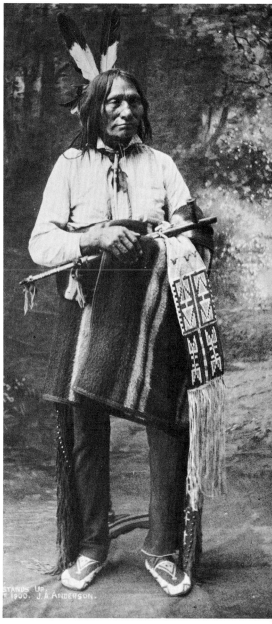

PLATE 218. Black Horn (Tahe Sapa) (copyright 1900). Black Horn was born in
 1852. His wife's name was Bad Humor. He is holding a beautifully
 quilled pipe bag and is wearing a hair-pipe breastplate. The men wore
 breastplates of horizontal hair pipes; those worn by women were
 arranged vertically (see Plates 145 and 215). (No. 919 in Anderson's
 numbering.)

PLATE 219. Bear Stands Up (Mato Najin) (copyright 1900). (No. 928 in Ander-
 son's numbering.)

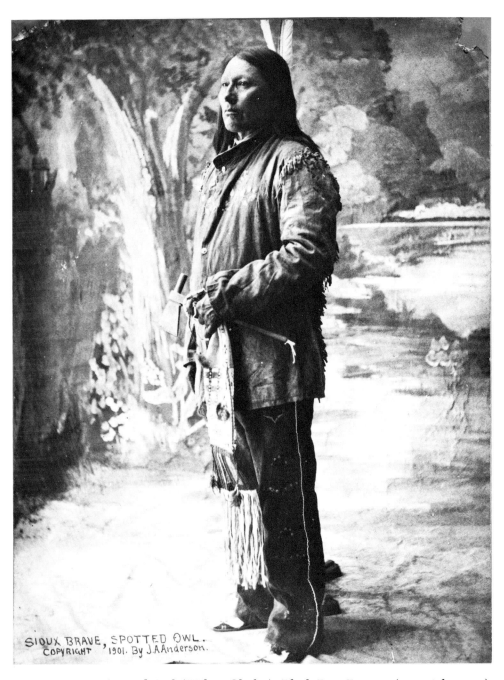

SIOUX BRAVE, SPOTTED OWL.
COPYRIGHT 1901. By J.A.Anderson.

PLATE 220. Spotted Owl (Hehan Gleska), Black Pipe District (copyright 1901).
Spotted Owl was one of the group of Brulés and Oglalas whom
Charles P. Jordan took to the Cotton States and International Exposi-
tion in 1895. His wife, Susie, was born in 1861.

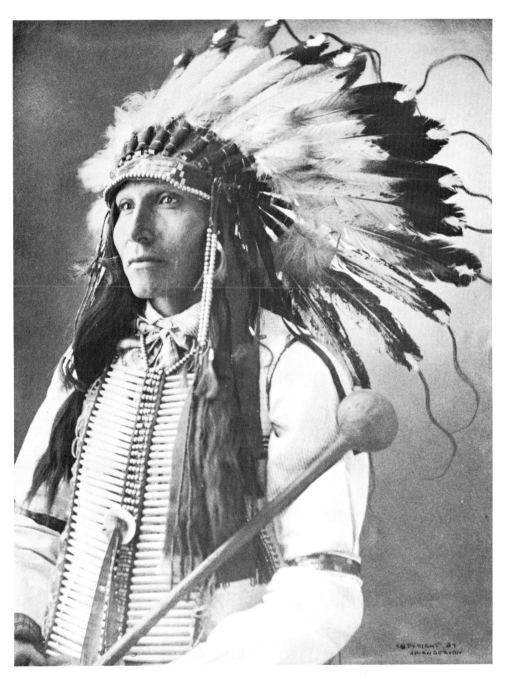

PLATE 221. Sioux brave (copyright 1900).

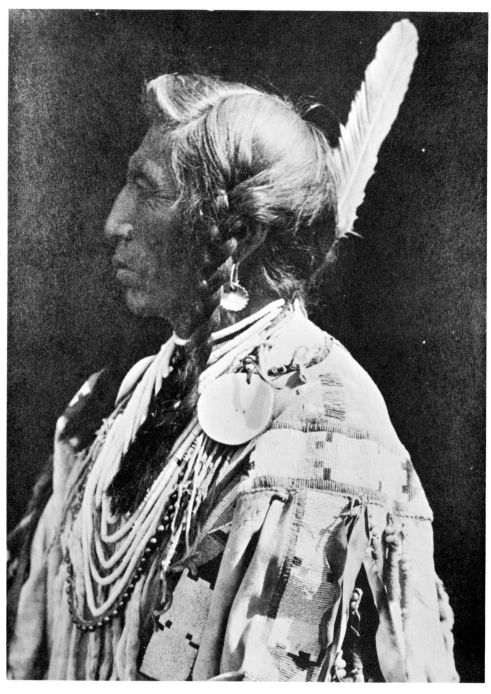

PLATE 222. Crow Chief (Kangi Itacan). Despite his name this man is said to have been a Sioux.

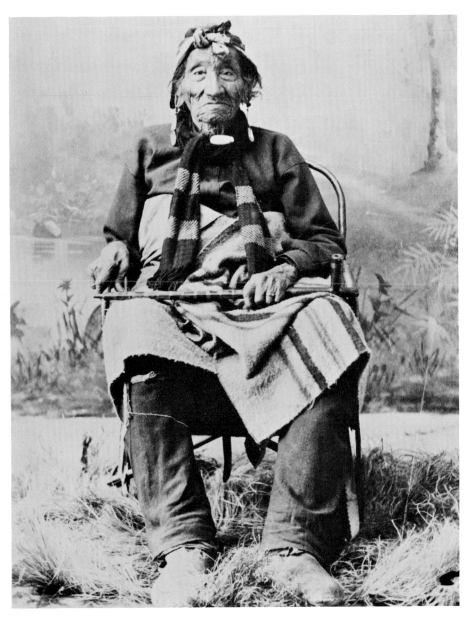

PLATE 223. Big Partisan, or Polecat (Blotka Honka Tanka), Butte Creek District. He lived to be over one hundred years old and in his active years was also called Grand Partisan. His allotment of 320 acres was half a mile south of the present town of Wood. It adjoined the area upon which the Butte Creek issue station was located, as well as one of the trading posts owned by Charles P. Jordan and sold by him to Albert K. Wood in 1913. Big Partisan's allotment also adjoined the allotment of Stands and Looks Back, his son-in-law. The Butte Creek issue station still stood, in fair condition, in 1963, but only some foundation stones remained of the old Butte Creek Trading Post.

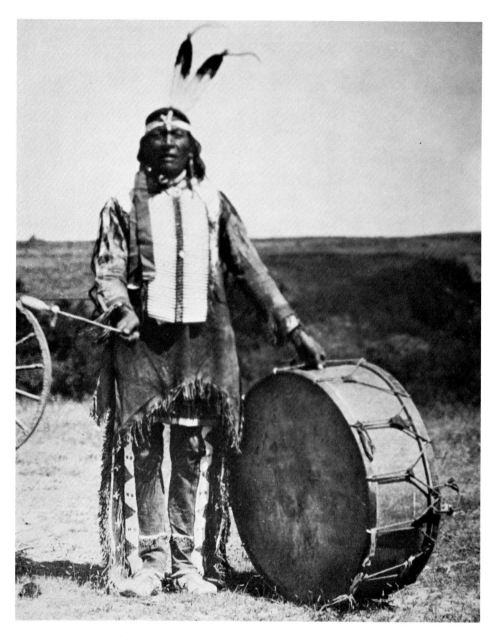

PLATE 224. Stands for Them (Nawica Kicijin).

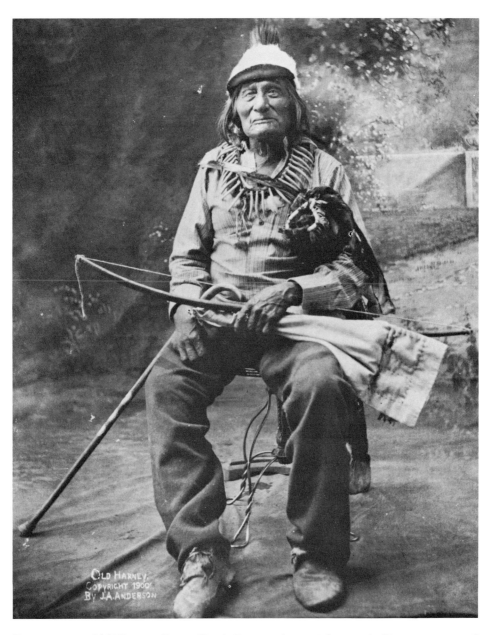

PLATE 225. Old Harney, Butte Creek District (copyright 1900). He was so named
because he had been a scout for General William S. Harney. He lived
near Oak Creek. (No. 913 in Anderson's numbering.)

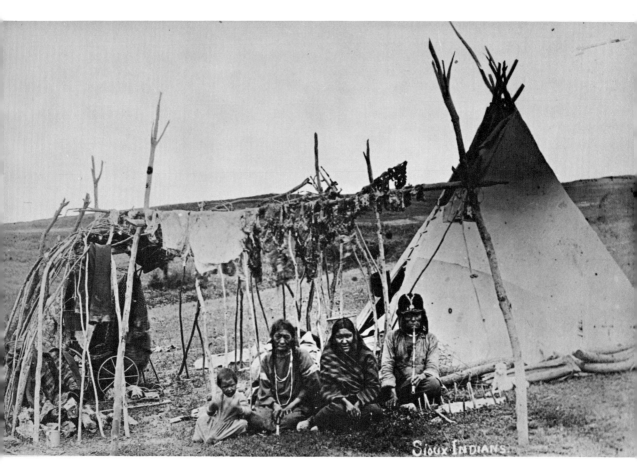

PLATE 226. Old Harney and his family at home, 1889. A wicker baby carriage is in the shelter at the left of the family tipi. The lower edges of the tipi cover are held down with short lengths of wood. Two small animal skins are staked out on the ground to dry, and meat hangs from a framework.

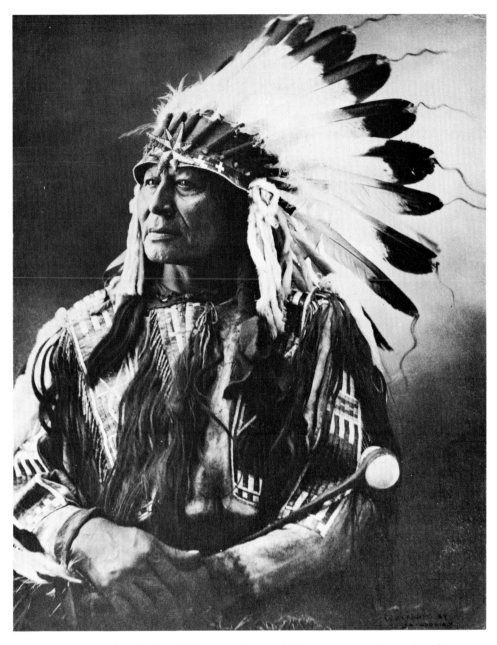

PLATE 227. Little Bald Eagle (Anin Kasan Cikala), 1903. He is wearing the same
shirt and war bonnet that a number of other Anderson subjects wear.

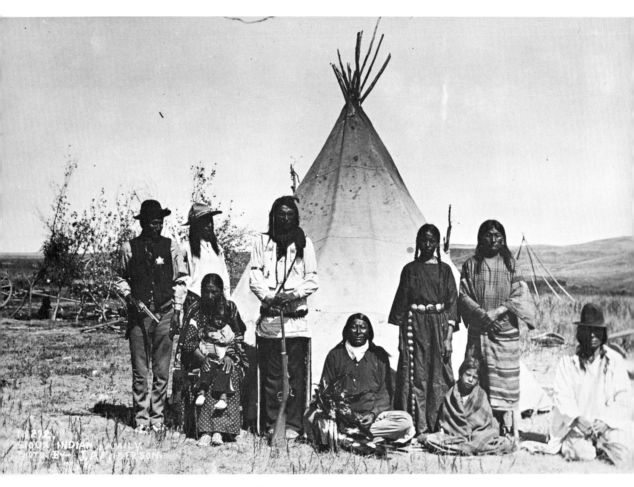

PLATE 228. Little Bald Eagle at home, 1889. Little Bald Eagle, here fourteen years younger than in his portrait (Plate 227), sits on the ground in the center. His wife and daughters are on the right. One of his sons is standing next to him holding a trap-door 1873-model Springfield carbine, which could well have been secured at the Little Big Horn, since Custer's men carried this model. This son may be Edmund Little Bald Eagle, who lived and died near Wood, South Dakota. The man with the star is said to be a member of a special police force. He holds an 1872-model single-action Colt revolver. (No. 272 in Anderson's numbering.)

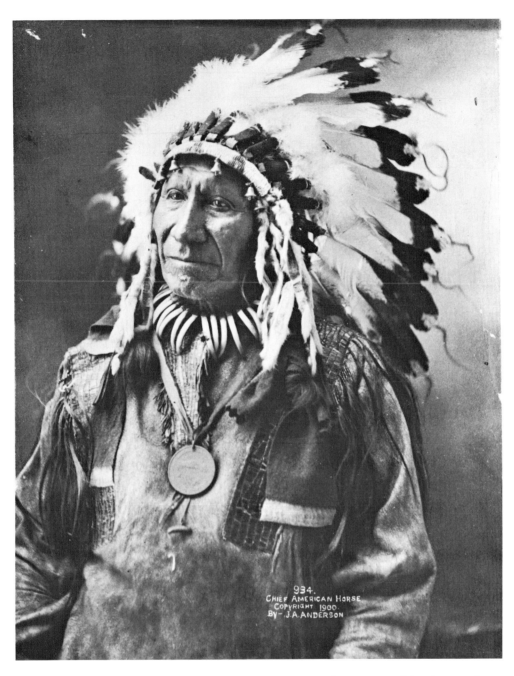

PLATE 229. Chief American Horse (Wasicu Tasunke), an Oglala (copyright
1900). He was a very prominent chief at Pine Ridge. In 1891 he led a
successful delegation to Washington which resulted in better adminis-
tration of Indian affairs and a more nearly adequate living ration. (No.
934 in Anderson's numbering.)

PLATE 230. Chief Red Cloud (Murpiya Luta), an Oglala (copyright 1901). Red Cloud was born in 1822 and died in 1909. He was probably the most powerful leader in the history of the Sioux. Red Cloud and the Charles P. Jordan family were always close friends. Mrs. Jordan had been a member of the Red Cloud band, and the chief became acquainted with Jordan soon after the trader's arrival at Fort Robinson in 1874. At the chief's request Jordan accompanied him to Washington in 1889 to confer with President Benjamin Harrison. During the train ride home from Washington, Red Cloud was accosted by a white man who in a loud voice demanded, "How many white men have you killed?" Red Cloud, who understood some English, drew himself up and told Jordan in Dakota, "Tell him I have fought fifty battles."

When Red Cloud went to the Rosebud to visit the Jordans in 1903, he took his grandson along to lead him, since by that time he was blind. Red Cloud himself was light-eyed, and he requested that Mrs. Jordan's light-eyed son William carry his name. William W. Red Cloud Jordan's right to this name has never been questioned by the Oglalas.

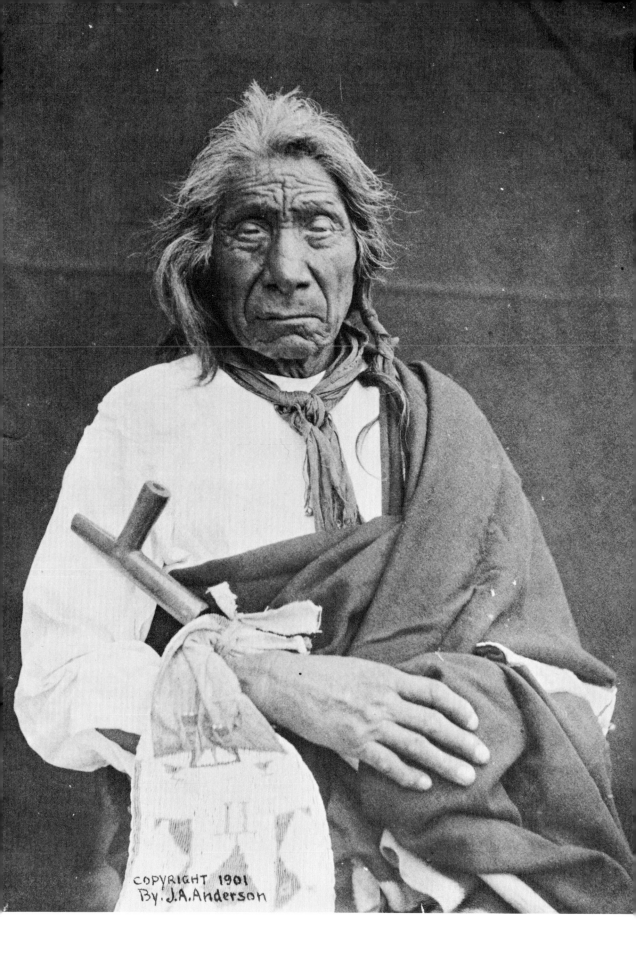

COPYRIGHT 1901
By. J.A.Anderson

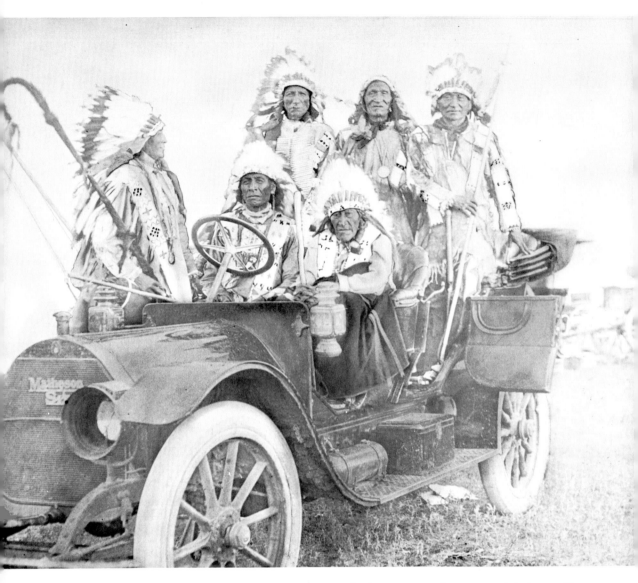

PLATE 231. The first car on the Rosebud, about 1910. The car is a Matheson Six. Front seat, left to right: High Pipe and Chief Two Strike. Back seat, left to right: first man on left, Turning Bear; center, He Dog. The man at the far left and the one at the right in the back seat could not be identified. The picture was taken no later than 1910, because Turning Bear was killed by a train in Valentine in that year.

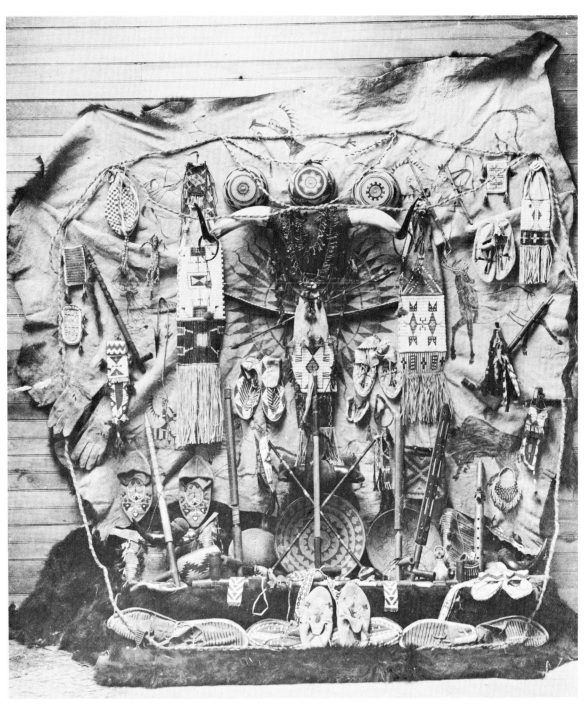

PLATE 232. Some of Anderson's Indian materials. Anderson owned a large quantity of Indian materials, and some of the clothing and accouterments worn and carried by the Indians he photographed in his home studio were furnished by him. It is possible that after the portrait of a man was made, the subject later sold or gave the clothing in which he was

(Continued on page 306.)

photographed to Anderson. That was the case with Fool Bull's shield and the ax with which Two Strike killed the two soldiers. Both items are today in the collection of the Sioux Indian Museum.

Custom among the Sioux decreed that certain items could be worn only by those who had earned them, and then only sparingly. It seems obvious, therefore, that some of the individuals in these photographs are wearing just for this occasion finery supplied by Anderson, since they could not all have qualified for these distinctions.

Eleven individuals, for instance, are wearing presidential medals. The number of different medals cannot definitely be determined from the photographs, but there are at least three, because Stranger Horse is wearing three—two suspended from ribbons and a third attached to a bone breastplate. The third medal is also worn by two other individuals in their portraits. It is most unlikely that all these men owned such medals, unless they were replicas made and sold by Lamere, the Indian from Pender, Nebraska, who owned the dies for the Washington Peace Medal and made a profitable business in reproducing them until the other Indians realized what he was doing. This story is told by B. L. Belden in *Indian Peace Medals* (New York, American Numismatic Society, 1927).

Many of the medals in the portraits cannot be identified, but two presidential medals are shown: (1) the Washington Medal, worn by He Dog, Picket Pin, Eagle Pipe, and Stranger Horse (who wears two) and (2) the Andrew Johnson Medal, worn by Stands and Looks Back. A third medal, not shown in this book, is the Chester Arthur Medal, worn by One Star.

There is an authentic Washington Peace Medal in the Sioux Indian Museum, and Stranger Horse owned one that was bought by Anderson and is now owned by a member of the Anderson family. Whether that one is authentic is not known. The Andrew Johnson Medal worn by Stands and Looks Back was in the Jordan family for years. A Chester Arthur Medal, in the Anderson collection at the Sioux Indian Museum, was presented by President Arthur to Chief Standing Cloud, who gave it to his grandson Ben Brave Hawk, who in turn sold it to the museum.

In the portraits available to us sixteen individuals are wearing war bonnets. Fifteen different bonnets are shown; Black Horn and Little Bald Eagle are shown wearing the same one. Decorations on the headbands of the other bonnets include beadwork, quillwork, brass beads, brass or metal sleigh bells, and clapper bells.

Thirteen of the men are wearing buckskin shirts, either beaded or quilled. There are ten different shirts; one is worn by four different

men. One is wearing a muslin scalp shirt, one a ghost shirt, and other shirts of calico, obviously their own. Four different beaded vests are shown. Three mirror-decorated otter-fur vests are shown, at least two of which are different. Seven men are wearing tubular-bone and brass-bead breastplates of five different styles.

Five men are holding beaded pipe bags, all different. Various styles of pipes are shown. Three men are holding the same pipe bowl but with different stems. In a print not included in this book, one man holds a stem with a bowl while the other holds a stem without a bowl. This may support the theory that the stem alone was the calumet, but it may merely illustrate the expediency of the moment.

20

Supplication to the Great Spirit

THE Sioux had customary ways of propitiating the gods, from offerings to supplications.

The belief had long prevailed that the Thunder Bird was a god to be feared. William W. Jordan wrote in a personal letter to the authors: "If a woman dreamed about a Thunder Bird it was necessary, in order to save her from being killed by lightning, that she carry out some sacrificial act, such as using her bare hands in feeling around in the boiling soup to pick out the head of a small dog. The participant in such a ceremony usually dressed in hideous fashion, perhaps wearing gunny-sack clothing with a mask over the head. Sometimes she would run hard toward someone, in order to scare them, but without touching the person."

PLATE 233. A medicine man's offering to the Great Spirit, tobacco, about 1896. Tobacco was also one of the offerings that a young man made on his vision quest.

PLATE 234. An appeal to the Thunder Bird, 1929. "One evening [in the summer of 1896] a thunder storm came up," Mrs. Anderson wrote: "I went over to the store porch where an Indian clerk was standing watching the storm, then I saw an Indian standing on a hill with both arms uplifted and he said, 'Praying to the Thunder Bird so the people won't be struck by lightning.'

"That picture stayed with me for years so in 1929 when I had my little book of verses published and it was illustrated by Mr. Anderson which we named "Sioux Memory Gems," I described that scene to him and he got an almost exact photograph for my book. His picture was later used on the outside cover of the *American Forestry Magazine*."

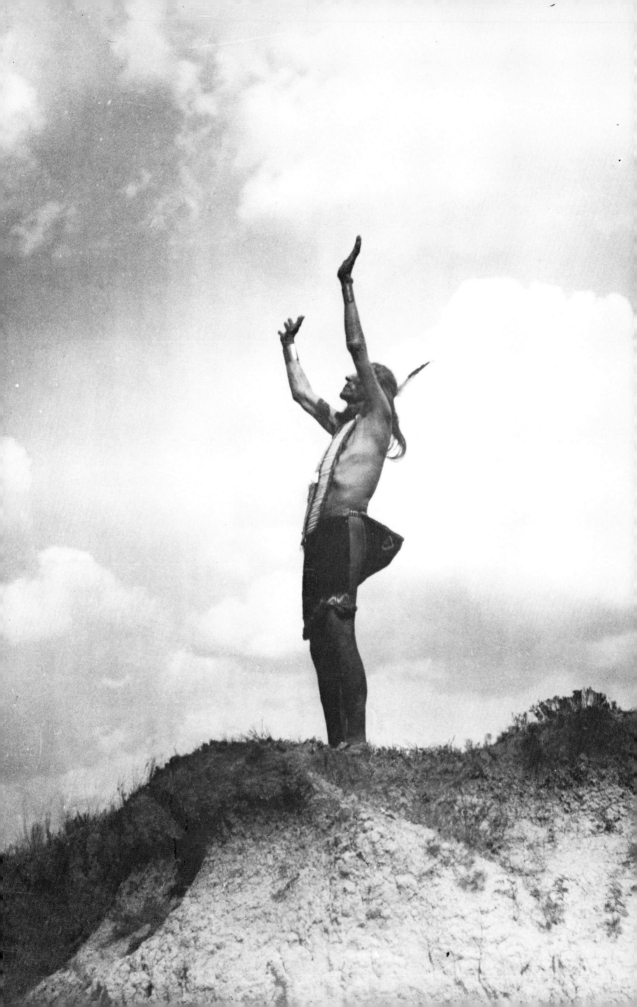

Index

314